A HOME *of* HER OWN

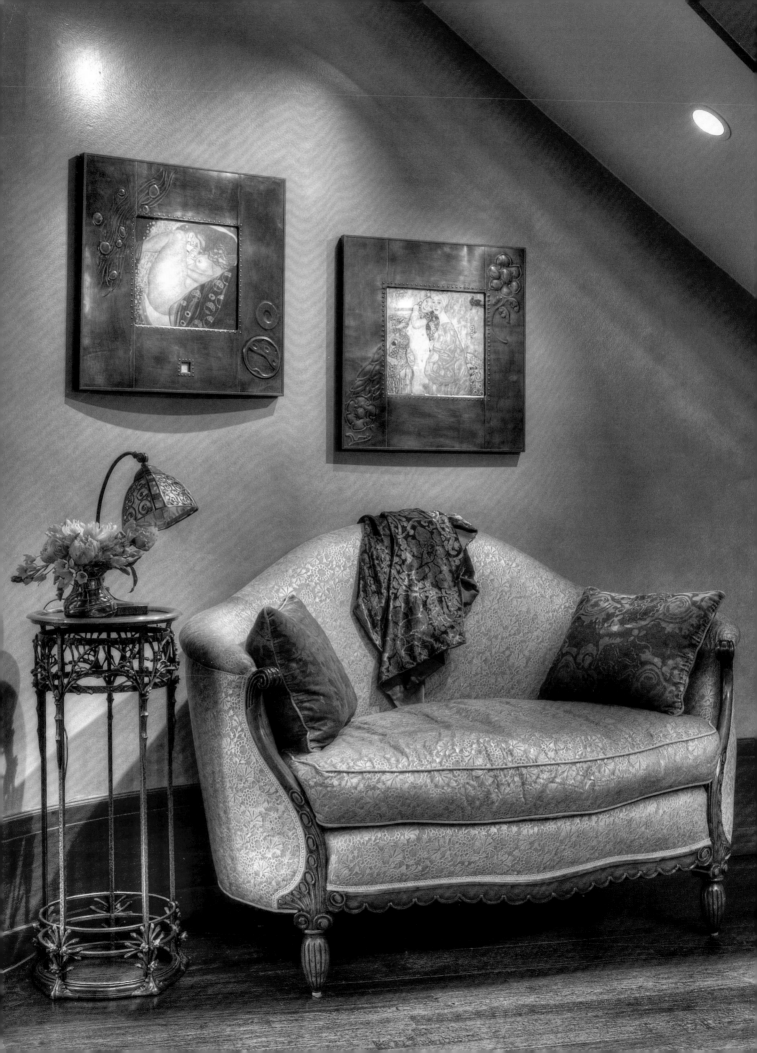

A HOME *of* HER OWN

NANCY R. HILLER

PHOTOGRAPHS BY

KENDALL REEVES

FOREWORD BY

PATRICIA POORE

INDIANA UNIVERSITY PRESS BLOOMINGTON & INDIANAPOLIS

This book is a publication of

Indiana University Press
601 North Morton Street
Bloomington, Indiana 47404–3797 USA

iupress.indiana.edu

Telephone orders 800–842–6796
Fax orders 812–855–7931
Orders by e-mail iuporder@indiana.edu

⊖ The paper used in this publication meets
the minimum requirements of the American
National Standard for Information Sciences—
Permanence of Paper for Printed Library
Materials, ANSI Z39.48–1992.

Printed in China

Hiller, Nancy R.
 A home of her own / Nancy R. Hiller ;
photographs by Kendall Reeves ; foreword
by Patricia Poore.
 p. cm.
Includes bibliographical references.
ISBN 978-0-253-22353-1 (pbk. : alk. paper)
 1. Architecture, Domestic—Psychological as-
pects. 2. Architecture and women. 3. Women—
Psychology. I. Reeves, Kendall. II. Title.
NA7125.H62 2011 2011019920
747—dc23

1 2 3 4 5 16 15 14 13 12 11

Photo on page vi. A banguette with flanking
bookcases in Clara Gabriel's front parlor.
Design by Jean Alan and Kathryn Quinn.

I dedicate this book to my grandparents—
ESSE AND ARTHUR ADLER,
STEPHANIE AND MORRIS HILLER—
and to all the mothers and fathers,
daughters, and sons who have worked
to provide a good home
for those they love.

CONTENTS

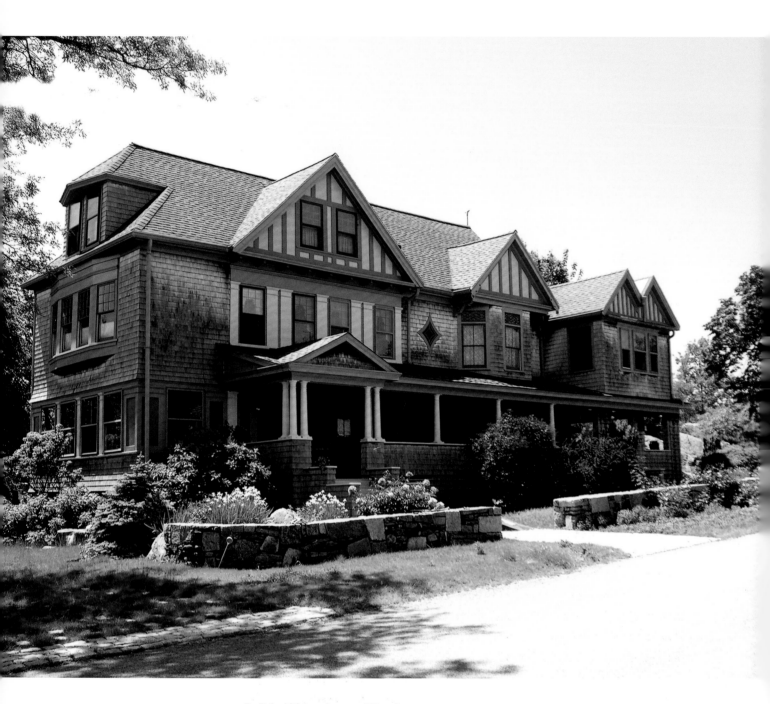

Built in 1904 and named Tanglemoor,
Patricia's house was originally used as a
summer cottage on the New England coast.

FOREWORD

MY HOUSE AND I DO NOT APPEAR as a chapter in this book because we are "not ready," even after eighteen years. During that time I have published lavishly photographed stories of hundreds of other people's houses. My own house, I'll admit, really is a lot like the cobbler's barefoot children. Or perhaps this cobbler has very high standards and the shoes I have just don't seem worthy enough to share. (Therefore I'm awed by the bravery of the women who did let the photographer in!)

Last year I sold my old-house magazine publishing business and, soon after, the building that had housed the operation. In a hurry, I moved thirty-odd years of stuff into my own dining room. Which is no longer navigable, filled as it is with boxes, books, files, framed prints, loose paper, old rugs, slipcased runs of GARBAGE magazine, memorabilia, a thousand slides from the 1980s, etc. etc. (I have promised to clean it all out by Thanksgiving so we can have a proper dinner.)

But then, this house has never been "done" in a magazine sense. Did I mention I had all boys? And dogs? And that there's a beach yards away, so that sand is everywhere? For many years ours was the neighborhood hangout and occasional roller rink. Now it is a boys' locker room and frat house. ("What's that smell in the mud room?") The restored exterior is quite impressive, especially late in May when the garden is filled with blossoming rhodies, wisteria, and climbing roses. Inside, though, the fir floors are a tragedy, and rooms are still fraught with unfinished projects and clutter.

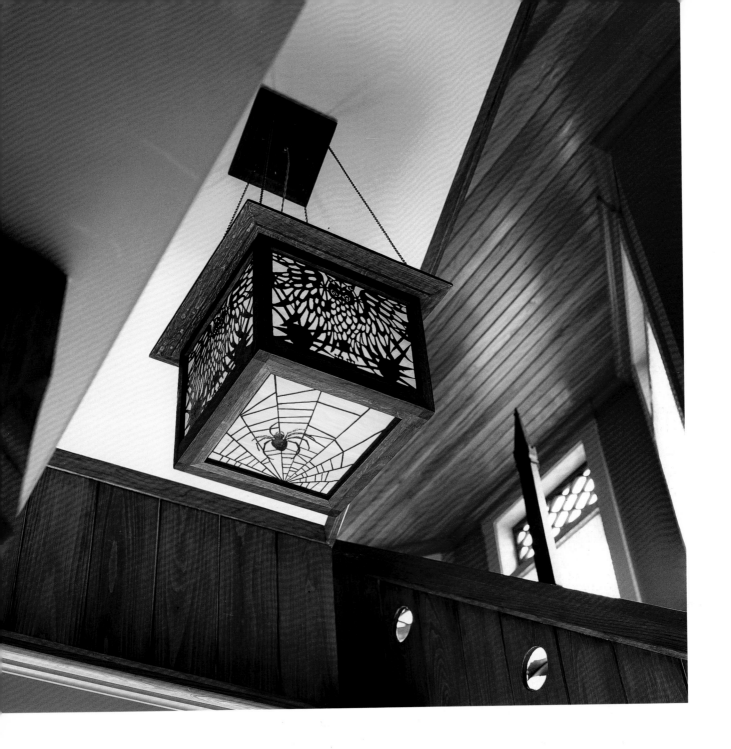

I bought the house in 1992, when my son Will was two years old. He liked to take his nap under the dining room table ("make me a tent, Mommy!"), curled up on the worn powder-blue broadloom with a story tape playing. On one of those days—how repetitive they seemed then, but how fast they went by!—I put the baby monitor next to him and carried its receiver to another room, to fold laundry or prune a philodendron. The story tape had ended. It was a cold day early in spring and the house was silent. I heard murmuring through the baby monitor: someone passing by? I went to the window, but the

street was empty. Vague conversation again; it sounded like a woman and a girl. Disconcerted, I hurried to the dining room, then to the window, then to scan the backyard. There was no one about.

A week or so later a neighbor surprised me with a 1910 postcard of my house. I already knew who had built it as a summer "cottage" in 1904—a Boston lawyer named Daniel Chauncey Brewer. His wife (who as a widow in 1945 sold the house to the hotel across the street, beginning its decline) was named Genevieve, and they had a daughter called Jenny. In the postcard photo I could just make out the blurry figures of a woman in a high-buttoned blouse and hat, and a girl, standing between the rugosa hedge and the porch. Genevieve and Jenny?

My mind flew to the conversation in the baby monitor. I smiled—how gullible!—surely the device had picked up a signal from one of those new wireless phones. But the hairs on my neck stood up, and at that moment I knew, viscerally, that I, too, am just passing through. The house isn't mine.

I learned, after my purchase, that not one prospective buyer had even bothered to go upstairs; the real estate listing hinted at a tear-down. But I saw the place as it once had been, not as it was. Here was a chance to redeem an old house for the sake of beauty, neighborhood values, and reuse! I bought it for its location and its promise—and because I wanted to buy The House where I would raise my children. The irony was that we had to move out twice over the years, so that structural work could be done, and again so that my son's asthma would not be triggered. (After the house was restored, Will outgrew the asthma.)

My boys love this place, and that fact holds sway over my own mixed feelings. Yes, there is much to adore about Tanglemoor . . . starting with the name the Brewers gave the house they built on brambled moorland. They carved a pergola-covered walkway through briars and blueberry bushes to the bath house at Good Harbor Beach; a hundred years later, neighboring ranches and paved roads have given it a more suburban aspect, but the briny air and sound of waves remain.

I still find mine a handsome house. It's rambling and unusual—as if the New England architect John Calvin Stevens (1855–1940) had interpreted Shakespeare's birthplace: Elizabethan Shingle Style? A huge outcrop of Cape Ann granite crashes into one end of the porch in a most picturesque fashion. (As a Jersey teenager bicycling around Gloucester and Rockport, I had dreamed of one day moving here and owning a big rock. My youngest son, Peter, is named in part for the rock.)

But wouldn't you know, I have soured on some of the things that at first attracted me. (This is a book about close relationships.) I also wonder what it means that I fell for a house that is, well, inconsistent. It presents differently

THE HOUSE AT ITS BEST: look up to avoid clutter. Tanglemoor's staircase, by Ipswich, Mass., stairbuilder Lee Wheeler, is after the one at William Morris's 1859 Red House by Philip Webb. The original staircase at Tanglemoor had been replaced by the time Patricia bought the house. The art lantern is by David Berman of Trustworth Studios, Plymouth, Mass. Courtesy of Bruce Martin.

Photo courtesy of Bruce Martin

PATRICIA POORE
is a magazine editor and former publisher. She was owner and editor of *Old-House Journal* for twenty years and also founded *GARBAGE* (the award-winning environmental journal published from 1989 to 1995), *Old-House Interiors, Arts & Crafts Homes*, and *Early Homes* magazines.

on every facade: the street front has an American porch over which steep Tudor gables pierce the sky; broken by flat-sided bays and dormers, the rear facade looms unapproachably. The east end is stoic and medieval with a clipped gable rising thirty feet, the west end enveloping and colonial with a catslide roof lowering to the granite rise. There is a similar disconnect between the impressive exterior and rooms inside. Tanglemoor is truly a cottage, with low ceilings of tongue-and-groove boards and an informal layout.

This sweet informality comes with siting that shields the sun and invites breezes—not very charming in February. The floor plan is long and narrow (I joked that I was subconsciously attracted to the house because it had the same dimensions as our Brooklyn limestone, turned sideways); the plan encourages indoor ball-throwing and unimpeded dog runs, but not zoning for privacy. I am annoyed by having two separate front doors, even though that quirk used to make me think of "the old days" when children and their nanny and the iceman used the kitchen door. Today's reality is that everyone enters through the chronically messy mudroom and kitchen. The door that opens to the parlor must be kept locked against northeast gusts that would smack up against the Steinway.

There were times when I thought this house would save my marriage. My boys' father had some building skills and I had the experience and paycheck that came from the magazines. We could collaborate! But he was still dancing professionally in those years and had little patience for the big needs of the house, or for mundane details. I set about finishing the project to keep it from eating at us. With a second mortgage, the house could be made sound, heated properly, painted and furnished for a loving family. And so it was. After he left, I became all the more determined to keep Tanglemoor, which seemed to be a big, tangible hedge against loss and uncertainty.

I think it was the right thing to do. I wonder what will happen in several years, though, when I'm alone here. I don't see how to create private quarters for rent-paying "roommates." On the other hand, the house has already accommodated one big change, when I moved the office home. Its third-floor suite generously holds me and another editor, and our accoutrements, books, and computer equipment. Who knows what unpredictable circumstance might come next, or how the house will adapt to help me cope?

When it's time for me to go, I'll be proud, as I am now, that Tanglemoor is so much better than when I found it. And I'll bet I have that in common with the women profiled here.

ACKNOWLEDGMENTS

KENDALL REEVES AND I would like to thank the following individuals who have helped make this work a reality, and we apologize to anyone whose name should have appeared here but has inadvertently been neglected. The individuals whose homes appear in these pages have been generous with their time and courageous in opening their homes and life stories to public view.

Linda Oblack, our sponsoring editor at the Indiana University Press, has championed the project from its inception. Her lovely home and story appear in Chapter 7.

Lee Sandweiss put us in touch with her friend Clara Gabriel. John Luke and Kathryn Lofton reviewed the book proposal. Tamar Kander introduced us to her friend Susann Craig. Karen Scales, Mick Harman, Carie Bender, Betty Shepherd, and Brian Bender provided invaluable help with the story about Peggy Shepherd. For assistance with other aspects of the work, we also wish to thank Martin Izzo, Dan Fierst, Liza Burkhart, Molly Carey, Kati Cohen, Katharine Bicknell, Michael Shoaf, Ben and Chris Sturbaum, Daniel O'Grady, Jonas Longacre, William Richard, Dale and Connie Conard, Benjamin Egnatz, Meg Cabot, Sophia and Greg Travis, Nancy Levene, Beth and Tim Ellis, Indiana University librarian Pam Glim, Chas Mitchell, and copyeditor Eric Schramm. A version of the essay on Mary Agnes Conard was first published in *Bloom* magazine, for which I thank its publisher, Malcolm Abrams.

OVERLEAF
Intersecting planes of wood, steel, and glass are reflected in Susann Craig's Chicago loft. Architectural design by Jeanne Gang.

I am personally grateful to Elizabeth Cox-Ash, assistant vice president of mortgage lending at the Liberty Drive branch of Bloomfield State Bank, for her confidence in my ability to pay my mortgage; Kent Perelman, Flynn Picardal, and Richard Stumpner (they will each know why); Scott Sullivan, HVAC professional and award-winning plein air painter, who presented me with what he modestly calls a sketch of my old house and permitted us to reproduce it here; and my mother, Mary Lee, who has taught me at least as many skills involving power tools as kitchen tools and who has run the household she shares with my father, Herb, with courage and ingenuity.

Kathryn Lofton has read and suggested improvements to large portions of the manuscript, in addition to editing the introduction. Martha Scott also read the introduction and suggested revisions, many of which I have incorporated. Any deficiencies that remain are due to my own stubbornness or ignorance.

My partner, Mark Longacre, has displayed saintly forbearance and loving support in the face of neglect.

Kendall Reeves has been the consummate collaborator in this project—unfailingly patient, generous, and unflappable. He has treated deadlines with a rare degree of respect in spite of numerous competing demands on his time. His wife, Stephanie, who is also his business partner, has my personal gratitude for sharing him with me over the past year.

After months of deliberation, Patricia Poore, in whose home and story I have long found inspiration, declined to be included as an official story subject. Instead, she generously offered to write a foreword. It is characterized by her special blend of personal narrative, architectural savvy, and humor. Kendall and I are most grateful.

A HOME *of* HER OWN

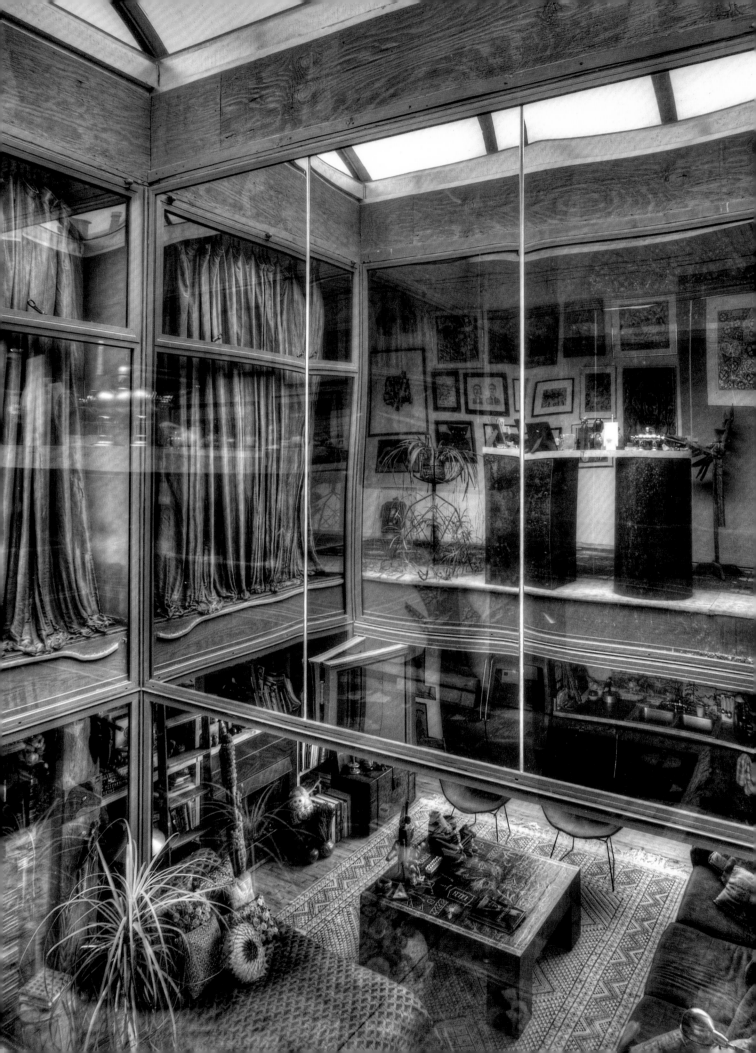

INTRODUCTION

A strong woman is a woman determined to do
something others are determined not be done.
She is pushing up on the bottom of a lead coffin
lid. She is trying to raise a manhole cover with
her head, she is trying to butt her way through
a steel wall. Her head hurts. People waiting for
the hole to be made say, hurry, you're so strong.

—FROM MARGE PIERCY, "For Strong Women"

After ninety gripping minutes of passion and violence, Jane Campion's
1992 film *The Piano* has a surprisingly happy ending. Ada McGrath, the
tale's defiantly odd, mute heroine, finds a man who adores her for exactly
who she is. The final scene shows her and her husband dallying on the
porch of their picture-perfect, whitewashed house.

 The blithe consummation represents a radical turnaround for them
both. Until now, we've known him as a sensitive, brooding man living
a semi-primitive existence in the New Zealand bush and her as a willful
artist rebelling with animal ferocity against the repressive conditions
of nineteenth-century middle-class female life. And so we find ourselves
momentarily confused. Is this the same Ada McGrath we have come to
know—self-avowed freak, impudent misfit, sensuous wild creature
clad in hoopskirts and bodice? How could a woman so untamed feel
anything but suffocated by married life?

Campion offers insight just before the credits roll, when she has Ada reveal the psychological counterweight to her picket-fence dimension. Far from having abandoned her cherished identity as a freak, Ada has merely cached it in a precious reverie she revisits each night while drifting off to sleep. Here dwells Ada's alter-ego—the Ada whose piano is her voice, the Ada with a crystalline sense of who she is, the Ada who would sooner die than compromise. This Ada, convinced that the world has no place for a woman unwilling to follow the dictates of feminine convention, has pursued her observation to its logical end, tying herself to her beloved piano and ordering it cast to the ocean floor.

The film concludes with a striking image of Ada floating above her piano—the artist who pursued her passion even to death. But this is a far-from-maudlin moment. Buoyed amid the turquoise vastness, Ada is unmistakably content. The sound track rolls, and in her impish voice, the real-life Ada tells us that this vision of herself tethered to her piano in its ocean grave has the calming effect of a lullaby.

This suicidal image is her *lullaby*?

What's comforting about the image, Campion proceeds to suggest, is its potent reminder that a strong woman need never feel imprisoned by circumstance. "What a death," she has her heroine marvel, "what a chance," ending the film with Ada's audacity.[1]

Such a death represents only one kind of chance—the decision to follow one's will resolutely, in defiance of cultural bounds. That achieving such self-expression requires Ada to give up her life is significant primarily because she is a woman. Women, we understand, are supposed to respect rules and limits, to preserve life, to take care of others, and most certainly *not* to focus on ourselves.[2] Our minds recoil at the selfishness of Ada's final vision and the succor she derives from it. But we don't hesitate to valorize such behavior in men—the captain who goes down with his ship for the sake of honor (how many children did he leave fatherless?), the mountain explorer who perishes atop a frozen peak (what thought did he give to the employees of his firm, who labored to finance his quest?), the doomed astronaut whose voyage we regard as an act of selfless devotion to industry and science, but whose career was fueled ultimately by a thrill in adventure, a need for self-expression not unlike Ada's own.

I begin this work about women and their homes with the character of Ada McGrath because her intense, complex relationship with her piano mirrors the passionate involvement many of us have with another kind of object, our home—especially in the absence of a domestic partner. The subject of women and home, typically portrayed in terms of cloying feminine stereotypes or

Martha Stewart's special blend of "can do" with "good things you can buy," deserves far more candid and nuanced treatment. Ada McGrath—protective mother, willful artist, self-centered female as dependent on the male-dominated culture that produced her as she is resentful of it—gives rare voice to the conflicting pulls we all feel in domestic relationships but rarely acknowledge. The pull between pious devotion and exhausted recusal. The sense that it's all just too much trouble. The walking on eggshells. The unacknowledged labor. The feeling of being taken for granted—or worse, a source of rancor. Having to choose between autonomy and being smothered.

Compared to the messiness of intimate relationships, having a home of one's own offers the tempting prospect of a certain liberation. There's the freedom to take meals when one will. To sprawl at night across the entire bed, or share it with dogs and cats. To work late into the evening without being called a workaholic—or worse, learning that one's partner, feeling abandoned, has sought, and found, someone more attentive. The very act of casting such freedom as desirable flouts age-old prescriptions for womanly behavior.

Of course, living without a partner also has its drawbacks, even if they are more readily recognizable when the loss of a partner occurs without, or against, one's will. To be without a partner is to be breadwinner, parent, driver, cook, cleaner, gardener, and maintenance person, with no one else to fall back on—at least, no one as convenient or as morally obligated to help as a domestic partner would be. It is to feel, at times acutely, the absence of touch, to miss the joy of sharing summer's pesto and winter's crackling fire, to lack the deep comfort of someone else's breathing through the night.

For whatever reason, most of us have found, or will find, ourselves alone at some time. While a man alone scarcely merits a raised eyebrow, a woman alone is still considered strange, even vaguely pathetic. Despite the many achievements of nineteenth- and twentieth-century feminism, negative cultural messages surrounding the solitary woman persist. We've come to accept that it's OK to be alone at certain times—after a break-up, or during a particularly focused moment of professional development. But for women, being without a partner is understood as ideally a temporary state, one we are expected to overcome. The woman alone exists outside the social order, which she threatens simultaneously by posing a sexual temptation to family men and by imposing the economic burden of her own support; if she has income-producing work (other than as a prostitute), she is still often seen as usurping the job that could be supporting not just a man, but also his dependents. Whether characterized as old maid or *Sex and the City* single, as androgynous professional, widow, or pitiable divorcée, a self-sufficient woman has no

easy profile to occupy.[3] Being without a partner has also historically meant that women have been less wealthy, with fewer opportunities for economic advancement through affordable mortgages, small-business loans, and other amenities available to those who promise a good risk. Viewed in this context, Ada's dangling form looks less liberatory and more like a vision of ultimately impotent self-delusion.[4]

Despite financial and psychic struggle, single women are in fact making enormous strides in contemporary culture, from Supreme Court justices to adoptive Oscar-winning mothers. Yet assertions that a woman needs a man are as ubiquitous as ever. Tips on snagging and keeping a mate share equal time with the latest fashions on the covers of many women's magazines, bombarding us with suggestions—some subtle, some blatant—that the lack of a partner indicates some deeper lack. The fact is, most of us do want an intimate ally who loves us for who we are.[5] But even those fortunate to enjoy such a relationship will almost certainly spend periods alone before or after. It is hard enough to endure the more challenging dimensions of being un-partnered—constraints on time and emotional resources, let alone finances—without also being encouraged to feel like a freak. *What are you—difficult, frigid, or just plain crazy?*

And so we return to Ada, with her imagined death and her chance at free-dom beyond these inhibiting climes—this time, with the added observation that for increasing numbers of women today, our homes have become the equivalent of Ada's piano: our voice, our art, and our instrument of rebellious consolation.

For some people, home is a means to an end—a place to eat, sleep, and store possessions. For others, home is an end in its own right. The activities of constructing and maintaining our homes—from dusting, sweeping, and furnishing to designing, building, or remodeling, as well as covering the mortgage or rent payment—provide us with a sense of existential purpose and connection.

Women and their homes have long been a subject of interest to writers, particularly in the twentieth century. In *Howards End*, E. M. Forster conveys a dying woman's devotion to her house and chronicles the development of a union in which the late wife's husband manages, in spite of himself, to provide the beloved home with a worthy new mistress. In *All Passion Spent*, Vita Sackville-West observes in exquisite detail an elderly widow's enchantment with a home of her own, unabashedly contrasting the rich contentment of her protagonist's new existence with the relative inadequacies and frustrations of her former life as wife and mother. In *Out of Africa*, Isak Dinesen tells the story of a woman who moved to Kenya for a marriage that proved bitterly disap-

pointing but encouraged her fierce attachment to a place and way of life she would later struggle valiantly to maintain. Although Virginia Woolf's *A Room of One's Own* is not, strictly speaking, about a woman and her home, that work, too, captures much of what home has come to mean for many of us today; it is a territory where we can let down our guard, express ourselves freely, and focus our thoughts without undue interference.

Writing that deals specifically with women and their homes need not be seen as exclusionary. We need not suggest some inherent difference as the cause behind women relating to their homes differently than men. That women do is simply a fact of history. Lacking formal education, regarded more often as chattels than as individuals, and shouldering the responsibilities of raising children, women have historically been preoccupied with their homes—not to mention those of others, where they have worked as nannies, housemaids, or laundresses—in ways that men, for the most part, have not.[6] Until the late twentieth century, home has at once been the condition for and the focus of most women's day-to-day existence. Home provides physical shelter while simultaneously making endless demands—preparing meals, tending the fire, sewing curtains and bedclothes—in addition to clothing for others—cleaning floors, doing laundry, tutoring children, etc. To this day it remains a primary focus for the majority of women around the world.[7] Even in wealthier households, where women typically engage their home at one remove—managing staff, overseeing the house's furnishing and decoration, planning menus and events—it has been women, not men, who treat the home as something closer to an end in its own right.

Traditionally, women have related to their homes within the context of families—often large ones encompassing parents, grandparents, siblings, hired help, and lodgers, in addition to the typical members of the modern nuclear family. Today, however, the abundance of intimates has altered. Many of us find ourselves living for long periods alone, or at least without a conventional partner. We may be single, divorced, or widowed. Unlike our sisters in preceding generations, most of us enjoy the blessings of education and opportunities to earn our livelihood without dependency on parents or a husband. Though cultural pressures continue to steer women overwhelmingly toward partnering through marriage, women today are freer than at any previous time to have our own home. By 2003, unmarried females constituted an unprecedented one-fifth of the home-buying market.[8]

We are inheritors of Catharine Beecher and other nineteenth-century activists who focused new attention on the minutiae of domestic arrangements, providing practical guidance to women who lacked adequate instruction from their mothers or other traditional family sources.[9] These early educators have been followed by burgeoning cohorts of homemaking celebrities with exper-

tise in every field from cooking, sewing, gardening, dressing, and decorating to household repairs.[10] As media have diversified beyond print to encompass radio, television, and now the internet, with its beguiling interactive potential, the focus of homemaking has shifted from providing the basics to a form of self-expression in which the self is precariously constituted of images furnished by a juggernaut marketing industry. Since the early twentieth century, women have been explicitly targeted by a marketplace determined to seduce, cajole, or shame us into viewing home as an object requiring regular updates, such as the expansion of square footage, improvements to mechanical functions, and periodic redecoration to keep up with the times.[11] We receive messages of feminism, domesticity, lack, empowerment, and obligation, in addition to aesthetic advice, much of it aimed at getting us to spend money on our homes as a means to improving *ourselves* and our lives. Granted, like all promptings from the market, these are less an imposition of alien motivations than an effort to exploit values, even if inchoate, that already exist; for many of us, the temptation to focus on our immediate surroundings is only heightened by a haunting awareness that home, in contrast to seemingly intractable realities at metropolitan, national, and global levels, is a world over which we can exercise a pleasing degree of influence.

The commercial pressure to identify intimately with our homes has gone hand in hand with other market-driven shifts. While the average size of newly constructed single-family homes in the United States rose from 1,065 square feet in 1950 to 2,438 square feet in 2009, the average number of household members has not increased; generally speaking, Americans, at home, have grown accustomed to occupying greater amounts of space.[12] As late as the 1960s, it was common for children to share a bedroom with siblings of the same sex, but it is now considered normal for each child to have his or her own bedroom, in addition to a separate room, whether shared or not, for play. The dramatic expansion of individual space has coincided with the unprecedented availability of consumer products as a result of inexpensive overseas manufacturing and international transportation, so that in many households today, every child has not only a room, but his or her own television, computer, and cell phone, and sometimes even a small fridge and microwave.

This increase in personal space, along with the practice of indulging individual preferences through providing multiples of the same appliance within a single home, has profoundly reshaped the domestic ethos in the developed world. Many traditional practices intended to foster coexistence have fallen out of favor, if not been entirely forgotten. Individual family members are largely free to eat what, and when, they please. Dick needn't suffer through Jane's movie choices but can escape to another room and watch his own, whether on television or laptop. Mark no longer has to adjust his alarm

clock to ensure he will have access to the bathroom he shares with three other siblings, in addition to their parents; now, he can shower whenever he so desires.

Given this confluence of socioeconomic factors—our habituation to taking up greater amounts of personal space, the reduced emphasis on traditional behavioral constraints designed to foster coexistence, higher rates of female education and income-producing employment, and commercial inducements to identify with and spend money on our homes—it should not be surprising that many of us have found ourselves living alone and forming relationships with our homes that rival the vitality and intimacy of those we might other-wise have with human partners. Many of us have found that the challenges and adventures of living alone, or at least in the absence of a traditional part-ner, have made home a kind of latter-day frontier, thrilling as well as daunting. Far from being clichéd centers of gendered convention and genteel domes-ticity, our homes have taken on new roles—expres-sive, reflective, and compensatory.

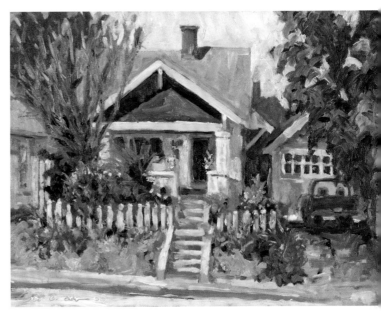

"SATURDAY MORNING COFFEE" Oil; 24" x 18." Scott E. Sullivan, 2000. With kind permission from Scott E. Sullivan.

While a home cannot provide everything available from a human partner, it can certainly bestow deep comfort, in ways that go well beyond the coziness of an upholstered chair or a thermostat's adjustabil-ity. It can provide a sense of purpose and identity. It can reflect an objective statement of its owner's or tenant's capabilities as designer, artisan, mechanic, and gardener, and as the wage earner who pays the mortgage and covers other expenses. It can also provide undeniable evidence of less concrete qualities of character such as patience, determina-tion, courage, and perseverance in the face of adversity. And notwithstanding the occasional expensive breakdown, a home doesn't attack, sulk, demand, or disappoint in the ways that human intimates sometimes do. Small wonder, then, that many of us today, like Baroness Blixen, Lady Slane, and Margaret Schlegel, have come to regard our homes, at some level, as loyal, worthy part-ners that nurture us just as we care for them.

For as long as I can remember, I have wanted a home of my own. The desire has nothing to do with ownership in an acquisitive sense, but with living in a place where I belong, and one I can have a hand in shaping.

The close connection between fashioning my surroundings and feeling at home undoubtedly owes much to my mother, the hands-on partner in her marriage. In the early 1960s, while my father was at the office, working

to fulfill his immigrant parents' dreams, she was subtly subverting her own parents' expectations for a daughter who had married a Harvard Law School grad with a promising future in public relations. A newspaper story of the time observed that instead of greeting him at day's end "ruffled and perfumed and bearing two iced martinis on a tray," she would be "barefooted and wearing slacks." Worse, she was engrossed in various construction projects, which often entailed "running her electric drill and smoking a big, black cigar."[13]

My sister and I remember her replacing the faucet on the kitchen sink, remodeling bedrooms, changing cabinet hardware, and—most impressively—building us an outdoor playhouse entirely from scratch. (My primary memory of that playhouse involves the expletive she uttered on smashing her thumb, and the dramatic black nail that resulted from the impact.) She furnished our home with old objects scavenged at the dump, turning an industrial cable spool into a coffee table in the living room, reupholstering a Victorian couch in black-and-white '60s paisley, converting a discarded Victrola into a modern stereo cabinet, and setting up massive salvaged beams to form a shelf for records.

On a cold December night circa 1969, when my sister and I would have been about eight and ten, our father—son of Polish immigrants for whom need was an all-too-vivid memory—invited some hippies from the local park to shelter in our living room. They and their successors ended up staying for years. Very quickly our home became something of a commune, though certainly no authentic commune, considering that my father alone was paying the mortgage. At one point at least eight people were making their home in an assortment of simple structures on our half-acre lot. As the elder sibling, I identified with these people, who, while not much older than I, were sufficiently distant in age to seem adult. They were vegetarians, so I eventually stopped eating meat. They didn't participate in the culture of consumerism, so I didn't either. Despite various sybaritic dimensions of their lifestyle, they counseled a moderate asceticism.

After several months our mother went away, entrusting my sister and me to our father and the hippies. My sister had no taste for self-denial. She wanted a normal American childhood with candy, television, hamburgers, and fashionable clothes, so she sought refuge with our maternal grandparents. I stopped going to school, which had come to seem more like a social battlefield than a place of education, and learned to make carrot and tofu pizza, carob cake, and home-churned honey-vanilla ice cream. I did my laundry by hand, drying it on an outdoor line. I took cold showers in an outdoor bathroom, reducing my dependence on supposed necessities to a minimum. The room my sister and

I had shared became a hippie hangout, complete with black light. I decided I no longer needed anything as childish and bourgeois as a bedroom.

Our house had a large garage where I arranged some of my mother's tool shelves in a corner to form a pair of perpendicular walls, creating an enclosure in which I set up a cot. This was my first experience of making a home. Each night I read a few pages from a mildewed volume entitled *Mother India*. It seemed appropriate for the times, considering the prevailing fascination with popularized versions of Indian mysticism. The Beatles were devotees of Ravi Shankar, and even our local park had a Swami who gave weekly yoga lessons on the grass. I loved my little space, which was cozy and gave me a sense of emerging adulthood.

After about a year our mother returned, and with her parents' help, planned a relocation to Israel, where we would supposedly live on a kibbutz. The night before our departure we stayed at our grandparents' apartment, and my grandmother gave me a bath. Forty years later I still recall the experience with clarity. The hot, fragrant water filled me with a sense of gratitude and goodness. My grandma sat on the toilet and talked about how she had worried about me, an emaciated 11-year-old with unbrushed hair, living in that house with all those people and their drugs. I was sorry that she felt the need to cast me as a victim, when I myself had found the whole experience empowering, but our differing views in no way diminished my awareness of, and appreciation for, her loving care. When I climbed out of the tub she wrapped me in a thick, soft towel, then dusted me with baby powder. It was heaven.

As things turned out, we did not settle in Israel; a woman with children but no husband was not welcome on any of the kibbutzim we visited. After two months of European peregrinations we settled in London, where my sister and I went through middle and high school. I later dropped out of Cambridge and became a cabinetmaker.

In 1981 I took my grandmother up on an offer she had made long before— "I want to help you buy a house." She recalled my saying, in those early post-hippie days, that all I wanted was a little house with a garden. To my profound gratitude, she and my grandfather gave me the down payment on a tiny row house in a working-class neighborhood overlooking downtown Reading, where I lived with my first husband.

Fourteen years later—twice divorced, back in the States, now with a master's degree in religious studies—I was trying to figure out what to do next. For the first time in my life I wanted to stay where I was—in Bloomington, Indiana. I was thinking about buying a house, confident that any job I found

would cover a mortgage payment that would almost certainly be lower than the typical university town rent.

Five houses in the newspaper listings seemed worth a look, so I contacted a realtor. The first was a bungalow built in 1925 with dark-green shingles on the gabled ends and white clapboards on the ground floor. It sat on a grassy rise, with several steps leading up from the sidewalk to a path across the front yard. The porch, like the rest of the house, had a massive limestone foundation, with limestone walls and corner piers supporting its roof. Spirea bushes billowed around the base.

The place was charmingly unfashionable, not the least bit done up. It had been well maintained by its owner, who had lived there with her family since 1925. In the center of the front lawn stood a beautifully turned limestone birdbath that reminded me of my grandparents' house in Miami Beach, circa 1965. Adding to the place's appeal was an aluminum-framed storm door adorned with the letter P, the first letter of the owner's surname—a detail endearing for its expression of modest pride.

Inside was more to love. The rooms were surprisingly spacious, with hardwood floors and fir trim finished in shellac. All the original paneled fir doors and double-hung windows still remained, and a divided-lite door made a lovely separation between the entry hall and living room. A hedge of peonies grew between the house and its next-door neighbor, and an old dogwood tree marked the rear of the lot.

The realtor said that the owner, Nellie P, was in a nursing home up the street. For years her children, by then themselves probably in their seventies, had tried to persuade her to move to a safer location, but she had stubbornly refused to leave her home. When she fell and broke her hip, they seized the chance to move her out for her own good. Though most of her furniture was gone by the time of my first visit, the house was still filled with signs of her presence. Shadowy outlines spoke of family pictures that had hung on the walls. An aqua carpet with a 1930s pattern covered much of the dining room floor, conjuring visions of family dinners. Several of the doors held racks hung with dresses, their styles spanning many decades of the twentieth century.

I wrote an offer on the spot, moved not just by the bungalow's architecture, but also by an immediate sense of stewardship for the place on behalf of this woman who had spent her entire adult life there and who had clearly not wanted to leave. In truth, of course, I knew next to nothing about the kind of people the P's had been—for all I knew, they could have been members of the Ku Klux Klan—but their house felt like home.[14] My partner generously cosigned the mortgage application, since I had not yet found a job. The single

disappointment was that the P's wanted to take the birdbath, which their father had made. How could I object to that?

I couldn't wait to move in. Several times over the next few weeks I awoke at night gripped with fear lest some chance event should derail the closing and thought *please, please—don't let anyone buy my house.*

My house.

The closing went through, but I was still unable to find a job. Between my professional background in woodworking and my humanities degrees, I was not exactly a shoe-in for the kinds of clerical and administrative positions I was seeking. Desperate to generate some income after four months of fruitless job hunting, I decided to go back to doing what I knew. I set up a crude woodworking shop in the dark, damp basement.

My partner and I lived there together about a year. I longed for a dog, but he had repeatedly said I would have to choose between him and the hypothetical dog I desired. Eventually I began a secret search. Hoping his threat would prove hollow, I brought home an eight-week-old puppy called William. My partner said the dog was cute and he would be moving out as soon as he could find alternate accommodations.

After about a year, my by-then former partner, with whom I maintained a cordial relationship, decided to buy his own place. He needed to unburden his credit report from the weight of my mortgage. Being self-employed and with a relatively low income, I struck conventional lenders as a poor risk. One loan officer laughed at my request while I sat in his office. To my relief, I finally got a loan through a neighbor who worked in the mortgage division of a local bank; as a neighbor, she knew I was in fact a *good* risk because I would do all in my power to keep my home.

The next five years were some of the happiest of my life, though there were certainly periods of despair. Exacerbating my economic insecurity was the cost of my home and garden habit, on which I spent the majority of my spare time. I had originally planned to keep the front yard simple—a classic bungalow entry with spirea bushes and lawn—and have a lush secret garden in back. I had fenced in the backyard to contain my hypothetical dog while still living with my former partner. When he left, I built a simple deck at the back of the house as a semi-private outdoor room from which to enjoy the garden I planned to create. But no sooner had I cleared an area and planted it in perennials than William undid my work, tearing through the delicate flowers and foliage or digging up plants and delivering them proudly at my feet. My dreams for an enchanted *hortus conclusus* were further trampled when I brought home a second puppy to keep William company. It was clear that if I wanted perennials they would have to go in front of the house.

Boyfriends came and went, and I comforted myself through every heart-break by having my way with the house and garden. When John informed me that "it's just not working out," I replaced him with lily, rose, and veronica, who would appreciate my attentions and never leave. If I couldn't hold Randall in my arms, I would fill them with bouquets of asters, anemones, and hydrangeas. I built an arbor at the south side of the front porch and planted it with wisteria after Sam, and I was sitting next to that arbor on the porch swing with Dan when he told me he would "rather just stay friends." I bought a pair of vintage striped awnings at a junk shop and hung them from the beam of the front porch gable, transforming the porch into an outdoor room. On Sunday mornings I gave thanks for my blessings by reading the local newspaper in the porch swing I had built, while eating Ben and Jerry's Chubby Hubby ice cream, relishing the scent of peonies or viburnum, and occasionally looking up to admire the garden. I went to bed with English garden authors Penelope Hobhouse and Rosemary Verey, had breakfast with cottage garden designer Margaret Hensel, and was endlessly inspired by Monet.

Inside, I put wainscot panels in the living room and filled them with a Bradbury & Bradbury reproduction William Morris wallpaper. A friend sold me her worn but serviceable cut-velvet couch from the 1940s; it was blissful to have a real couch, and I smiled at its ghosts, a couple of gossiping wartime housewives with curlers in their hair, straight out of an English soap opera. I installed a gas fire for warmth and gave the dogs permission to join me on the furniture. To support my homemaking habit, I rented out the pair of rooms behind the kitchen, which had the house's original full bath, and incorporated a salvaged claw-foot tub and the space from an extra closet into the former half-bath upstairs, which became mine.

I hired a carpenter to make a few exterior repairs and had the house painted yellow and green by a gentle fellow who went door to door on his bicycle seeking work. At $8 an hour he was affordable, and I was grateful not to have to scrape and paint the house myself. I removed the overhead door from the 1920s garage and replaced it with a pair of homemade doors patterned after original examples of similar vintage.

None of this activity was motivated by a desire for status or acquisition. Rather, I was moved to create a place where I would simply, and genuinely, feel good. I was no longer a child or even a youth, but an adult, and I realized it was foolish to attempt to get myself through the kind of hard times we all sometimes face by looking to the future. The future no longer lay beyond some hurdle—graduation, a better job, a relocation with potential for self-reinvention; it had arrived. I recognized that I had been largely responsible for creating the very circumstances I now occasionally lamented, and the

time had come to make peace with that creation. My home provided a small corner of the world over which I had some measure of control, and I was making it into a place that would comfort, nurture, and please me, with or without a man.

My head was full of undermining messages—the voices of older female relatives from my childhood, speculating as to why this friend of theirs or that one had been left by her husband, or—far more embarrassing—had never even married in the first place. "Maybe she has a social disease" was one possible explanation, "She obviously wasn't giving him what he wanted" another. The voices of former husbands and partners sneered that I was difficult, even joyless . . . a fishwife, a bitch, or crazy. And wasn't my single status proof that they had been right?

Making a home had much to do with answering those interior voices. This was not decorating, nor was it concerned with fashion. Rather, it was a way of proving I was good enough. I was lovable. I had a right to the space I inhabited. I no longer needed a man to reassure me of these popular affirmations; the house did so, every day. The words on the card my mother had given me when my first husband and I bought our house in Reading—"Take care of your house, and your house will take care of you"—came back to me now. No one could deny that the house, quite literally, embraced me, sheltered me, and kept me warm, in addition to delighting me with its beauty. It was, in its own way, a companion. The plants in the garden expressed their appreciation for me by bursting forth every spring to greet me with their leaves, their stalks, and their flowers. Granted, they would have done so anywhere; but it was I who had planted them where they now stood. The basil, dill, and tomatoes fed me. I had planted those seeds and starts, fenced the garden to protect it from the dogs, and made the compost pile that nourished each season's harvest. It's no exaggeration to say that I felt I lived in a kind of earthly heaven that I had helped create. The beauty around me was a living expression of my physical strength, practical abilities, and character, reflecting my ingenuity and stubborn perseverance back at me, irrefutably, no matter how unloved or undervalued I occasionally felt.

Over the years I became aware of another sense in which the house had gained the quality of a companion. It wasn't my house, really; it was Mrs. P's. She and her husband, a lathe operator at area limestone mills, had had the house built and had lived in it their entire married life. After her husband passed away in one of the downstairs bedrooms, Nellie had stayed on some thirty years—almost as long as I had been alive—sometimes taking in renters. Neighbors remember her as a tall, elegant woman who was active in the Baptist church two blocks away, where she taught Sunday school.

Above the little wall-hung sink in the upstairs half-bathroom was a mirror without a frame, on which someone had painted, in neat italic script, "Fear Not. I Am," and then, below the space in which one's face would be reflected, "With Thee." Whatever Nellie had read in that message I could only guess; it was most likely church-related. But what I read was: *I am not alone in my aloneness here.* Nellie had experienced a similar aloneness in that place before me, and I found that knowledge profoundly reassuring.

Further, it's no stretch to claim that, in common with some of the other women whose stories appear in this book, there was a sense in which I adopted Nellie's family. Although I never formally researched their history, I took a lively interest in whatever news I could pick up about them from neighbors and was fascinated as scraps of their past surfaced to my attention—old marbles dug up in the garden, a 1940s newspaper found, yellowed and crumbling, in the attic, with its headline about "pretty girls" and "brave men in uniform." There were two pages from a letter handwritten to Nellie by a country friend who inquired what it was like to have moved to the "city" (which had a population of fewer than 18,000 when the letter was sent) and told of how she herself got up at four to make breakfast for the men who would soon come in from dawn chores on the farm.

Although the P's no longer lived in the house, I felt it was still very much theirs. My interest in them was a way of peopling my home, writing its story for myself, not unlike the way a caterpillar embowers itself in a cocoon, or as though I could put on another family's history just as one would put on a deliciously soft cotton shirt. Other women hinted at similar phenomena during our interviews for this book. Kitty Burkhart, for example, said she had asked herself why she was working on the Stouts' family history instead of on her own family's.

In my case, this sense of living in someone else's house—another *family's home*—had a reassuring effect, similar to the sense I have when spending a stormy night in the well-built home of a relative or friend. In circumstances that might have me tossing and turning with worry about a place for which I am responsible, it's a luxury to relax and have faith in the solidity of someone else's construction. *This roof will hold, these walls are well reinforced.* Some of us look to that other family's history for a kind of structure. The framework of their story, the sheer fact of their having made their lives for so long in what is now our place, provides us with as firm a sense of home as the pine boards, bricks, and mortar that give us physical shelter.

My garden was the most vibrant expression of the home I had made, perhaps because it was a living creation needing regular care and rewarding me with beauty that was alive and ever changing. In 2001 my home was included on the local garden walk, which gave me a sense of validation. When

an acquaintance who had visited during the tour later told me how much she appreciated my garden as an example of something a person with limited resources could create, I explained that my garden's super-abundance, its winding limestone paths and contrasts between rampant growth and ordered space, had come about due to repeated relationship breakups, that it was a constructive response to those disappointments and heartbreaks; every time I broke up with a man, I went to a nursery and allowed myself the luxury of forbidden spending on plants, which would encircle my home, creating a place of beauty, privacy, and lasting pleasure. She found the story behind my garden hilarious and laughed so hard that she nearly fell off her chair.

In reality my financial situation was ever precarious, not least because I was financing my nursery purchases with cash that should have been saved for taxes. Every April, when my accountant reported the damage, I paid the state and federal taxes by credit card—not a strategy for long-term financial security. As with most businesses, there were times when work was slow, and I wondered how I would make my mortgage payment. I lay awake, weighing the pros and cons of keeping my house and trying to focus on the comforting press of my dogs and cat. Perhaps I should sell the house and buy something smaller? But property prices had gone up so much that even a smaller place would cost more than I had originally paid for my home.

In a recurring dream, I had taken the supposedly responsible step of selling my house. Immediately after the closing I was assailed by horror and damning disbelief. *How could you have sold your house?* Though I have no children, I can only imagine the sensation was something like what one might feel on learning one's child had suffered a terrible injury due to one's own unintentional action. Reminding myself that it actually made financial sense to keep the house and do all in my power to make the necessary income, I concentrated on the contented rhythm of the animals' slumbered breathing. I had to make things work for them. Where, other than in a home of my own, could I keep my family together, especially considering William's delinquent personality and behavior? That settled the matter, and eventually I fell back to sleep.

One night I had a different dream. This time I had sold my house, but having done so felt all right. I was walking around another old house. The woman who had lived there had died or moved away, but her long cotton underwear was soaking in the clawfoot tub. A window over the tub flooded the bathroom with sunshine.

The front door opened onto a stone yard protected by an old stone wall covered in moss and lichen. A vine-draped pergola spanned the distance between the wall and the house. There was something so compelling about this other woman's place, with its sunny bathroom and its old-world stone wall, that I felt ready to move on. In fact, more than ready, I felt drawn.

In conversations with two friends, Peggy Shepherd and Edith Sarra, similar themes and patterns emerged. It was clear that for Peggy, fixing up a house was a way of improving her domestic circumstances and giving herself great pleasure. She completed three major home restorations during the fourteen years I knew her, doing much of the hands-on labor herself. Working on each of these places—a Civil War–era house in the country, a turn-of-the-century gable-ell in town, and a timber frame barn conversion—was a substantial challenge. Each demanded complete creative focus. No sooner had she begun making a home in her new space, even if the only livable area was a basement sleeping room without plumbing or proper cooking facilities, than her project became a daily source of joy and satisfaction. She had everything on the line. There was no turning back. She invested her entire self in each project—not just in terms of capital and loan funds, not just her emotions and imagination, but her very body. She worked on the houses every day, usually while living onsite amid tools, sawhorses, and stacks of salvaged floorboards.

In Edie's case, I was struck not only by her impressive restoration of a house many people might have abandoned to the bulldozer, but also by the depth of her attachment and commitment to that place over more than twenty years. It was clear that Edie's home gave her a sense of purpose, as well as satisfaction, similar to that which many of us get from a marriage or other intimate partnership.

While living alone, these two women had formed passionate relationships with homes that were largely of their own making, and the places they had made were breathtaking, particularly considering that they had been done with limited finances. I was struck not just by the pathos of Peggy's and Edie's respective stories, which resonated with my own experience, but by how impressively they had marshaled their capabilities—their vision, patience, ingenuity, and physical strength. I found myself pondering two questions. First, what, if anything, was peculiar about how *women* related to the experience of making and living in a home, in the absence of a partner? Second, in which ways might a home be distinct from any other object of engrossing creative activity, such as writing a book or restoring a motorcycle? I have attempted to address these questions in the essays that follow.

The stories are as varied as the women about whom they've been written. In some, interior design or decorating is a significant focus; in others, the actual process of a home's transformation, which can take many years. Some stories follow their protagonist from one home to another, while others deal with houses that have sheltered multiple generations of the same family—

or, as in one case, four women, unrelated to one another, who happened by coincidence to be single female members of the same male-dominated profession. Other stories track how their subjects' involvement in making a home has shaped their career, or vice-versa. The essay about Mary Agnes Conard deals with home not in the sense of a house, but in terms of place.

Taking a quite different perspective, the story about Diana Hawes considers how a house's sheer physicality can serve as an expression of selfhood and the right to take up space. Not so long ago, before the tattooed assertiveness of today's young western females, women were assiduously discouraged from occupying more than a minimum of physical and social space. Trained to dress modestly, watch our weight, cross our legs while seated, hold in our stomachs, and avoid speaking—or, heaven forbid, guffawing—loudly, women learned that the world belonged to others—fathers, husbands, children, employers—whom we were meant to serve.[15] A woman's very body has scarcely been her own, regarded instead as a vessel in which to procreate future generations of her husband's, or even God's, estate. Taking on a home of one's own is a radical shift from these timeworn imperatives. To have one's own home is to stake a claim on space well beyond one's body—in a sense, to make one's body grow much larger, announcing *I live here, and I have a right to the space I occupy.*

I know couples who have intense relationships with homes they have fashioned into vivid expressions of their unions—exuberant, cerebral, period-perfect, or refined, as the case may be. I also know men—single, widowed, and divorced—who are ardently attached to their homes and have stories every bit as compelling as those included here. But I have chosen to focus specifically on women and their homes because at this point in history, women face a set of cultural, economic, and existential issues that I find intriguing. This is a book of essays, not social-scientific studies—tales for the bedside table or beachfront chaise. I hope that these tales, with their striking photographic images by Kendall Reeves, will intrigue, delight, and touch, as well as contribute to the appreciation of home as something with far greater ethical and spiritual significance than "real estate."

Finally, a note is in order to explain certain glaring lacunae, most often surrounding the ending of relationships. Because these stories are about some of life's most intimate subjects—home, family, and partnership—I have exercised a heightened degree of sensitivity to privacy concerns and have respected my subjects' desire to exclude material with evident potential to cause hurt or offense. The stories should be read with this in mind.

NOTES

1. Of course, there are alternative interpretations. "What a chance" may refer to the chance to live. Alternatively, she may be musing that the contented life her will chose is a kind of death, particularly in relation to the intensity of her previous ups and downs.

2. Countless late-twentieth-century exhortations to women to focus on ourselves—think of *Self* magazine, L'Oréal's "I'm worth it" advertising campaign, or the casting of luxuries such as grooming products, makeup, or sexy undergarments as "essentials"—simply underscore this point. There is no exact equivalent directed at men, because they have not, as a class, received messages of self-abnegation.

3. See Alice Friedman, *Women and the Making of the Modern House: A Social and Architectural History* (New York: Harry N. Abrams, 1998), 29. "Unlike women, even when men remained single they were not considered outcasts from the social order." On the other hand, Friedman acknowledges that during the early twentieth century, "the social pressures placed on men to marry were as great as or even greater than those confronting women, since the specter of homosexuality was far more threatening for bachelors than for single women" (29).

4. On gendered income disparities, see the National Organization for Women website, www.now.org.

5. This and other notions regarding what constitutes a good relationship are historically relative.

6. See, for example, Witold Rybczynski, *Home: A Short History of an Idea* (New York: Viking Penguin, 1986); Antoinette Burton, *Dwelling in the Archive: Women Writing House, Home, and History in Late Colonial India* (New York: Oxford University Press, 2003).

7. See Betty Friedan, *The Feminine Mystique* (New York: W. W. Norton & Company, 2001), and Sheila Rothman, *Woman's Proper Place* (New York: Basic Books, 1978).

8. See Rachel Bogardus Drew, "Buying for Themselves: An Analysis of Unmarried Female Home Buyers," (Cambridge, Mass.: Joint Center for Housing Studies, Harvard University, June 2006). Drew acknowledges that "unmarried female home buyer" is a category made up of other sub-categories and does not necessarily imply the absence of a partner. Many unmarried women are widows or divorcées who previously had a husband. Some do in fact have a partner, though they are not married. Drew puts the figure for "unmarried female buyers" who actually live alone at 45 percent of unmarried female buyers (8).

9. See, for example, Catharine Beecher and Harriet Beecher Stowe, *The American Woman's Home* (New York: J. B. Ford & Co.; Boston, H. A. Brown & Co., 1869); Nancy F. Cott et al., *Root of Bitterness: Documents of the Social History of American Women* (Boston: Northeastern University Press, 1996); Ellen Plante, *The American Kitchen, 1700 to the Present: From Hearth to Highrise* (New York: Facts on File, 1995).

10. Gurus of domesticity have become increasingly commercial with succeeding generations. While Beecher and her sister, Harriet Beecher Stowe, along with others among their contemporaries, were motivated by a religious sense of obligation to improve women's circumstances, the profit-generating potential of dispensing household guidance seems to have been appreciated by the time Christine Frederick rose to fame in the early twentieth century, as spokeswoman for the Hoosier Manufacturing Company. Many Hoosier cabinet models boasted "Mrs. Christine Frederick's Housekeeper's Food Guide" as "an exclusive feature," and Frederick, along with other "household consultants," "domestic science specialists," and "domestic efficiency engineers" such as Nellie Kedzie Jones, were used as

brand representatives much as Martha Stewart, Jane Seymour, and Rachael Ray are today—though contemporary equivalents tend to have their own product lines. See Nancy Hiller, *The Hoosier Cabinet in Kitchen History* (Bloomington: Indiana University Press, 2009).

11. The HGTV.com site extols HGTV's potential to be employed as a marketing tool. "From television viewer to online user to consumer and back again. That is the powerful HGTV.com circle that brings a pre-qualified audience face-to-face with the advertiser," reads the site's page for prospective advertisers (http://www.hgtv.com/advertise-with-us-audience-profile/package/index.html). And there are data to support those claims; according to the Nielsen Online RDD//Online Panel figures for July-September 2009, HGTV site metrics include 99.9 million monthly page views with 3.6 sessions per person averaging 10:48 minutes per person—figures they proceed to describe as superior to those of other sites such as marthastewart.com.

12. The figure for average square footage of new domestic single-family construction and average household size in 1950 is taken from "The U.S. Homebuilding Industry: A Half-Century of Building the American Dream" (John T. Dunlop Lecture, Harvard University, October 12, 2000), www.jchs.harvard.edu/publications/markets/balexander_M00-1.pdf.

For 2009, the figure for average square footage of new domestic single-family construction across the United States is from "Median and Average Square Feet of Floor Area in New Single-Family Houses Completed by Location," www.census.gov/const/C25Ann/sftotalmedavgsqft.pdf. The figure for average household size is from "Average Number of People per Household" 2009 (www.census.gov/population/socdemo/hh-fam/cps2009/tabAVG1.xls).

"Average number of people per household" is difficult to gauge; the census differentiates between "family" and "nonfamily" households, with average figures of 3.22 and 1.25, respectively, for 2009.

13. "Mary Lee Only Tackles Substantial Jobs," Grace Wing Bohne, *Miami Herald*, mid-1960s; precise date unavailable.

14. Part of making a home is making a narrative. We fill that narrative at least partly with our own hopes for the place.

15. Consider the practices of foot binding, polygyny, and the stoning or burning of wives for even *suspected* infidelity.

1 A PAINTER'S HAVEN

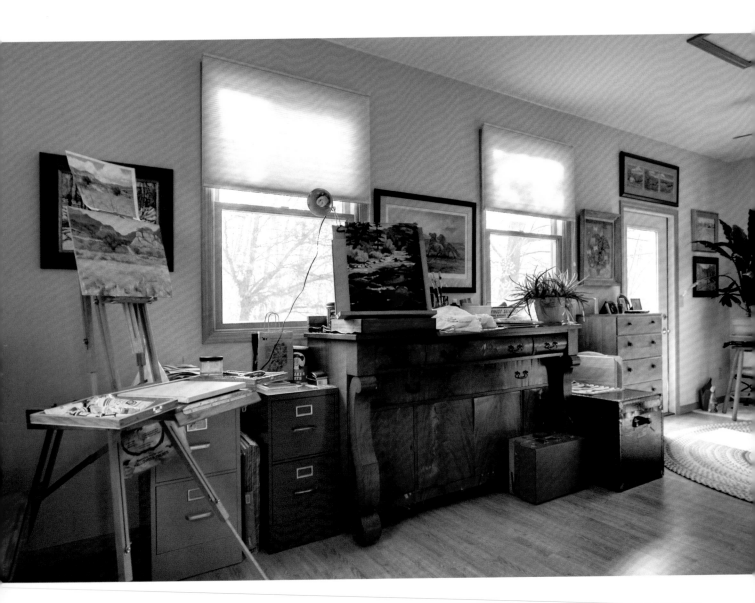

SOME GIRLS ARE CRAZY ABOUT HORSES. You know the type. While their friends' bedroom walls are decorated with posters of rock stars and supermodels, these girls surround themselves with pastoral images of grazing foals and mares, prints of derby winners, and dramatic shots of Olympic jumpers in mid-leap.

Rachel Perry was one of those girls. Her father joked that from the moment she learned to talk, she found few subjects besides horses worth discussing. One of her earliest memories is of wanting to own a piece of land she could turn into the picture-perfect horse farm of her dreams.

Rachel acquired her first horse at the age of 13, and the following year she grew a full foot, coming to tower over most boys her age. Her coltish looks made her something of an outcast, and she quickly came to prefer the company of young men in college whose physical stature and social maturity were more compatible with her own. Eventually she was paying more attention to her young suitors than to her horse, and in 1966, at the age of 16, she dropped out of high school and ran away to San Francisco.

Those were tumultuous times. In less than a year she had returned home and forced herself to earn a GED. She enrolled in college, thinking she might major in flute. But after a few semesters she was back on the road, thumb outstretched, headed west with her then-boyfriend. She took a job working for a theater in Berkeley. Once she had residency, she was able to take classes at no charge through the state university system. She found a scuba diving

THE GUEST BEDROOM in Rachel's house doubles as her studio and is filled with her own paintings, including those in progress, and various works by friends. The massive antique sideboard was a gift from a former neighbor.

course so thrilling that she considered becoming a marine biologist, but after more than a year of prerequisites—calculus, physics, fresh water biology, and medical history—she decided she was not cut out for science. She moved to Boston, where she wound up selling coffee and Danish to staff at the John Hancock Building. Every day at lunch she wheeled a cart of chips and sandwiches around the offices, plying her wares. It was not a life she wanted.

Exhausted by her decade of adventures, Rachel returned to Indiana in 1976. That summer she spent some peaceful days at the edge of a wooded lake with her mother and a close family friend. Mrs. Perry had bought a small lake house, thinking it would make a nice getaway from life in town, as well as from her husband's relentless work schedule. The house itself was modest, built in 1962 when the valley below was dammed to form the lake. The views, however, were breathtaking. In winter, the frozen smoothness cradled between steep, brown-gray banks snaked as far as the eye could follow. During warmer months the water danced in the sun, its hilly borders shifting slowly from spring's pink and white confetti to exuberant chartreuse, followed by deep greens in high summer and autumn's crescendo of crimson, rust, and gold. Scarcely anyone else visited the lake, which made it ideal for swimming, napping, and long conversations with friends.

Rachel needed a place to live, and the lake house was available. No one had ever actually spent the night there; it had just been a place to visit. The structure was bare-bones basic—concrete block with single-pane aluminum windows, a small kitchen and sitting area downstairs, and two rooms on the entry floor above—but it would do, until she had established herself in the area. Her mother's friend, who owned a winery, offered her a job, and she quickly worked her way up to manager of the tasting room. But again, it was not the kind of work she could see herself doing indefinitely.

At 28 she decided to become a farrier—that is, a specialist in caring for horses' hooves. She completed a three-month training course at a college in Oklahoma, then apprenticed herself to an established tradesman with sizable accounts in Indiana and Kentucky. Income was sporadic but sufficient, and she was able to spend most of her days in the company of horses.

The time had come to put down roots. In the fall of 1979 she received a small inheritance, which she immediately invested in 17½ acres near the end of T. C. Steele Road in Brown County. The road was named for Theodore Clement Steele, a midwestern impressionist painter who lived from 1847 to 1926. In 1907, T. C. and his wife, Selma, had purchased 211 acres of these wooded hills for an idyllic getaway; Selma would later describe it as an "isolated spot of a wilderness"—a place so culturally backward and geographically remote that some of her friends considered it "God-forsaken." Atop a

ridge the Steeles built a small house, and later a studio. They eventually made it their permanent home, and, upon her death in 1945, Selma bequeathed the property to the State of Indiana. When she bought those 17½ acres, Rachel had no idea how significant a part the Steeles would come to play in her own life.

At last she had her land. That fall, Rachel and her mother planted drifts of daffodils in the partially cleared bottom land and tramped around her hilly woods, getting to know the place. She wanted to build a house, but since her income from shoeing horses was modest and unpredictable, she figured she could only afford it if she did much of the construction herself. Charlie Gaston, a farmer who was one of her clients, also worked as a carpenter. He showed her a simple twenty-four-by-forty-foot one-room frame house he had recently built for a client. It was an inspired design—960 square feet, with hardwood flooring and a bank of windows to the south that made the most of winter sun. Additional heat was supplied by a wood stove. Three skylights on the north-facing slope of the roof flooded the house with light, and an overhang at the south side shaded the house's interior during summer. Charlie figured he could build the same basic structure on Rachel's land for $25,000 if she worked as his helper. She borrowed the money, and they spent several weeks determining the optimum site.

"The daffodils bloomed and we broke ground on Easter Sunday," Rachel remembers. "A shallow creek burbled across the newly established driveway. It later grew into a raging torrent at times, due to upstream building and clearing, but that first summer a natural pool formed by nearby tree roots served as a refreshing place to cool off during breaks from the constant hammering." Rachel and her mother stained the exterior themselves.

That summer she met her future husband, Michael. They moved into the finished house in late September and were married the following February.

Charlie and Michael set the posts for a two-stall barn, which Rachel finished covering with board-and-batten poplar siding in 1981. Over the following years, she fenced in pastures and an arena, added a large detached garage, and built an arched footbridge over the creek. For a while, she had a buckskin gelding called Barney, a pacer with a silky-smooth gait. She found an elderly Shetland pony, Sugar, to keep him company. Later she became seriously interested in competitive trail riding, for which Barney's gait was less than ideal; she found him a good home, gave Sugar to a friend who had an 8-year-old daughter, and bought herself another horse, Joshua, a Standard bred trotter. Her investment became "a picturesque little farmstead with horses grazing in green pastures." She was in heaven.

On a late autumn day in 1985, a large tree fell across T. C. Steele Road. Traffic was diverted through the Steele home site. Cars, trucks, vans, and all comers had to pass under the broad pergola at the entrance to the house, which had become rather shabby over the previous forty years. As Rachel reached the pergola she was flagged down by a man in a suit who asked for a ride. He introduced himself as the new curator of the historic site and mentioned that he would be looking for an assistant maintenance person. Rachel, whose work as a farrier always dwindled in winter, applied and was hired.

There was much to be done. The gardens, lovingly created by Selma and immortalized by her husband in numerous paintings, were overgrown and choked with weeds. The house and studio, though structurally sound, were badly in need of attention. The new curator was charged with restoring the property and getting it ready for public tours. Rachel would be one of the laborers.

The restoration began with careful research. Paint chips were analyzed for clues to original interior and exterior colors. Historic photographs by Brown County photographer Frank Hohenberger, along with paintings of the property by Steele himself, guided the placement of rugs and furniture. The porch was restored and fitted with new screens that made the winds sing anew as they blew across the ridge.

Immersed amid the Steeles' work and possessions, Rachel became intimately familiar with the way the couple had lived. She inventoried each book in the couple's extensive library, catalogued their pottery, and wrote descriptions of the fine paisley shawls in Selma's collection. "I daily cleaned and tidied their house," she says, "knew what books they read, who their friends were, and their spiritual leanings; learned Steele's painting and cigar-smoking habits; and read stacks of Selma's notes about her gardening and decorating plans. . . . T. C. and Selma became much-admired close acquaintances. I often joked that I knew the Steeles better than my own grandparents, who all had lived a great distance away and were, by then, deceased." In the early 1990s more staff was hired, and Selma's gardens, walkways, and lily ponds were brought back to their former loveliness.

By 1988, Rachel had become assistant curator of the site. Although her three years of in-depth work there made her by far the best-qualified candidate for the position, the formal job requirements included a bachelor's degree. On accepting the job, she had promised to make good on that requirement. Though she had already completed numerous disparate university courses, she would need many more to get the degree. For the next five years she worked full-time and took night classes, finally earning a general studies diploma in 1992.

By then Rachel was 42 and on a roll. She signed up for a master's in a museum studies program run by the University of Oklahoma. Designed for full-time museum employees, it was a correspondence course with regular on-campus seminars lasting two to three weeks. Her thesis on a female Brown County artist was later published as a book, *Children from the Hills: The Life and Work of Ada Walter Shulz.*

In the course of her research, she was struck by the absurdity of writing about artwork, let alone criticizing it, without actually knowing how to paint. She took an oils course at the Brown County Art Gallery and started painting as a hobby. One of her fellow students became a close friend, and over the years they spent vacations at Ghost Ranch in New Mexico, where Georgia O'Keeffe had built her house and done much of her painting. Increasingly, Rachel found friends among painters. They traded work, and before long the walls of her home were filled with oil paintings and pastels.

In 1995 she was hired by the Indiana Department of Natural Resources as deputy director of historic sites, a position that took her all over the state. She oversaw restoration and construction projects, personnel, and site interpretation. "Just for fun," she says, she began curating exhibits of paintings at the Indiana State Museum. Four years later she was promoted from assistant to full director of state historic sites. Now, as she puts it, she was responsible for "ninety-two buildings with backed up sewers and leaky roofs, with no budget," while managing sixty employees and going through menopause. She had also come to appreciate how unhappy she was in her marriage. The realization had grown gradually, largely through long conversations with Christine, her good friend from the oil painting class. Rachel and Michael were divorced in 2001.

After the divorce, Rachel stayed on in the house. Her commute was over seventy miles each way, and now that she lived alone, she was under constant pressure to get home at a regular time every night to feed her horses—a special challenge during icy winter weather. With Michael gone, the five acres of mowing fell to her, on top of regular housekeeping and maintenance. She was also taking care of mowing and household maintenance for her mother, who lived fourteen miles away. And though she scarcely ever found time to visit the

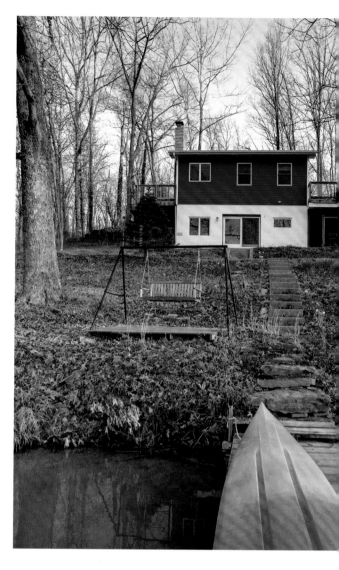

WITH TWO STORIES at the rear, Rachel's house is thoroughly focused on the water—appropriately so, considering the splendor of the lake.

house at the lake, its upkeep, too, had become her responsibility. There were not enough hours in the day. Meanwhile, the property to the south of hers was purchased for a different kind of getaway. A group of men came out on weekends to drink beer, shoot firearms, and ride all-terrain vehicles up and down the wooded hills. The shouting, gunshots, and racing engines terrified Rachel's horses, and as a woman living alone in a remote location, Rachel herself felt threatened by the rowdy behavior.

In the spring of 2003 she was hired by the State Museum as Fine Arts Curator—something of a dream, as it aligned her job with her passion for painting. She had lived alone in her house for three years. For much of that period, the frantic pace of driving back and forth to work and caring for three separate properties had been more than outweighed by the time she was able to spend savoring the home she had created. But the impossible weekend neighbors had turned that home from a refuge into a locus of anxiety. A small voice repeatedly urged her, *Simplify, simplify*. As she allowed herself to heed that voice, her fatigue and worry gave way to relief. Painting had become a more sustainable passion than horses. She would move on.

She retired Brandy, her 31-year-old sorrel mare, to a friend's farm. She visited regularly and continued trimming her old friend's hooves until Brandy's death seven years later. She found a good home for her other horse, Les, a rescue who stood just three-feet tall—a rascal of a pony whose name stood for "little equine shit." Les went to live with a couple who raised miniature horses. Rachel sold her property to some buyers from California. She was able to obtain her siblings' shares of the house at the lake and still had enough cash to have a builder turn the place into a year-round home. Perched on a slope, its front door opening onto a cascade of stairs that run down the center of the house, out a big glass door, and down a few more steps to the water— right there, immediately and fantastically present—her home is focused fully on the long, quiet lake.

At a small desk in her bedroom, Rachel wrote her major work about Steele, *T. C. Steele and the Society of Western Artists*, published in 2009 by Indiana University Press. She is currently writing a biography of the painter for young adults. Over the years she has come to consider him something of a kindred spirit. Born near the small river town of Gosport in Owen County, he chose not to make a life in farming, banking, or any other branch of the local economy, but threw convention to the wind and pursued his artistic ambitions. He studied abroad, then returned to Indiana to paint what he knew best, rather than relocating to the eastern seaboard, where he would likely have had greater success as an artist of national acclaim. Steele and other members of

the Hoosier Group saw, and celebrated, the beauty of the Midwest's modest landscape. Their works helped others to appreciate that beauty in their own backyards. After suffering the death of his first wife, he remarried, and at 60 he found a tranquil setting perfectly conducive to his art and flouted convention again by settling in that backwoods place.

But Rachel feels a stronger kinship still with Selma, who saw the potential in that breezy hilltop wilderness and turned her rustic homestead into a work of art—a clearing in the woods made thoroughly charming with paths and gardens, a cozy house, comfortable old furnishings, and turn-of-the-century colors. Rachel adopted the Steeles and their home as her own, and they helped her discover a constructive, fulfilling direction.

OVERLEAF
Mist rises on an early spring morning.

2 TRADING UP

MARTHA SCOTT'S 1930 TUDOR REVIVAL HOUSE stands on a busy corner near the university where she teaches. The austere limestone facade rises out of a handkerchief-size lawn bordered by a short lavender hedge. The scene is a study in simplicity, flouting the grandiose columns and elaborately carved entrances of neighboring mansions built as Wall Street shimmied to its crash in the late 1920s.

Inside, rooms are large and dimly lit. White plaster walls and unpainted wood trim evoke a serenity that might feel churchlike, were the space not furnished with objects so expressive of its inhabitants' cosmopolitanism. A living room ottoman bristles with the mane of a wildebeest hunted and eaten by Martha's South African father. Other skins serve as rugs on bare wooden floors around the house. At the ceilings sparkle crowns of illuminated crystal pendants, a bit of elegant, tongue-in-cheek excess amid the prevailing restraint.

The dining room walls are hung with sketches of thin women, nude but for their outlandish headdress, which finds echoes in giant dried alliums from the garden. Scrubbed pine bookcases salvaged from a public school rub soft, pale shoulders with pointy Gothic candelabra. Window sills host rows of petite African violets in matching vintage ceramic pots, while a table of strapping orchids and amaryllis bloom lavishly against a backdrop of winter gray.

The many contrasts are artfully assembled. And no wonder. Martha, a journalist and media scholar, has devoted her career to studying the power of imagery.

A RETRO-STYLE telephone with contemporary push buttons sits in the original telephone niche.

31

MARTHA HAS furnished her home with a mix of antiques and architectural salvage. The pine bookcases, salvaged from a school, were restored by her father. The dining room light fixture is vintage. Martha sewed the curtains herself.

Growing up in South Africa during the 1960s, Martha was immersed in the censorship and media distortions of apartheid. Most American children were glued to the tube from birth, but television was effectively nonexistent in South Africa until the mid-1970s; for years the medium was banned in an effort to deny access to international broadcasts, with their generous evidence that members of different races could co-exist. What news was available focused almost exclusively on the word, whether written or spoken, rather than on visual content.

Martha was first exposed to television as an adolescent. She was struck by the medium's power to convey complex meaning, even without accompanying verbal text. Over time she became increasingly aware of a disconnect between word and image in television broadcasting; though the censors were expert at interpreting words and controlling their use, they were only just beginning to grasp the communicative potential of images. Might visual

imagery provide a means to convey important truths while evading the censors' notice? It was a thrilling notion, and she decided to pursue a career in documentary journalism.

After college she worked for the South African Broadcasting Company in Johannesburg. Determined to study abroad so that she would have access to journals unavailable in her native land, she applied for graduate positions in the United States and found herself, through an exchange program, at Baylor University in Texas. She was stunned by the robust influence of the First Amendment on American media and recalls one interview with special clarity, in which Ted Koppel trenchantly questioned a senior government official on national television. This was freedom of the press, however imperfect. She would be free to pursue her professional ambitions here.

She moved to her present location in 1996 after earning her doctorate at Temple University. Within a year she had adopted a Scottie, whom she named Elizabeth, and bought a classic Craftsman bungalow on a quiet street in a neighborhood of small old houses, most of them student rentals. Martha's house had wooden floors, original double-hung windows, period woodwork, and charming built-ins. There was a little yard, in which she immediately began creating a cottage garden. It was exactly where she wanted to be. She had her possessions brought over from South Africa.

While living in her bungalow, Martha became involved with a man who eventually moved in with her. It was a somewhat strained arrangement; Martha adored her house precisely because of its cozy, unpretentious character, but that same modesty struck her partner as reason to upgrade. He pressed her to consider a move, and she eventually agreed to look for a place where he would feel more comfortable.

At their realtor's suggestion, they visited a spacious, three-bedroom house in a respectable neighborhood of professionals and academics. Over the years, the house had suffered an odd combination of updates and neglect. The front garden was lumpy and completely overgrown with ground cover and rose of Sharon. The interior had been extensively modernized during the 1980s, with little sensitivity to its historic architectural character. Polished marble tiles had been laid on the kitchen floor—so wrong for the house!—and the cabinets were painted a cold mint green. Many of the house's original features—lighting, plumbing, and tile—had been replaced by generic fixtures. Thick shag carpet covered the upstairs floors. Several of the original steel casement windows, along with their crank-out hardware and stylish latches, had been replaced with modern versions, and an atrium window had been installed upstairs near the front of the house, where it stuck out like a sore thumb. Much of the woodwork had been painted. An en suite bath had

been appended to the master bedroom by enclosing the indoor balcony that had once overlooked the staircase.

The realtor made deprecating comments about the house's condition, which evidently constituted a greater liability in this neighborhood than it might have presented in another location. As she wandered around the house, Martha looked beyond the adulterated surfaces, trying to make out the essential structure. There were some lovely elements—original textured plaster on the walls, spacious rooms, wooden floors. The living room had an elaborately carved limestone fireplace surround, in addition to four recessed bookcases with arched tops. A telephone niche still straddled the wall between the living room and kitchen. The staircase had wrought-iron balusters set into ascending arched cutouts in the textured plaster walls. Sunlight streamed through tall windows.

Had the place been modernized just one step further, had any more of its essential architecture been destroyed, Martha thought there would have been no compelling reason to save it, other than for its sheer utility as shelter. But just enough original character remained to draw her in. And once she allowed the house to speak, she felt a tug of obligation as hard to ignore as that of a homeless dog. The place was structurally sound. Although she had resisted the idea of leaving her bungalow, she could dimly see herself rising to the challenge posed by this grander place—undoing the inappropriate alterations, paring it back down to a fitting simplicity, and restoring the warmth that would make it a home.

They bought the place in 2002, agreeing to share the substantial mortgage payments. Shortly after the closing they went to the house and removed the upstairs carpeting, only to discover that the floorboards underneath were too badly stained by dog urine to be saved. They pulled up the soiled wood and hired a carpenter to install new oak flooring. Next, Martha moved on to the half-bath downstairs, which had been updated during the 1980s with a shiny built-in medicine cabinet and vanity she considered an affront to the house. She removed them both, replacing the cabinet with one from a salvage yard and forgoing a vanity in favor of a diminutive old wall-hung basin. She painted the tiny room in dramatic white, gray, and red and installed vintage light fixtures. When it was done, she stood back and admired her accomplishment. She had bonded with the house.

Scarcely three months after moving in, Martha learned that her partner was having an affair. Their relationship was clearly finished. Overnight, the house came to symbolize disappointment and betrayal. He had been the one who pushed for the move, who wanted this house with its prominent address, but now it would be up to her to make the mortgage payments on a single salary.

FACING. Martha removed the polished marble floor tile and had the original pine floor refinished. She furnished the kitchen with a mix of custom cabinets and antique pine furniture, some of it restored by her father, and some of it by herself. Her father made the circular stand for potatoes and onions, seen here beside the cupboard near the back door.

She would be the one investing thousands of dollars and years of her life on this project begun as his fantasy. Adding insult to injury, the busy corner location showcased her partner's departure—in several U-Haul trips—to those who knew them.

To her relief, it took little time to disassociate negative feelings about the relationship from the house. She had only lived there with him for three months, and for much of that time they had camped in the dining room while the upstairs floors were being done. Martha's early steps toward turning the place into a home had already shown potential for causing a rift; her partner had complained about the noise and disruption entailed by the half-bath project. And that was a minor bit of remodeling! The place was much larger than she needed, but she already felt a sense of responsibility toward it. She would not abandon it.

She had to refinance the mortgage in her name. She sobbed in one broker's office when he said he could not give her a fixed-rate loan—a reality he attempted to mollify by offering her an adjustable rate. The monthly payments were overwhelming, but no match for her determination. She collected her thoughts, moved into survival mode, and rented out a room to help cover expenses.

Lacking money for hired labor, she did what she could by herself in her spare time. With infinite care, she stripped the paint from yards of woodwork. Atop a ladder, using alcohol and steel wool, she cleaned decades' worth of grime from the crown molding in the living room and dining room, then got down on her hands and knees to give the baseboards similar treatment. She restored the window and door trim throughout the house and stripped layers of paint from the remaining original metal casement windows. She found antique curtain rods that complemented the Gothic metalwork around the house. For the windows at the entry, she sewed a pair of sumptuous drapes in gray velvet, onto which she appliquéd black harlequin stripes.

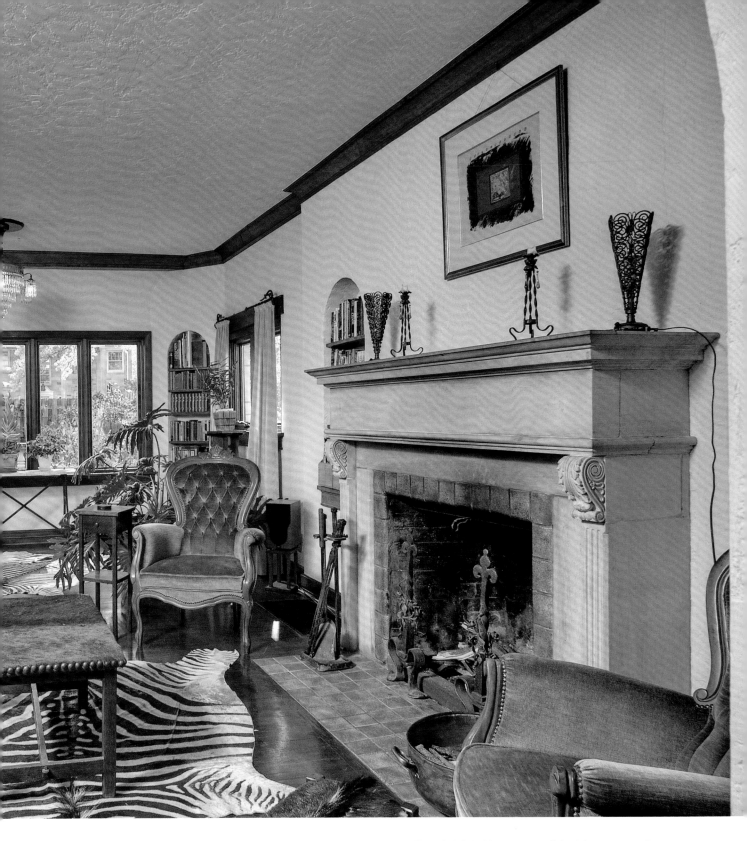

THE LIVING ROOM has many original features, such as crown molding, a pair of arched bookcases recessed into textured plaster walls, a hand carved stone mantel, and oak floorboards. Skins from Martha's father's hunting expeditions serve as area rugs and upholstery material.

The following spring she moved outdoors. She cleared the chaos of over-growth, trucking the debris to a composting facility on the outskirts of town. Determined to give the house the perfectly flat front lawn she had pictured as the ideal complement to its architectural starkness, she began to dig, remov-ing the excess soil a spadeful at a time with a handheld shovel and smoothing the surface with a rake. The massive earthworks took place in a very proper part of town, in full view of every passing pedestrian, cyclist, and driver. She heard that several neighbors disapproved of the project—which, she acknowl-edged, had turned her front yard into something resembling a war zone—but she continued, unabashed. There was no alternative.

The Sisyphean task took two seasons. To make it psychologically manage-able, she counted the loads of soil as she shoveled them into the wheelbar-row and removed them to other parts of her property. There were thirty-eight barrowsful altogether. Once she had meticulously raked the flattened ground, she sowed her grass seed.

Martha abandoned herself completely to the garden. From the earliest warm spring day through the last autumn frost, she spent every available mo-ment working the soil. Often she would realize she had gone all day without food; she would run into the house, covered with mud, to eat something over the kitchen sink before returning to her rake or shovel. Dripping with sweat, her cheeks flushed bright red, hair pushed back from her forehead with a muddy palm, she remembered what it was to be happy.

The flat sward sprouted and turned green. She dug out a perfectly rectan-gular border, amended the soil with yards of gravel for drainage, and planted her lavender hedge. In a side garden she added perennials for color—peonies, columbines, and giant allium. By the front door she planted apricot roses in a bed of chartreuse Creeping Jenny and masses of lilac foxgloves interspersed with purple sage. At the end of a long, hot day she would sit outdoors and look through the windows to the lighted rooms inside. The house was so much more than real estate. When she gave to the house, it responded—primarily in terms of stability. And as a single, newly tenured faculty mem-ber resolved to succeed on her own terms, she found her home's stability profoundly supportive. She had borne the loss of her relationship, but she could not imagine losing her home, as well.

"It wasn't a house anymore," she says. "It was a companion. It was the house and Elizabeth, and my truck. Those were the dependables. I would leave for the day and then come back, and there would be Elizabeth, in a very strong, stable old house. Walking in was an embrace. It was sanity, stability, comfort, embrace."

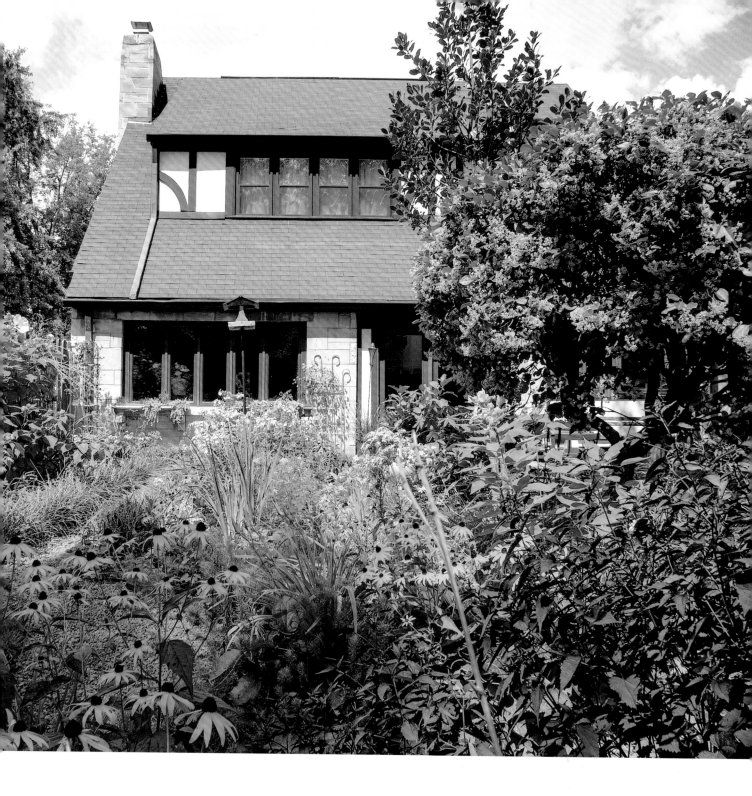

Friends speculate that Martha will move on once her projects are complete, but she is no renovation junkie. The process itself has many satisfactions, but her greatest reward comes from the sense that she is giving to the house. It's an ongoing reciprocal relationship. The house supported her through trying times. She feels honored to return that care, and honored to enjoy the results.

IN A CORNER of the back garden, a stone birdbath stands amid a happy riot of black-eyed Susan and perennial hibiscus. Earlier in the summer this corner is fragrant with lilies and phlox.

3 A HOUSE OF STONE

February, 1948
Thursday

Dear Mrs. Brown,

Mrs. Ward and I are going to Logansport today and I will
see if I can git a copy of M. Living, if I can not I will send to
Chicago to the Fair and can git it there.

I had a letter yesterday from Mrs. Bruner and she said she
had subscribed for the magazine and had got her first copy
with the article and picture in it of the old stone house. She
said they were good and it made her home sick to git back
again to the old stone house. . . .

Ira G. Ward
Camden, Indiana

KITTY'S COLLECTION
of spoons started with
souvenirs from her
parents' travels.

IN THE WINTER OF 1818, Daniel Stout, a veteran of the War of 1812 and
a miller by trade, journeyed by horse from Harrison County to the Land Of-
fice at Vincennes, capital of the Indiana Territory. It was a bitterly cold trip of
some 120 miles each way. On January 23 he purchased 160 acres of land, in
proof of which he received a certificate "whereby it appears full payment has

BELOW
The hand-dug cellar has a
foundation built of stones that
were cut and laid by hand. The
undersides of the floor joists
still show the rounded shape of
the logs, though they now have
modern kraft paper-backed
insulation between them.

FACING
Constructed in 1828, the Daniel
Stout House is recognized as
the oldest residence in Monroe
County, Indiana.

been made for 'Northwest Quarter Section Nineteen of Township Nine North, Range One West in the County of Monroe.' Here granted to Daniel Stout, his heirs and assigns forever."

Like countless other intrepid souls, Stout was buying opportunity. At just $1.25 an acre, the land, densely forested and watered by streams, was too good a deal to pass up. Bargain land was a powerful incentive offered by a government eager to populate the frontier with settlers who would buttress the nation's westward expansion and soon qualify the Territory for statehood.

Stout cleared a home site overlooking the creek that would later bear his name. He built a log cabin for his family—wife Sarah and their three children—fetching them from Corydon soon after. Down by the creek he built a grist mill, where he ground grain for area farmers between a pair of massive limestone millstones.

After several years, Stout was ready to replace his family's cabin with something better. Since the entire landscape sat on limestone bedrock, the choice of building material was clear. With his older sons, Stout pulled layers of stone from the creek banks and hauled them up the hill. They dug a cellar, dressed the stones, and laid them in place one by one, without mortar, doing all the work by hand.

It took two years to build the house. When the structure was completed in 1828, it measured twenty by thirty-two feet at the exterior, with walls two feet thick. The main floor had two rooms—a kitchen and a room likely used

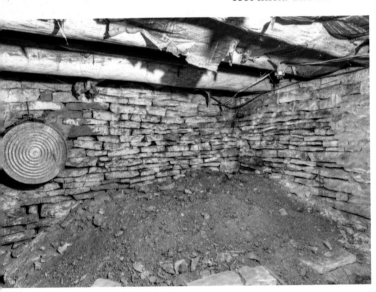

as a bedchamber, separated by a partition wall with a center door. Each room had its own fireplace. Above were two sleeping chambers. Curiously, there was no interior stairway; the second-story bedrooms were accessible only by a set of outside steps.

For Carol and Hubert Alaska ("Brownie") Brown, as for most people, the early 1940s were years of intense uncertainty and upheaval. The '30s had been a struggle in their own right, but America's entry into war brought new stresses, worries, and hardships. Fathers left home in search of work or were sent off to aid the military effort. Brothers, sons, boyfriends, and uncles were deployed in the services, usually overseas. "No one was where they were supposed to be," says the Browns' daughter, Kitty, who is now in her mid-eighties. The future, once bursting with possibilities, had been reduced to getting by one day at a time.

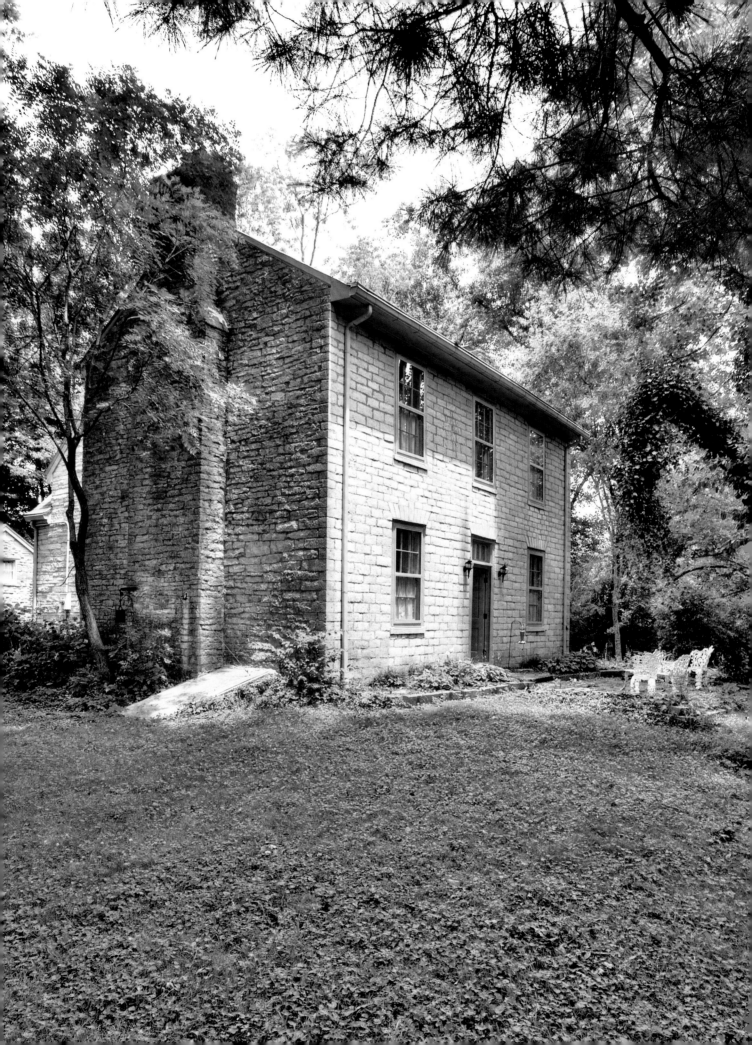

Kitty was a young woman then, attending Indiana University and praying that her fiancé, Wayne, would come home alive. Her brother, Chilton, was also in the armed forces. Her father had made his career in the limestone industry near Bloomington, but when world events brought residential construction to a standstill, Brownie was compelled to take a position at an armaments foundry far away in Detroit. Because he and Carol wanted to keep their roots in Monroe County, they resolved to bear their enforced separation with courage "for the duration."

Carol was in her early forties. Over the years of her marriage, she had turned her family's modest turn-of-the-century farmhouse into a cherished home, with every detail fixed just so. The house was her family's anchor, a point of certainty from which husband and children could depart each morning in pursuit of business or adventures, confident that Carol would be ready to welcome their return. But then America had joined the global conflict. Facing an uncertain future, Brownie and Carol made the wrenching decision to leave their home. They passed the house on to Carol's sister and her family, who were moving to Bloomington and desperately needed a place to live.

Mother and daughter took a suite at the Graham Hotel downtown. For Kitty, living in a nice hotel had its redeeming qualities. It was glamorous and offered a respite from housekeeping chores. She and her mother ate in the dining room every night. There were even slot machines to toy with on occasion, though she swears she never put in more than a few quarters. Carol, on the other hand, was completely adrift. She missed her husband and worried about her son. She was distraught over having had to leave her home and longed for everyday order. Yet even as she pined for stability, she recognized her good fortune compared to that of so many others.

Brownie was acutely aware of his wife's distress. So was Carol's physician, Margaret Owen. In addition to being her doctor, Margaret was a family friend who understood the centrality of home to Carol's well-being.

Margaret knew of a house in the country whose owners might be persuaded to sell. It was an intriguing house, old enough to have considerable history, if one took the time to do some digging. The place was occupied—it was shelter, after all—but in dire condition. Restoring it to a family home would require colossal effort. But a large project was just what this doctor ordered. She took Carol, Brownie, and Kitty out to see it on a snowy winter evening.

The old stone house stood close to the graveled country road. Two stories high, with a keystone engraved "1828" over the door, the place was austere and imposing—a thrilling contrast to Carol's simple, if beloved, farmhouse. Unaware that the house lacked indoor plumbing, and that the rural neighborhood had not yet been supplied with electricity, Carol could not still her

pounding heart. Even after she discovered these and other practical realities—the mortar between the walls' stones had deteriorated so badly that sunlight shone through in many places, and there were blacksnakes nesting between the first and second floors—she was undeterred. This house was what she had been looking for.

After months of consternation, Carol's excitement came as a welcome relief for Brownie, and at her insistence he agreed to take Kitty for a second viewing. Carol was not invited, lest her excitement undermine her husband's negotiations. Peering through the door, Kitty and her father exchanged anxious glances, wondering what to say to the resident to explain the reason for their visit.

"It was not a desirable dwelling," Kitty remembers. The woman living in the house was pregnant, with two other children under school age tugging at her apron. Her husband was in the navy. Selling the house would translate to income, which meant hope. "Well, I've never seen a house like this," said Brownie. The woman leaned her head against the door jamb and replied, "I reckon no one else has, either."

But Carol was in love, and her husband wanted her to be happy. They closed on the purchase in September 1943. Now that the property was theirs, Carol was like a horse at the starting post. She couldn't wait to break out of the gate.

The sellers were delighted and built a cozy ranch house on the outskirts of a nearby town.

"How will I ever get this place the way I want it?" Carol lamented, seized suddenly by awareness of what she had undertaken.

"She'd walk around this place and weep," recalls Kitty, who spent most days with her mother during that deeply disrupted time. Brownie and the family's other men were still away. Carol engaged some workers from the Pike Lumber Company to make the home habitable, the project financed willingly by her husband. She had decided the house should have electricity and indoor plumbing, a proper kitchen and bathroom, and an indoor staircase, all of which could be tidily accommodated within a small addition she would design. She based her plans on documentary and architectural evidence, taking pains to ensure that the addition would harmonize with the house's original period character. She took no shred of potentially useful evidence for granted; when she and Kitty visited Chilton at the Aberdeen Proving Grounds in Pennsylvania, they scrutinized dwellings in nearby Bucks County for guidance in early-nineteenth-century mortar techniques and instructed their masons to tuck-point the house's stone walls accordingly.

In the process of restoring the house, Carol added many of her own touches. Among the most visible are the stones that form the main fireplace hearth. She carried the stones up from the creek with her own hands and sealed them with wax before having one of the builders set them in place.

Neighbors whose families had lived in the community for generations shared stories about the house's past and put her in touch with members of the Stout family still living in the area. Slowly, she pieced together a history of the house, thrilled by every detail she discovered. As more distant members of the Stout family became aware of her interest, they visited, sometimes bearing gifts. One presented her with the original land grant signed by President Monroe in 1818. Another brought an oil portrait of Daniel Stout's eldest son, which Carol hung over the mantel. Still another provided a portrait of Daniel Stout's granddaughter, Kiturah.

"She saw what it could be," says Kitty of her mother's approach to the restoration, "and once she got that bit in her teeth, get out of the way, buddy! Father let her have her head, which was smart." She adds, with touching hyperbole, "Mother was so up to her ears in the house that she hardly even noticed he was gone." In the spring of 1948, the house would be featured in *Mademoiselle Living* magazine.

Kitty and her mother moved into the house in 1944. The men were still gone, but Carol felt confident of her landmark's power to recall them home. Though the structure had been wired during the restoration, it would not be connected to the grid for another six months. The two women turned their sojourn into an adventure, relying on kerosene lamps for light and comforting themselves with the knowledge that such conditions would have been normal for the Stouts.

When Wayne returned home on leave in 1945, he and Kitty were married in the house. It was a simple wedding. Because of the war, most of the guests were women, few of them under the age of 70. Carol's first grandchild, too, would later be married there.

Shortly after Carol began researching her home's history, she came across an article in the local paper. The piece had been written by Ira Ward, a great-grandson of Daniel Stout. Carol wrote a letter of introduction and sent it to the offices of the Bloomington *Evening World* with a note requesting that they pass it on to Mr. Ward.

So began a correspondence that would last seven years. Though Ira was in his early seventies, he had vivid memories of the house, where he had often visited cousins during his youth. He and Carol wrote to each other several times a week, their subject matter varying from personal anecdotes and news about their respective family members' health to world events. Their letters

FACING. Today, the house's original hearth has a mantel and brass surround. The stones in front of the fireplace were carried up from the river by Kitty's mother, Carol Brown, who sealed them with wax before having her builders set them in place.

Over the mantel are portraits of Daniel Stout's son and of Kiturah, the elder Stout's granddaughter. Kiturah was banished from the house at a young age for becoming pregnant before marriage. Kitty considers it fitting that Kiturah has, in a sense, come home.

always included some bit of news or reminiscence about the house. Ira's letters clearly proved a source of companionship and reassurance to Carol. Ira, for his part, was undoubtedly flattered by the attentions of a woman some twenty years his junior. At one point, Ira and his wife visited Carol and presented her with a small gingko tree, which has now grown to more than twenty feet high.

As far as Kitty can ascertain, Carol kept every letter. She folded each one and replaced it in its original, elegantly hand-addressed envelope.

Things changed dramatically after the war in Europe ended in 1945. The extraordinary amounts of energy and material consumed by the war effort suddenly, wondrously, became available for peacetime activities. "The men wanted life to be normal NOW," says Kitty. Soon, Carol's son, Chilton, returned to civilian life; he settled in Chicago, where he worked at Marshall Field and Company.

Simple ranch houses that were easy to build and affordable to buy became all the rage, and the stone industry boomed. Brownie and Wayne went into business together, forming the Hoosier Stone Company, which manufactured popular stone veneers. They could hardly keep up with demand.

After Brownie passed away in 1967, Carol continued living in the house until her own death eighteen years later.

In 1973, the house became the first property in Monroe County to be added to the National Register of Historic Places.

After Carol passed away in November 1985, Kitty and Wayne moved into the house. Living there seemed quite familiar, as they had stayed with Carol from 1945 to 1947 while establishing themselves

THE DINING AREA occupies a little less than half of the house's original ground floor, with the living room on the other side.

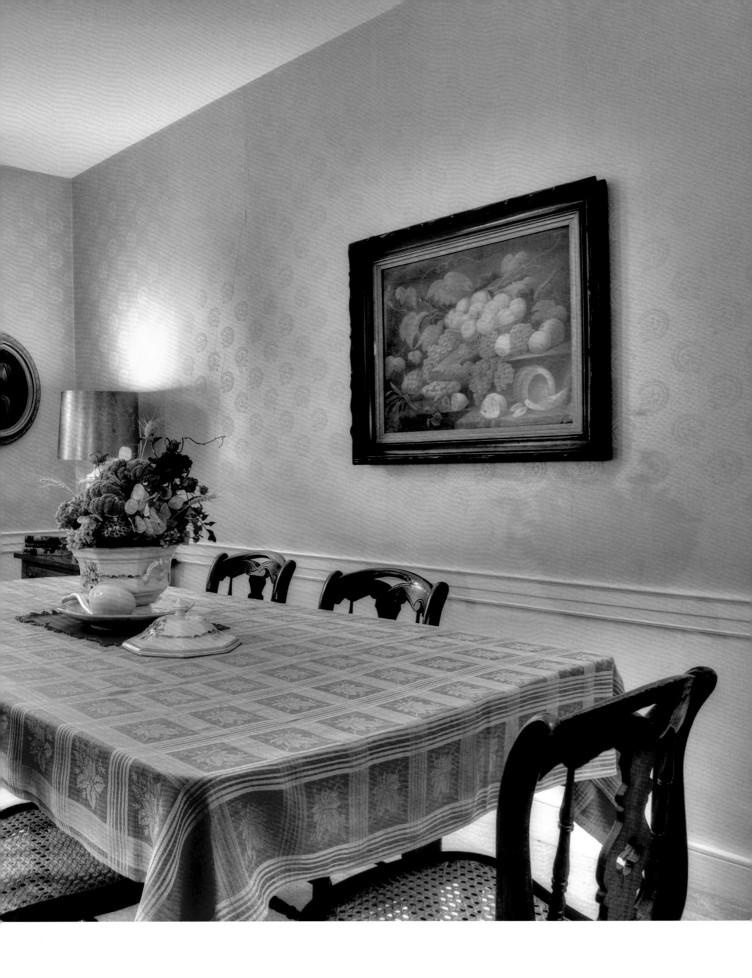

FACING. The house has its
original window trim. The
solid limestone window sills
are two-feet deep, the thick-
ness of the walls around them.

financially after the war. But this time, Wayne was dying. Fortunately, he was able to spend most of his last year at home living a relatively normal life. He died in December 1987.

To keep herself sane after such great loss, Kitty, a full-time administrator at Indiana University, filled her time away from work with the house and its records. She had known all along about the correspondence between Ira and her mother, having lived in the house during much of that time. Ira and his wife had visited frequently. His letters, which numbered in the hundreds, were scattered around among the rooms. Kitty found them pressed between the pages of books and stashed in unexpected corners. She collected them together and organized them by date, summarizing each on a small card for future reference and adding pertinent information gleaned from further research. She carefully unfolded the letters and tucked them, with their envelopes, into archival plastic folders that she collated in three binders, each seriously overstuffed. This simple act of stewardship constituted the fulfillment of a covenant between herself and her mother.

Today, Kitty lives alone in the house. Her son died in 2001, and her daughter works in Texas, where, Kitty muses, she is married to the Bank of America, her employer, and has established many friendships.

An iron dinner bell is the latest piece of the house to have found its way home. It stands at the south side—originally the front, before the county rerouted the road—where it is shaded by maples Carol planted as saplings in 1943. The bell was a gift from a distant Stout family member who showed up at Kitty's door one day in June 2009. "I've got something that belongs to the house," he announced, returning to his truck to retrieve the bell. The stranger, then in his fifties, explained that ever since he was a child, his mother had instructed him to ensure the bell was returned to the old stone house when she died. He had carried out her wish.

In the living room, a door to the south—another of Carol's innovations— is almost always open. The view forges a bridge between the interior of the house today and the lives lived on this land for two hundred years. "You can see Daniel Stout through that door," Kitty says, "and hear Sarah ringing the bell, telling the family to come back up for dinner."

Daniel and Sarah Stout, along with other family members, are buried in a small cemetery that was part of the original 160 acres. The burial ground now lies between a discount furniture store and a power generating substation. Kitty's father always intended for the Old Stone House, as it came to be known, to serve as his family's headquarters, as it had for the Stouts. Kitty considers herself "the keeper of the flame" until her tenure ends and another family member takes her place.

4 COMING HOME

SOME HOUSES ARE BUILT TO IMPRESS. The tenth-scale manor proclaiming its owners' wealth, the ode to modernism expressing its architect's intellectual rigor and aesthetic restraint—these face outward, clearly on show. But other houses have an inward focus, guarding their inhabitants' privacy behind studiously unassuming facades. Here, the simplest features—a walled garden, a pebbled path, an unexpected dormer—sing like Sirens to the rare passing stranger whose ear is attuned to their pitch.

Ask Margaret Carey.

In 1986 Margaret and her then-husband, Timothy Richards, moved to Bloomington, Indiana, with their daughter, Molly. Timothy had been hired to teach in the English department at Indiana University. Margaret had completed the coursework for her doctorate from Emory and was writing her dissertation in twentieth-century British and American literature.

They rented a limestone house near campus. It was a sparsely furnished home; neither Margaret nor Tim had ever been particularly interested in houses as anything more than a base. They didn't even have a couch. Their days were devoted to the work of academics—reading, writing, and traveling for research. When they had time to spare, they spent it outside, camping and kayaking as often as work and finances allowed. Friends who had helped with moves over the years joked that Margaret and Tim were easy, since they owned little more than a pair of typewriters and shelves of books.

A TRIO OF windows overlooks the street in Margaret's second-story bedroom.

53

Living near downtown, they typically got around on foot, and one day they passed a house that stopped them in their tracks. It was plain and solid, with smooth limestone walls and a path leading up to the door. The setting was modest—minimally landscaped, with three old maples growing out of a flat front lawn. The house itself took up most of the lot's width, and a driveway led back to a garage. The structure was rambling and asymmetrical. The front door stood in its own house-shaped entry, an architectural protrusion so shallow as to appear almost like something out of a story. A trio of sash windows was centered in the gabled wall above, and French doors led to a small stone patio to the right of the entry. The divided-lite windows and paneled wood doors were clearly original, and they were charming. Margaret recalls thinking, *I want that house.*

Tim, too, was struck by the place. They continued their walk, and shortly after, Margaret dropped a letter through the mail slot in the front door saying she and her husband loved the house and would be interested in buying it, should the owner ever wish to sell. The owner, a widow, replied that she had no intention of selling her home.

Margaret and Tim eventually bought a house in a wooded location on the outskirts of town. Molly went to school, and Tim was immersed in teaching, research, and departmental obligations. Margaret felt isolated during the long months of writing her dissertation. In her twenties, she had worked as a counselor for female felons in her hometown of Detroit, and she had never lost her interest in social activism. So when an acquaintance invited her to become a rape victim advocate, she agreed, aware that it would be a way to aid a worthy cause. She also became involved in a program for at-risk youth through her daughter's school.

By the time she completed her doctorate, Margaret had decided she did not want an academic career. She embarked on a master's in clinical social work, and, after graduating in 1995, did further training at the Gestalt Institute of Cleveland and the Gestalt International Study Center on Cape Cod. She then started her own psychotherapy practice.

Every so often she passed the striking limestone house and wondered what was going on there. Friends and colleagues knew that she and Tim had been interested in the place, and one day a coworker, who happened to live behind the house, mentioned that he had not seen the owner in some time. Margaret made some inquiries and discovered the owner had died. After a respectful delay, she contacted the owner's daughter, who said she was still too attached to her mother's home to imagine parting with it. But a few months later she contacted Margaret and arranged to show her the property.

"It was cavernous," Margaret recalls. "You'd walk into one room and it would open onto another. There was a wonderful feel of continuousness." There was also a captivating element of surprise; where any other house might have had an exterior wall, this house had a sunroom, a patio, or a porch, producing a rare sense of communion between inside and out. As she went from room to room, Margaret felt what she describes as "a selfish giddiness—something like, 'This house can't be true!'" Did the owners know what they had?

Even the lot behind the house was magical. Just beyond the garage, stone steps led into a sunken garden surrounded by a tangle of vines, in the midst of which stood a limestone sundial. Near the rear property line a majestic tree of heaven and a cluster of ancient conifers watched over the house and its garden like a convocation of druid priests.

THE SPACIOUS DIMENSIONS and bold architectural elements that first appealed to Margaret are clear in her living room, with the staircase just visible through the door on the right.

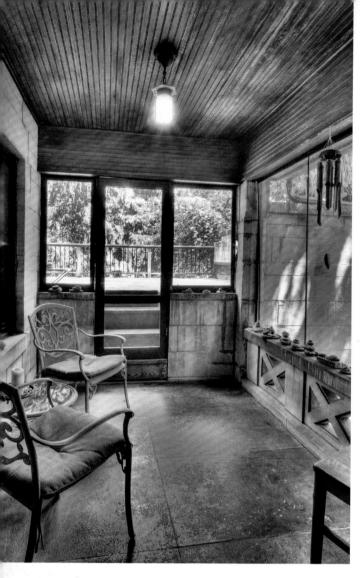

ABOVE. One of Margaret's favorite places in her house is this quiet side porch with a beadboard ceiling, shaded by trees. Steps lead up to a porch area on the flat roof of her garage.

FACING. The kitchen counter, sink, cabinets, floor, wallpaper, and appliances all date to a fabulous mid-century makeover.

After that first visit, she felt compelled to return. The house was still not on the market. One day, while looking around the back, she discovered an unlocked door. Could she go in?

The question was rather, could she not? She felt drawn. She quietly stepped inside and pulled the door shut behind her. Keenly mindful that she was in someone else's home—the interior seemed as intact

as if its mistress had just popped out to buy a quart of milk—she found her way through the dimness to the built-in window seat on the south wall of the dining room. She sensed a need to sit there, quietly, attending to the experience of being in that place, observing how it felt.

It felt like home. "I felt so peaceful," she says— "I arrived. I'm here."

The next time she drove down that street she parked her car. Without thinking, as though moved by some external force, she went to the back of the house and let herself in. "I've always had dreams about being in a house," she says, acknowledging that the house in her dreams had just one story, whereas this house has two. "The experience is, when I think I've come to the end of the house, there's always another room. To have that experience in my waking life was satisfying."

Beyond evoking this profound sense of familiarity, the house appealed to Margaret because it was filled with evidence of having been lovingly lived in. There was pink everywhere—even on the brick fireplace surround. An upstairs bedroom, clearly the daughter's, had been lavishly equipped with built-in dressers, closets, and a window seat for a cherished child. The original '20s kitchen had been the site of a thorough mid-century update; a vision in cream, gray, and pink, it looked like an illustration in *The Joy of Cooking* snipped from the book and brought to life. The walls were papered with a delicate pattern of stylized roosters, plants, and flowers. Counters were pale pink Formica, with stainless steel for the cooking area. Still-gleaming appliances—a compact oven, with coordinating electric hot plates designed to fold back into the wall, replacing a traditional stove—exuded space-age glamour and effortless convenience. There was even a pink wall-mounted can opener. But the *pièces de résistance* were a curvy peninsula and matching bulkhead, which swooped out from the wall with a Hollywood flourish.

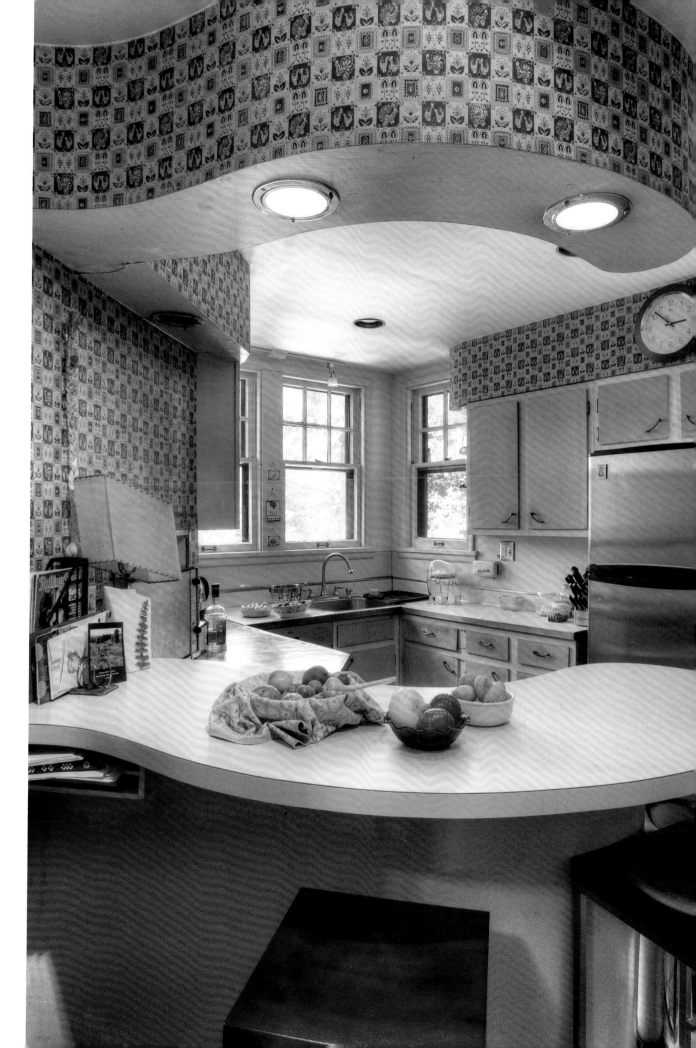

Margaret was thoroughly respectful toward the house and its absent family, grateful for the opportunity to acquaint herself with the place. She returned on several occasions, timing her visits during rainstorms so that she would not be tempted to leave her car and venture inside.

A few weeks after her first visit, Margaret learned that the late owner's daughter had spoken with other interested parties. Concerned that they might love the house as much as she did, she hired an attorney to write up an offer to purchase, based on the appraised value published with other details of the recently settled estate. The daughter accepted the offer, and they closed in August 2003.

As things turned out, this would be Margaret's house alone. Shortly before the closing, she and Tim decided to separate. They agreed to go through with the house purchase and sort through details of ownership later. In the end, Tim would keep the rural house, and she would get the one in town.

After the closing, she went to the house and discovered that the sellers had taken the refrigerator. When she called to ask about this, they said they hadn't considered it a built-in appliance. The opening in the cabinets turned out to be smaller than conventional for a modern kitchen, so a new refrigerator of standard size wouldn't fit. For several weeks she kept perishables in a cooler set in the snow on the back porch, until she found a used fridge the right size.

Before moving in, Margaret had a new electrical panel and wiring installed and did extensive work to dehumidify the house. She had the roof repaired where a fallen tree had made a hole large enough to allow a family of raccoons to nest in the attic. There were no gutters, so she had them installed, determining the locations based on historic photographs of the house and using the old fashioned half-round variety with matching downspouts. She had the soil graded to slope away from the foundation, and she worked side by side with a handyman to shovel six inches of soggy debris out of the basement before installing a dehumidifier.

She moved in that December. Almost immediately, the water main broke, a calamity that required installation of a whole new sewer line. The muddy, messy job was drawn out for several weeks due to winter weather, and since the house lacked water and sewer service, she stayed with Tim.

When Margaret returned to her house for good in March, she moved in with little furniture. She slept on a futon on the dining room floor while getting her bedroom ready. She hired a couple of tradeswomen to strip the layers of wallpaper, repair plaster damage, and paint, and she worked alongside them as time allowed. Asked how she felt on moving into the big, old house, she says, "I had only one fear of being in the house alone. I wasn't alone! I had bats visiting. In the upstairs middle bedroom, in the kitchen, in the basement.

It unnerved me to have a bat fly over my head in the middle of the night or to wake up and find one dangling from the crown molding in the kitchen." She felt as though she was reacquainting herself "with an old friend, learning her quirks and limitations."

The bedroom wasn't the only space in need of attention. Every room needed to be repainted, and before the painting could be tackled, plaster would have to be repaired. Where there was wallpaper, it was peeling and would have to be stripped, reglued, or painstakingly patched. The downstairs sunroom had suffered long-term damage caused by a leaking roof and would have to be gutted down to the studs. The old windows and doors needed to be repaired and repainted. The structure of the wood-frame garage had been seriously undermined by years of inclement weather.

At times, the magnitude of the project seemed overwhelming. Margaret willed herself to adopt a Zen-like acceptance—"to be with what is." If the once-formal garden had suffered years of neglect, its built-in limestone bench and barbecue consumed by vines, she would savor that blend of exuberant growth and decadence as a reminder of nature's ultimate redemption. Rather than lament the breakfast room's crumbling plaster and cracked linoleum tile floor, she would recast the fading décor as a chic backdrop to a vintage table and chairs, viewing the signs of wear not as detraction, but as decorative enhancement. How she felt in the house never changed. Though the place would still need years of work, its palpable history of having sheltered and been loved by previous families gave Margaret an enduring sense of safety and contentment. "I would go to my office on the east side of town and come home and think, 'This is how some people feel when they come home to their partner,'" she says. "I felt embraced by it."

She relished the house's openness to the towering trees whose boughs swished against the walls and sheltered wildlife. She focused on the sense that she was living almost outdoors. "The birds are right there," she says, pointing to a window. "The squirrels are pushing at my screen door. I've had bats in the house. There's not a clear distinction between inside and outside. From my office you go to a screened porch, then to an outside porch, and then to the garden." It's all connected. During storms, the house speaks. "It's an eerie sound, like a high-pitched moan or groan. Not a depressing sound. But it's alive. You hear it throughout the house. Whatever you're doing, you will stop . . . and listen to it until it's done. It's like the house is carrying the wind."

Over the years, she has worked through the house as time and finances allowed, repairing structural fabric and repainting in cool, elegant colors that accentuate the period details and generously proportioned rooms. Today her home is sparely furnished, comfortable, serene. The room that first beckoned her to sit is now the office where she sees clients.

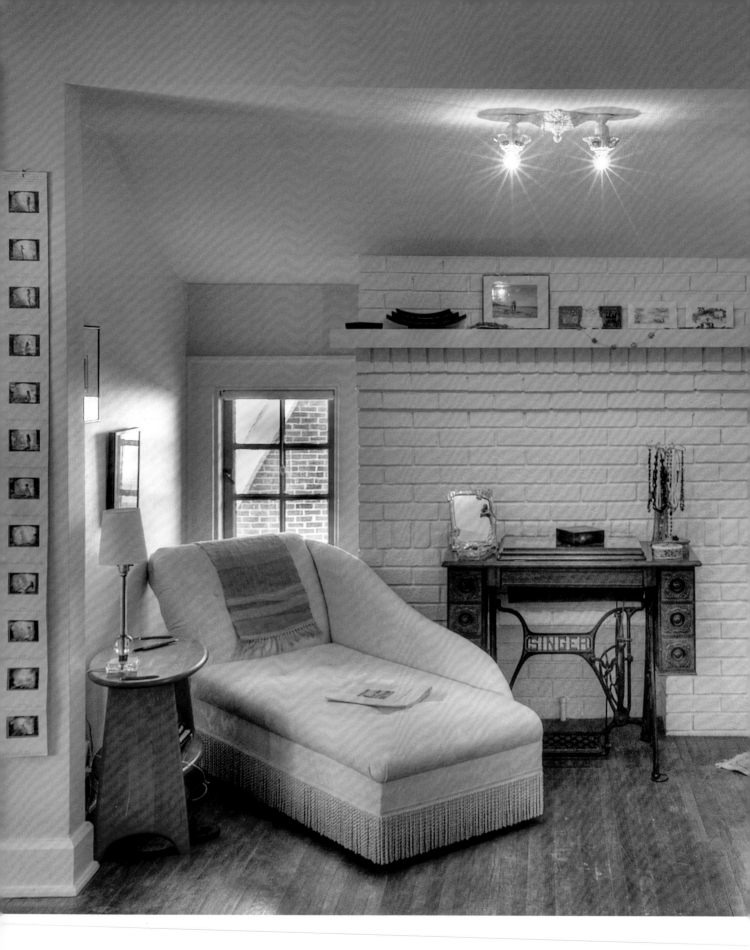

Though she long regarded houses as little more than shelter, Margaret has discovered in herself a powerful domestic streak. She credits the house with eliciting this latent potential. "I felt like I belonged here," she reiterates. "I didn't have that strong sense of belonging anyplace else I lived. Not that I was ever unhappy in those other places. I've always enjoyed where I lived, in part because I required so little from my living space. I've always thought I could live in a tent just fine. But this space and structure matched something in me in a way that is hard for me to explain."

She was moved to work with this place in ways that were new to her. Walking the path of home required heeding her responses to her immediate surroundings—the warmth of a spring breeze blowing through a window, the rattle of a poorly fitted door, the sense of solidity and centeredness she feels in the stairway that leads from the public realm downstairs to the intimate spaces of the second floor—and furthering the house's development into a place *where being felt good.* She notes that this change in perspective is less the result of having reached a certain age or point in her life, and more a "co-creation of this particular house and this particular woman."

"My connection to this house is somatic. I feel alive in it." And while that aliveness is something she treasures, Margaret is clear that the house is still a house, and she could leave it today if she chose to and be fine. She draws a clear distinction between loving the house and needing it. "But I love being here. I love reading the newspaper in my house, I love the ritual of making a meal at the end of the day. It's really satisfying to be in this house."

A COMFORTABLE CHAISE, vintage sewing table, and rack of woven textiles in the master bedroom make for an inviting corner to curl up in with a book.

5 STAYING HOME

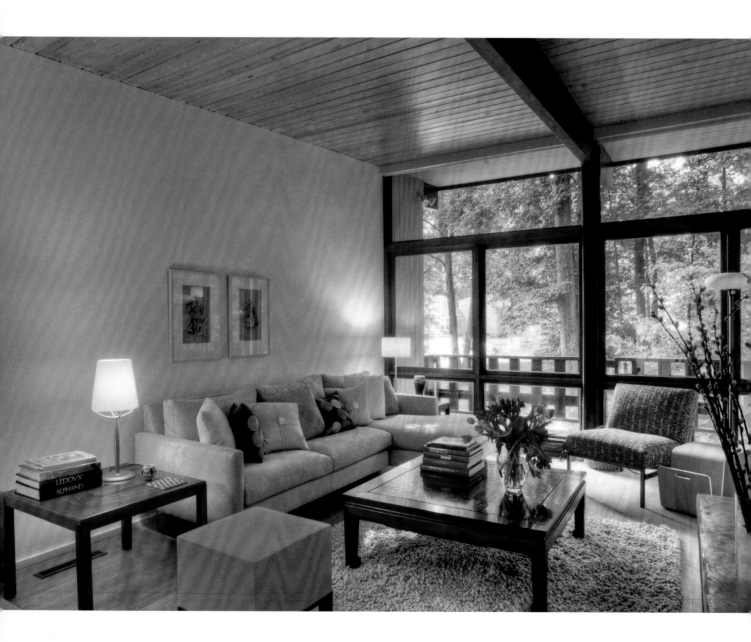

WHEN INDIANAPOLIS ARCHITECT Ed James designed a modernist split-level in 1958, he could not have imagined that his vision's full potential would be realized by another architect, this time a woman, half a century later.

Christine Matheu first saw the house on an autumn afternoon in 1989. Earlier that day she and her husband, William Cohen, had spent three languid hours rowing around a nearby lake, discussing their domestic arrangements. Although they had been married a year, they lived in different places. Christine was based in Philadelphia, where she taught architecture at the University of Pennsylvania and where she had an architectural practice after having worked many years at the office of Venturi Scott Brown & Associates. William lived in Bloomington, where he chaired Indiana University's history department. Having sustained their long-distance relationship a total of four years, they were well acquainted with the drawbacks of living so far apart, and they had spent much of their time on the lake weighing the pros and cons of making a home together. Doing so would be no small task. Since Christine needed a home office, William's one-bedroom cottage would be too small. They would both have to move—a huge upheaval for two professionals in mid-career.

They rowed the boat back to the dock and continued the conversation on their way back to town, where they wended through a neighborhood near campus. The streets meandered south before stopping at the boundary of a wooded estate, which made for a quiet area with little traffic. Rounding a bend, they were struck by the sudden appearance of a modernist house whose

CHRISTINE'S living room faces east and catches the morning sun. The house is shaded by woods to the south and west, which help keep the interior cool in summer.

street-side elevation, a geometric grid of wood-framed glass, could have been a Mondrian painting brought to life. A "For Sale" sign happened to be standing in the yard. They noted the realtor's number and arranged to visit the next day.

That Christine and William should have been so taken with the house was surprising, even to them. His favorite style was Victorian. She, too, loved old houses, and, after ten years in Philadelphia, had been spoiled by the city's wealth of eighteenth- and nineteenth-century architecture. No small midwestern town could compete. When it came to looking for a home in Bloomington, she had, in her own words, "shifted mentally into another place."

Arriving at the property the following day, they realized how well the house was positioned on its site. Bordered by tall deciduous trees to the south and set near the rear of its lot, the structure was shady and secluded, with a long expanse of lawn separating it from the street. To the north, a covered breezeway connected a carport to the house's front entrance, itself a study in modernist design, the door a smooth rectangle of opacity in an asymmetrical arrangement of transparent glass. Aside from this focal point the façade was plain—a long wedge of painted wood rising out of its gently sloping site like a piece of sculpture placed at the edge of a forest.

Inside, a hallway at the right led to three bedrooms, a laundry room, and a pair of baths. At the left, a short flight of open-riser stairs led up to a living room, dining area, and kitchen. Christine had begun exploring when William, discovering the upstairs space, swung around with a big smile and exclaimed, "Oh, Christine, this is wonderful!" The living and dining areas were less like actual rooms than two halves of a single, loft-like space. The separation between them was merely *suggested*—albeit by a massive brick chimney, which emerged like a solar plexus from the ground beneath the basement, rose upward through both floors, then shot skyward through the roof's angled plane. Emphasizing the spatial ambiguity of the living area, the fireplace opened out to both sides, with a cantilevered hearth. The wall of east-facing windows suffused the entire place with light.

The ceiling, a vast expanse of pale V-groove fir decking, swept upward toward the east, tracing the lift of the roof. The post and beam structure was fully exposed, its soaring timbers piercing the wall of windows and continuing on for several more feet outside, where they supported an overhang that shaded a full-length deck. The effect was fearlessly modern, like nothing either of them had previously encountered in Bloomington.

Not that the actual décor was especially to their liking. Turquoise curtains hung at the edges of the magnificent windows, meddling with the architecture's lines. The oak floors had an amber finish obscuring the wood's freckled

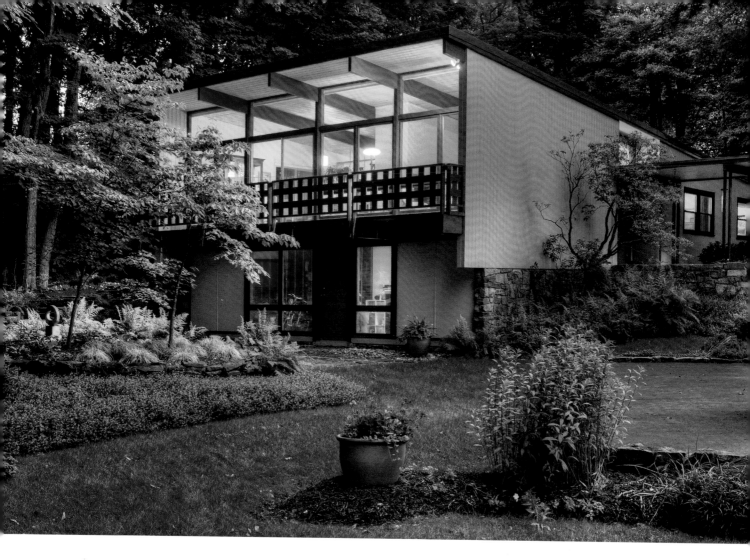

vitality. Adding to Christine's dim sense of a suffocating effect, several walls were hung with beige grass cloth. All these elements made sense in terms of a mid-century aesthetic, but in 1989, years before the resurgence of interest in '50s décor, they seemed decidedly out of place. More disturbing to Christine than their decorative effect was how these elements obscured the power of the architecture.

The Pullman-style kitchen was a painfully narrow space closed off from the rest of the interior, like a shameful secret hidden by a sliding pocket door. A pass-through window between the dining room and kitchen served as a means by which dishes could be transferred conveniently between the two spaces. Inside this workroom, built-in cabinets lined every wall—a model of efficient storage that promised to engender feelings of claustrophobic isolation. A single small window over the sink offered a vista beyond the tasks at hand. Although Christine understood the social history underlying the kitchen's design, she did not particularly relish the prospect of cooking there.

DUSK at the edge of the woods.

Still, the kitchen was the sole significant detraction from an otherwise admirable house. At some 2,250 square feet, the size was ideal, with room for two home offices. Christine, who had majored in Fine Arts as an undergraduate, loved the loft-like living area upstairs. As an architect, she appreciated the connections between the house's various spaces, even as each had its own distinct personality. The interface between house and garden also resonated with her take on the relation of landscape to architecture, a subject she had researched extensively in Paris on a Fulbright fellowship, and one she had taught at Penn.

They bought the house and moved in that fall.

Christine set up an architectural office in the lower-level study area, which was fitted with original cherry built-in cabinets and had a sunny view into the garden. William located his office in one of the bedrooms. Once they had banished the turquoise curtains in the living and dining rooms and furnished the place with their own possessions, the interior felt more like home. They worked at viewing the cramped, dark kitchen—a monument to outdated gender relations, and especially ironic given that William was the primary cook—as a bit of period kitsch, trying not to focus on the impractical and uncomfortable features of its design. Three years later, on Halloween, their home itself seemed to celebrate the birth of their daughter Laurel, the amber maples filling the house with golden light.

Over the years they made some changes inside and out. By moving the laundry room downstairs, they were able to enlarge both bathrooms and add a dressing room to their bedroom. In the lower level, they removed 1950s rec-room wood paneling and replaced plaid carpet with new carpet to coordinate with the natural colors in the house. On taking out the dropped acoustical tile ceiling, they discovered beautiful wood beams, which they left exposed. They also added wood trim to the windows and provided a new bluestone surround and hearth at the fireplace. At the completion of the lower-level renovating, William moved his office downstairs.

Christine redesigned the garden on classic English principles with a modern twist. Keeping the area immediately around the house somewhat formal, she expanded and opened up the existing wood deck, adding a Pennsylvania bluestone patio and walkway flanked by retaining walls of local Brown County stone. A modern parterre of shrubs and annuals eases into a more natural look with distance from the house; a moss path leads uphill through the forest, where drifts of impatiens give way to a naturalized understory. She and William gardened together, and in 2002 they bought a limestone sculpture carved by their artist friend Frank Young, placing it outside William's office, where it was visible from his desk.

After initially practicing on her own, Christine decided to join a local architectural practice that specialized in educational and institutional facilities, where she was appointed project architect for a job of major local significance—the conversion of the former Showers Brothers furniture factory into offices for a consortium of city government, university, and private business entities. She spent four years working with representatives from this unlikely trio of client constituencies to develop the project's parameters and construction schedule. She has an especially vivid memory of the meeting at which she presented the schematic design. The meeting was locally televised, and, nine months pregnant, she was praying she would make it through the presentation before she went into labor. Two days later she gave birth to Laurel.

The Showers project, which became home to Bloomington's extraordinarily popular farmers' market, in addition to City Hall, brought Christine invaluable professional exposure, and in 1997 she established her own architectural practice. Over nearly a decade and a half since then, she and her associate, Kristopher Floyd, have worked on numerous religious, educational, commercial, and residential projects.

On an autumn day in 2002, while cleaning leaves off the roof of their garage, William fell. He later died from his injuries. "Some people think you have to change everything to deal with loss," says Christine, but she and Laurel responded to their devastation by staying put. "The house represented a really *nice* place to be," explains Christine. It had been their family home for many happy years. No other place could match it for stability, which was exactly what they needed.

Time passed. Perhaps as a means to rebuild her life, or perhaps as a chance to be her own client, in 2005 Christine began thinking seriously about making some changes to her house. For years she had looked up at her wood deck ceiling, savoring its interplay of angles and lines, its dark and pale elements. She had imagined a couple of ways the kitchen could be reworked—perhaps relocating it in an addition on the south side of the house, or perhaps leaving its basic footprint intact while opening the room to the surrounding space.

As it happened, she chose the latter, keeping the kitchen exactly where it always had been, but utterly transforming the feel of the space. She had long dreamed of removing the wall between the kitchen and dining room, but a post, which supported the roof, would have to stay. Rather than seeing this structural constraint as a liability, she turned it into a dynamic feature of the new design, using it to emphasize the post and beam architecture of the entire space—living, dining, and entry areas, as well as kitchen.

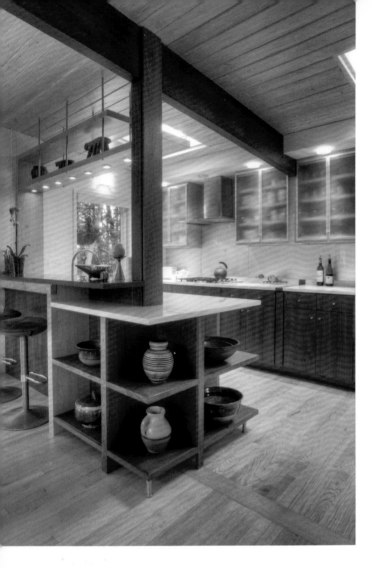

CHRISTINE completely reworked the kitchen without increasing the footprint of the original room. She removed the wall between the kitchen and dining room, added windows, and had new cabinetry made from walnut and maple to her design. The carved wooden animals on the shelf over the sink were collected by her husband, William, when he was researching French Colonial Africa. Most, if not all, are from Senegal and were market stools for ladies to sit on while selling their wares.

In place of the lone window above the sink, she installed one that reaches from floor to ceiling. She added a matching window at the opposite end of the room; it overlooks the entry area, offering a dramatic view of the spatial relationships between different parts of the house—carport, front door, entryway, and stairs—with their intersecting planes of glass, wood, and metal.

She commissioned custom cabinets in dark walnut and creamy maple to highlight distinct areas within the kitchen. A staggered-height counter creates a formal separation between kitchen and dining spaces, with an open display shelf suspended from the ceiling above. To ensure ample natural light, she added a second skylight to the original, and she had the linoleum floor replaced with tongue and groove oak, which further identifies the kitchen as part of the public space.

In the dining area, to distinguish punched wall openings from post and beam framed openings, she had the dark wood trim around the punched openings painted white to blend their outlines into the walls instead of distracting from the overarching structure of floor, walls, and ceiling. She painted the cold gray concrete brick of the chimney a warm off-white and had the floors refinished with a clear coating that allows the oak's iridescent flecks to shine.

Christine also reworked the master bedroom. The original space had been designed with just one possible location for the bed—headboard against the house's southern wall, under a bank of high windows intended to ensure privacy. This meant that the bed faced a wall of built-in closets. The house's original architect had taken such pains to ensure that his clients' experience inside their home would encompass its outdoor setting, but the master bedroom's layout seemed to ignore this aesthetic directive. She understood the desire for privacy—all too well, in fact, now that she and Laurel were living alone. But the bedroom had privacy enough already; it faced the forest, not neighbors or the street. Why should her first view every morning be a wall of boring closets when she could instead awake to a living mural of garden and forest? The time had come to refocus the room outward.

She had a wall of floor-to-ceiling windows installed to the south, echoing the design of the street elevation. Once the built-in closet had been removed,

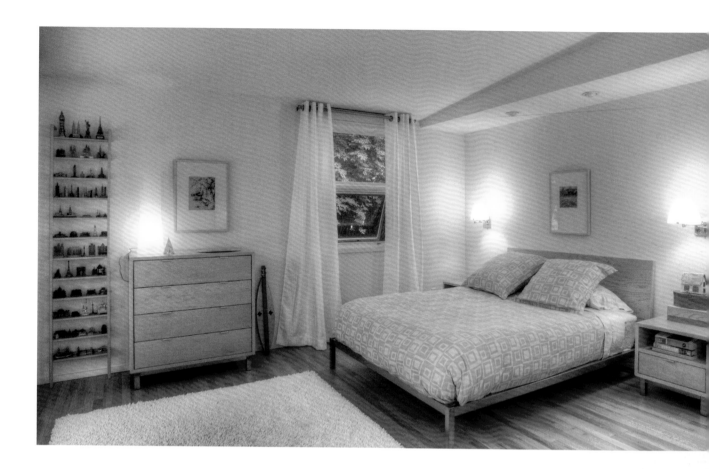

she positioned her bed in the resulting alcove, subtly suggesting a certain snugness by means of a soffit. She removed the wall-to-wall carpet from the bedroom and hallway and had the oak floors refinished, unifying these rooms with the other living spaces. Now, her first sight each morning is of sunlight filtering through a woodland canopy—of clipped boxwood, clusters of pink and white impatiens, and a stone wall bedecked with ferns and moss.

Her house's design has been something of a time-lapse collaboration spanning half a century. Its original architect drew his ideas in wood and glass at a time when middle-class women were expected to center their lives on home, and no room personified "home" more powerfully than the kitchen. Less than thirteen years had passed between the end of World War II and Ed James's drawing of the house; the original kitchen had been planned at a historical moment when women were still being cajoled to give back the professional positions they had filled when their husbands and sons were displaced by wartime activities.

But those were other times.

Today the kitchen is a sphere for men as well as women, a room whose functions are not concealed, but celebrated. Ironically, by whisking away the

IN CHRISTINE'S bedroom a shallow set of shelves houses her collection of architectural icons, which range from the Eiffel Tower and Empire State Building to the Lincoln Memorial, Golden Gate Bridge, Taj Mahal, and Gaudi's Sagrada Familia.

outmoded value system embodied in the original kitchen's walls, Christine has honored James's modernist expression and enhanced the eloquence of his overall architectural conception. Similarly, her twenty-first-century variation on his master bedroom theme brings the garden into the experience of the house's interior more faithfully than James, for whatever reason, was willing or able to achieve.

Freed from its cloying layers of cloth, its dark coatings and excessive interior divisions, the house feels open, as though it is finally able to breathe. Christine feels just the same. She finds the spaces and views relaxing now, the effect of being in them "like a kind of yoga." Though she concedes that others might have different responses, she finds the large windows and minimalist aesthetic extraordinarily calming and conducive to an attitude of openness to her present reality.

ON THE WEST WALL of the living room hangs an original Deco-era wall hanging by Ruth Reeves. The brick fireplace with cantilevered seat is original and also opens into the dining area.

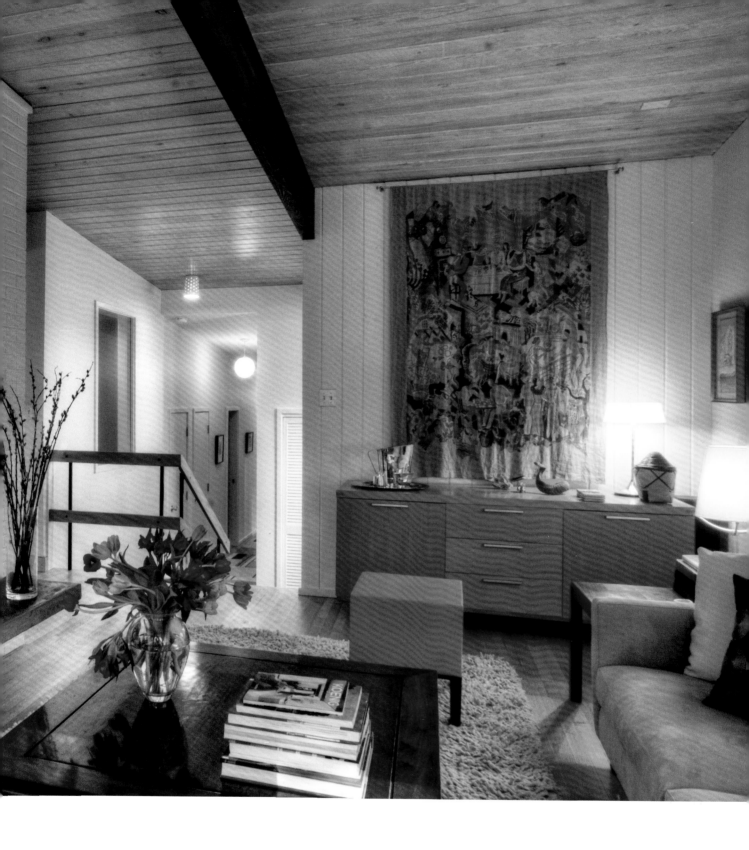

6 A May-December Romance

EDIE HAS A COLLECTION of vintage kitchen equipment, such as the scale and can opener seen here, which she uses in preference over things that are new. The table cloth, too, is old.

IN 1989, EDITH SARRA and her then-husband, Robert, moved to Bloomington, Indiana. Edie had been hired to teach classical Japanese literature and language at Indiana University, and since her husband was still in graduate school, her tenure-track appointment decided where they would go.

When the time came to find a home in their new location, Edie and Robert agreed they wanted a place with history. Both adored old houses. Robert had acquired some carpentry skills remodeling an old house some years back, and Edie had grown up in an I-house built for a nineteenth-century tobacco farm near Greensboro, North Carolina. Her mother and father had restored the place together and were madly in love with it. Even as a child, Edie sensed that her family's home was an intricate embodiment of her parents' marriage.

As children, Edie and her younger sister, Laura, rode bicycles through the nearby fields and forest in search of abandoned houses to explore. The more derelict a house's condition, the more compelling was its appeal. Broken windows and boarded doors signaled the prospect of hidden treasure, the thrill of forbidden discovery. Pulling aside the veil of tangled vines and overgrown shrubs, the sisters were drawn spellbound into each deserted bower, whose neglected dignity they honored as their eyes adjusted to the dim light.

From childhood through their teens and even into college, the girls kept up this sacred archaeology. What lives had been witnessed by these walls, now cold and silent? Every scrap of fabric from a once-elegant dining room curtain, every Ball jar fallen to a root-cellar floor, was picked up and celebrated with a spontaneous envisioning of scenes from the past.

While poring over the pages of a realtor's listing book, Edie found an entry under "farm acreage" that caught her eye. Seventeen miles from town, the ten-acre property also had a house—a stark, imposing residence likely dating to the 1850s.

"This could be the house of my dreams for $29,500!" Edie gasped. But then, she hadn't yet seen the property. The sellers' realtor, a former English professor with a genteel manner and florid complexion, laughed when she asked for a key. There was none. "You're welcome to walk right in if you can get past the hole in the floor," he advised.

They first visited the place in early May. Low in the sky behind them, the late afternoon sun illuminated the statuesque facade as they drove up the narrow gravel lane between fields that would soon be planted with soybeans and corn. The place seemed desolate and totally wild. The grass around the house was knee high, and rippled in the late-spring breeze. A majestic Norway spruce brushed the house's southern flank with its spreading boughs, and another, its top long ago blown off, stood like an embattled sentry at the front. Unlike the forsaken houses of Edie's youth, this one lacked "eyes," its window openings having been boarded up to keep out the rain. More distressing, much of the architectural fabric had been vandalized or even stolen; interior doors, all but one of the windows, the entire staircase, mantelpieces and fireplace surrounds, interior and exterior hardware had either been destroyed or else benignly spirited away for safe-keeping. The place, at once sad and magical, called to them. It seemed to be holding its breath while they tip-toed from room to room trying to imagine what it would take to turn the house back into a home.

It's too far out of town, said friends. Family members pointed out the financial risk of buying a dilapidated property at a time when Robert was in graduate school and Edie didn't yet have tenure. And wouldn't the hardship of a protracted restoration project take a toll on their marriage?

Undeterred, Edie and Robert bought the place and moved in that August. The weather was stifling. They tacked up screening over the window openings and put up a temporary screen door to keep the swarms of mosquitoes out of the upstairs room where they camped for the fall semester. Nature, they saw, had been gradually working to take back the house for her own. Birds, bats, and other uninvited creatures had laid claim to their various corners, and groundhogs were living under the back porch's rotting floor. At the same time, the company of other wild animals proved a source of comfort; a pair of great horned owls perched in the spruce trees and called to each other at twilight, lulling Edie and Robert to sleep in their crumbling, once-stately encampment. Coyotes sometimes awakened the pair with unearthly yodeling.

Beyond the absence of windows, the place lacked cooking facilities and plumbing. As Edie began her teaching job and Robert attended business school, the two were grateful for access to campus showers. Their plan was to make the house livable by finishing three rooms, to start—the kitchen, the bathroom, and the dining room, the last of which would serve as an all-purpose space for living and sleeping.

They hired a contracting firm to repair the roof and rewire the three rooms. Using the one remaining window as a template, they had new sashes made, scrupulously following the original six-over-six-pane pattern and with pegged-joint construction. Edie and Robert glazed the sashes themselves with salvaged wavy glass. They had their contractor tuck-point the old limestone foundation, replace the floors in the bathroom and kitchen, craft a cellar door, plaster interior walls, and install their new windows.

December approached, and they were still living without a regular source of heat, relying on a borrowed kerosene heater to keep the temperature in their sleeping area above freezing. They worked on the three-room restoration after school and on weekends, resisting the creep of demoralization as the reality of their project's scope became clear. Aside from the window glazing, it was crucial to finish removing all the flaking lead paint from the three rooms the new furnace would heat. In the late afternoons, before heading to dinner at a nearby country restaurant, they donned respirators and bore down on the woodwork with heat guns and scraping tools. The pair took care of school-work at night, huddled in bed under blankets.

Edie and Robert completed some major steps of their home's restoration before they parted three years later. Paradoxically, perhaps, the house's demands had not contributed to the rift but delayed its onset; their excitement about restoring the house had so consumed them that they had overlooked some increasingly pressing interpersonal problems. The weightiest was Edie's desire for children.

Sensing that they had reached their marriage's end, Edie took off on a research trip to Japan while Robert stayed home and continued the restoration. He moved out on Edie's return. At that point they had replaced the roof of the ell and restored its massive chimney, and they had finished the back porch and the first three of the house's seven rooms—and "finished," in this case, did not mean decorated, but made livable. They put the house on the market, knowing it would be far from an easy sell.

The house remained essentially in this same state for three more years. Robert returned from time to time to help with the ongoing restoration. The pair completed the two-story portico two years after their divorce became

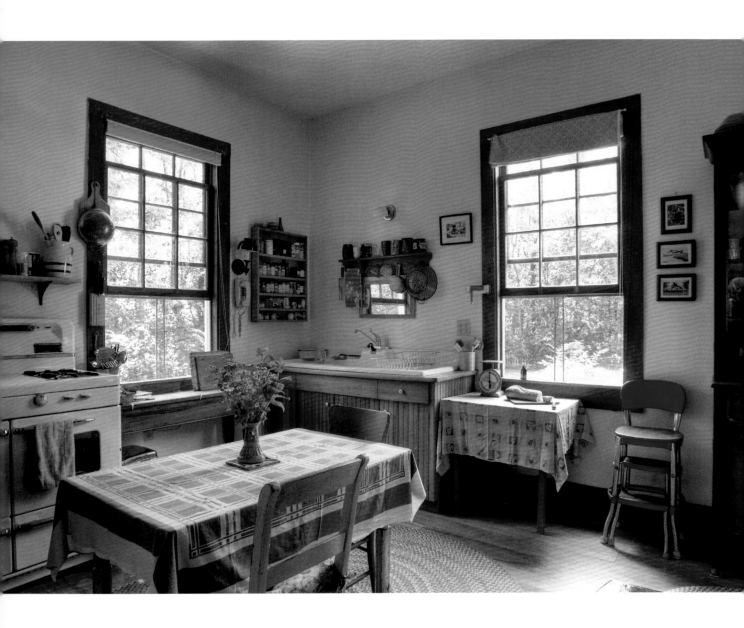

IN EDIE'S KITCHEN the work-
table, which doubles as a place
for taking meals, holds prime
position. The double-drainer
sink belonged to the house
before she bought it; she had
the base cabinet custom built.
The 1950s Caloric stove still
works well.

final. Meanwhile, Edie was granted tenure and belatedly relinquished her
hope that Robert and she could patch things up. Without a human partner,
she found that the house took on a different presence, becoming more per-
sonlike. She had moved into the archetypal abandoned house of her child-
hood explorations. Here was the dreamwork of her youth made tangible in
Southern Indiana brick and limestone.

Another winter passed. A single serious offer was made on the house,
but it fell through.

"I was weeding the back garden on a dreamy, rain-washed April after-
noon," Edie remembers. "A trio of deer emerged from the woods, bowing
their heads and peering at me, advancing one tentative step at a time into
the garden." The moment crystallized her situation, recalling her somehow

to the place itself, and to her life in it. Perhaps, with her enhanced job security, she could continue to live there. But what about the social price of living so far from town? She thought hard about potential implications for other relationships. It occurred to her that although she was alone in her peculiar setting, the house brought other people into her life; the majesty of its architecture, made all the more striking by its remote location, exerted a powerful draw on acquaintances and friends who lived in town. She took the house off the market and committed herself to staying.

That summer she adopted a Belgian Tervuren puppy, whom she named Genji after the princely character in a classic Japanese tale. This was a different sort of partner—an unshakable ally who eagerly molded his desires to mesh with hers. They became inseparable. As she had with her sister, Edie took long walks with Genji through the fields and forest around their home. Evenings they would sit in the open front door and let their yips and howls echo up the stairwell and out across the hayfield, sometimes provoking, to their delight, a crazy call-and-response from neighboring coyotes.

It grew on her, this way of being in the place she had helped create. At night the rural sky was filled with stars. In winter, she returned home after work to build a fire in the same hearth around which earlier families had cooked suppers in a great black pot suspended from the crane partly attached to the fireplace bricks. On snow-bound days, the farmer down the road would clear her lane with his tractor, a kindness offered without her asking.

Summers, she quit keeping a lawn, mowing paths instead through the waist-high grass to the woodpile, the lane, the vegetable garden she dug out with a spade, and the hammock she slung between a pair of trees.

In 1998 she became involved with a new partner, Ben. For several years she lived in the house part-time, staying in town during the week to be with Ben and his two daughters from a previous marriage. But the place continued to exert its pull. The family would retreat to the rural home for long weekends and dinner parties, gathering together disparate groups of friends. Ben and his daughters, Emma and Toma, brought a new level of social energy to the house. With the girls, especially, Edie spent long, dreamlike hours in kitchen table conversation, going over the minutiae of their individual pasts, making up for lost time.

Between teaching, high-school soccer games, and her new role as second mom, Edie made time to push the work of restoration forward again. By 2002 the remaining four rooms, two chimneys, and ruined staircase had at last been finished.

That summer, Ben and Edie were married. They planted an orchard as part of their celebration.

BELOW. At the top of the staircase, a landing leads onto a porch with a glorious view to the west.

FACING. The original dining room floorboards are painted mustard, and the walls are covered with paper by Bradbury and Bradbury. An old cupboard is faux-painted to resemble fancy wood grain. The chandelier, which holds real candles, is a reproduction of a late-eighteenth-century piece. Edie rescued the plate rack on the wall from the "Little House," an artist's studio-cum-playhouse that used to be in the backyard of her mother's house in North Carolina. The plate rack, one of the first pieces of furniture her parents acquired when they were married in 1945, hung in Edie's bedroom when she was a teenager and then in college; she used it to display blue glass insulators and Ball jars she had "liberated" from abandoned farmhouses. Today, the rack holds hand-thrown plates from a pottery in Seagrove, North Carolina, and a pair of bowls presented to Edie by one of her Japanese language teachers in Tokyo.

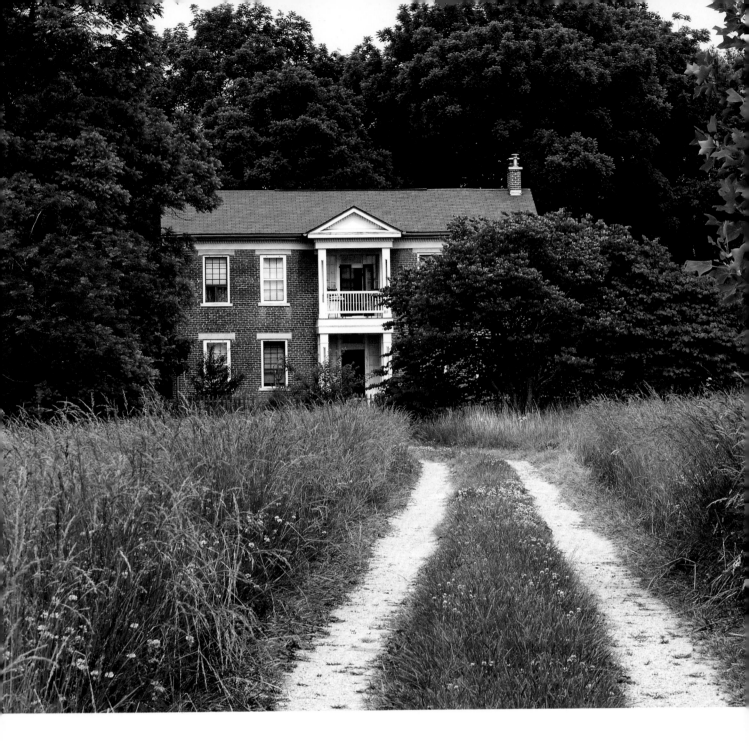

Ben's and Edie's partnership embodied both grace and tumult. Their mutual love was bone-deep. But their union had also been characterized from the start by ineradicable wildness and wariness. Altogether, it was a balancing act too easily and too often undone.

Eventually, the marriage reached its breaking point. But this time Edie remained where her heart had always been. There was no question of leaving the house that had become so much a part of her, and she of it. She was 50, and the house 150, the place more beautiful and dear to her than ever. She had been its mistress for nearly twenty years.

On a spring night in 2006, straight-line winds tore across the hayfield and buffeted the house's face. Edie and Genji huddled together underneath

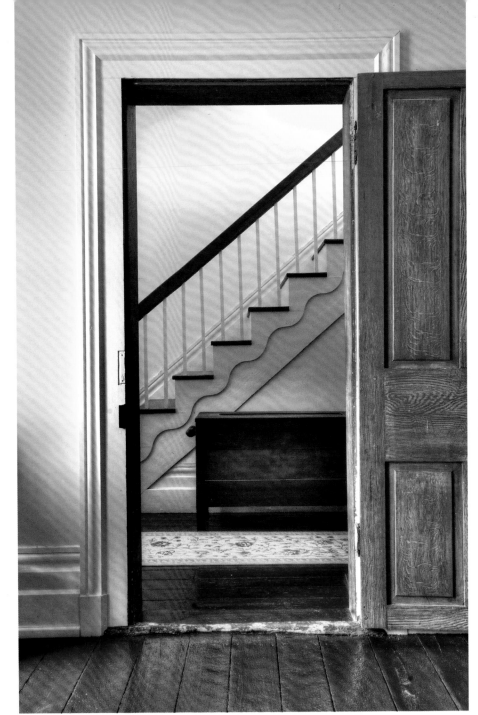

the bed, where they spent a harrowing fifteen minutes locked together in a terrified embrace while the winds howled as they'd never howled before. The two emerged to find the Norway spruce by the house's south flank snapped off at its base, leaving a blank patch of sky above the ell roof, which Edie could clearly see from the bedroom window. Dog and mistress crept out to the kitchen, expecting to

FACING. The 1850s house is surrounded by farm fields and forest. Invisible here, behind the trees at the right, is a large garden where Edie grows tomatoes, herbs, and flowers.

ABOVE. The poplar blanket chest with walnut handles next to the staircase in the central hall dates to the mid-nineteenth century and came from a brick I-house overlooking the Ohio River near Rockport, Indiana.

THE BATHROOM, just off the kitchen in a former pantry, is furnished with old fixtures—a clawfoot tub, sink, and toilet—which suit the room perfectly.

find the tree in the middle of the room. Instead, it was lying parallel to the house, a merciful ten feet from the kitchen wall.

I met Edie and Genji for the first time three days later. The hulking carcass of the tree still lay in the yard beyond the kitchen window, where we sat till eleven o'clock on a work night. For years I had been hearing about this woman and her home from a carpenter friend, Ben Sturbaum, who had worked on the restoration. He called it his "favorite house in the world." Now I understood why.

We sat at the old kitchen table and talked over steaming bowls of home-made soup. I found myself smitten by this woman and the home she had created. No, she hadn't been its builder; nor had she restored it entirely by herself. But her love of the place had matured over the years into a fierce commitment that had outlasted two marriages. Embracing her own part in the house's history, Edie had extensively researched its past and written documents for its nomination to the National Register of Historic Places.

She secured the National Register listing, which she hoped would not only memorialize her home's history, but help protect the place itself. While the listing alone could not prevent the house from being substantially modified or even demolished at some future time, she knew that highlighting the property's significance to local history might at least tip the scales in favor of preservation.

The bond between Edie and the house was palpably vibrant. I drove away under a star-studded sky, my heart singing with excitement. I wanted her to be happy. Maybe, I mused, she should meet my friend Michael Shoaf, a carpenter, cabinetmaker, and longtime practitioner of Japanese Buddhism. I felt sure that Michael would have a fitting appreciation of this woman and her home.

He did.

The two were wed the following year. You could call it an arranged marriage, effected not through parental negotiations but silently and inexorably by the house, in return for the love that Edie had bestowed on it.

OVERLEAF. On the north side of the house, this screened porch provides a cool place to sit or take meals in summer. The window visible here is the lone surviving original on which the new sashes throughout the house were patterned. Against the far wall is a handmade cabinet that Edie believes was built by a member of Gosport's Hoadley family.

7 SMALL IS BEAUTIFUL

WHEN LINDA OBLACK first saw her house, which sits on a quiet corner in a neighborhood both literally and figuratively across the tracks, it was covered in crumbling sheets of brick-print asphalt siding. The house's shabby exterior was an apt reflection of Linda's personal and professional situation. At 53, she was recently separated and out of work. The heater in her rented house had broken yet again, and her landlord seemed in no hurry to have it fixed. The time had come to make some changes.

A formally trained Montessori teacher, Linda had operated her own school for fourteen years. She founded the school when her ex-husband moved to Canada, leaving her alone to raise three sons. A friend helped finance Linda's Montessori training with a view to enrolling her own children in the school, along with those of several other friends.

The Montessori years were the happiest of Linda's life. She loved her work as the school's headmistress, with one assistant teacher and three part-time instructors of music, French, and art. A parent-run board raised funds and handled bookkeeping and other administrative tasks. Linda's own children were young enough to attend the school, which gave her plenty of time with them every day. Unlike so many people, she actually looked forward to going to work.

In 1990, Linda began dating a watercolor artist. They married, and James took enthusiastic part in raising Linda's sons. The family lived in an old log cabin that had been added onto several times. James painted in one of the house's rooms and sold his work at art shows.

A SHELF ABOVE the opening between kitchen and dining room holds some of Linda's vintage kitchen wares.

With both partners self-employed, household income was unpredictable. The school's enrollment had always fluctuated, along with revenues from tuition. Government financial aid was not available to private schools in her state, even those serving a low-income demographic. As the original cohort of students graduated and their dedicated parents were replaced—increasingly with couples in which both partners had to work full-time—finances flagged. By the end of the 1990s, the rising cost of insurance, rent, and other overheads had exceeded the school's income. In an effort to save her school, Linda waived her own salary for a year. But even that was not enough.

Linda and James parted ways in 2000. Neither was able to keep the log cabin, and Linda moved into the only place she could afford to rent—the house with the recalcitrant heater.

It was around this time that Linda happened on the house in which she lives today. A handyman friend who knew she needed to move told her that his cousin had a house for rent—a rundown bungalow he described as a dump. At $250 a month—less than half what she might have expected to pay for most places—it was too good a deal to pass up.

The house was small—a mere 750 square feet—and as raggedly Dickensian on the inside as the exterior had suggested. But it had come by its humbleness honestly. The original owners, Fred and Jean Walls, had bought the tiny corner lot in a working-class neighborhood in the 1930s, and Fred had built the house himself. For Mr. and Mrs. Walls, the home seemed anything but mean; it represented a rich opportunity and offered the young couple a precious leg-up.

The structure originally comprised three rooms—a bedroom, living room, and eat-in kitchen—and occupied a scant 500 square feet. Like most homes in its neighborhood during the 1930s, the house was built without an indoor bathroom. There was a privy in the backyard, and the kitchen was large enough for bathing in a movable tub. After Fred and Jean had children, Fred added a bedroom, a bathroom, and a dedicated kitchen at the back of the house. They raised four children there.

By the time Linda discovered the house, it had been a low-cost rental for at least ten years. Fred had passed away, and Jean had moved to another location. The kitchen was cold, dark, and ill equipped. The floor was covered with the same gray linoleum it had had since the 1930s; instead of replacing the entire floor, Fred and Jean had patched random sections of tile into the areas that had worn through. The cast iron sink was so deeply stained and pitted that no amount of scrubbing would restore its whiteness. The counters were covered with ancient, cracked linoleum, and the stove was a tiny apartment

model. The back door, whose joints had failed, was held together with mending plates; it was so badly warped that it was impossible to close fully, which made the room perennially drafty.

The bathroom was the size of a small closet. In fact, it had been ingeniously, if crudely, shoehorned into an actual former closet. The sink was pitted, with separate hot and cold faucets that leaked uncontrollably. When they added the bathroom, Fred and Jean had cut a hole in the wall to accommodate the toilet tank, because the room was too narrow to hold the entire ensemble. Bathing was something of an adventure; a concrete shower base poured directly onto the ground was supplied with water from a curved metal pipe with a screwed-on shower head. It was primitive but functional.

A SELF-DESCRIBED "hard core Dylan fan," Linda bought her "big brass bed" at an auction for $90. The bed came with headboard, footboard, and side bars but no structure to support a mattress. Linda dismantled a futon and used the boards for slats to hold her box spring and mattress.

In every room, the walls and trim had been blanketed with a uniform coat of white, which did nothing to mitigate the house's aura of deprivation. But at least the white was less offensive than the bright orange starting to show through the thin coat of gray on the old wooden floors.

Linda was unfazed. She focused on positives—the lovely plaster walls, the original interior trim, the charming old double-hung windows. Beyond the grime and shabbiness, she sensed a cozy home waiting to be brought back to life.

The house, and Linda, would have to be patient for quite a while longer.

Around the time she moved in, a friend suggested that Linda apply for a position as a filing clerk at his place of employment. It would be a huge step down from running her own school, but the job would provide a steady income, and there would be opportunities for advancement. She applied and got the job. Later that year, when there was an opening for a better position, she applied for it and was hired. This time, the job included benefits. In 2006, she got a job as a full-time editor.

Meanwhile, Linda had settled into her rented home. The location was ideal—just a few blocks from work and downtown. She loved the neighborhood, which was quiet and unpretentious, with a mix of artists, young families, and older people who had lived there many decades—some, their entire lives. Across the street, in a ramshackle house with fake-brick asphalt siding that matched Linda's, a craftsman in his sixties ran an antique repair shop. The place was packed to the gills, its contents ranging from useful junk-store finds to precious family heirlooms. Mac had inherited the premises, along with the tools and a heritage of craftsmanship, from his father and uncle; both had spent their careers employed by one of the country's largest furniture manufacturers, which had been located just over the tracks.

Her neighbor to the west was a widow in her nineties whose husband had worked for the same furniture factory. Jenny had spent her adulthood as a homemaker, and she had decided to remain in her home after her husband's death. She endeared herself instantly to Linda, who was cleaning her house's windows one day shortly after moving in. "Ha!" called Jenny wryly, making her way slowly across her porch, "I don't think those windows have been cleaned in twenty years!" The impromptu meeting sparked an easy rapport. Linda was impressed by Jenny's matter-of-fact perseverance; even in her nineties, Jenny did odd jobs to supplement her income, ironing clothes, baking bundt cakes, and making egg noodles from scratch. When Linda and Jenny were better acquainted, Linda made a point of visiting every morning to apply Jenny's heart medicine patch. She especially loved Jenny's occasional spunky

outbursts, a favorite provoked one day by her glimpse of some children visiting across the street. "See those kids?" she asked. "I practically raised them, and now they don't even wave at me. Isn't that a bunch of fucking shit?"

Every winter hordes of chipping sparrows would nest in the safety of the dense, old flowering quince in her front yard. It was a large quince even when she moved in. Must have been there since shortly after the house was built. How many people through the years had joyously marked spring's arrival by the opening of its deep salmon blossoms? And the soil! Linda found out from Jenny that the farm nearby had once used the neighborhood lots for sheep pasture. No wonder everything she planted thrived. She found the continuity of her surroundings deeply comforting. Unlike a newly built subdivision, this modest, established neighborhood actually felt like home.

Linda asked Jean to give her first right of refusal should she ever decide to sell the house.

In 2004, a periodic rental inspection by the city revealed multiple code violations. Whether because she was unwilling or simply unable to make the necessary repairs, Jean offered Linda an opportunity to buy the house on contract for $40,000 with only $1,000 down. Linda jumped at the chance.

By the time Jean passed away in 2006, Linda had paid off nearly half the contract loan. Neighborhood property values had been rising, and she had enough equity to qualify for a mortgage. No sooner had the papers been signed than she had a patterned burgundy carpet installed in the living room and bedroom, to counteract the drafty floors; the warm color and traditional design grounded the rooms, imparting a sense of coziness and warmth. She had the house rewired and she painted the rooms, each a different color, which gave each space a distinct personality. Her patience was beginning to pay off.

With help from a close friend, Linda tackled the kitchen. They painted the cabinets—still the original ones, installed when the addition had been built. She had the back door replaced and put down a floating floor in the kitchen and dining room that's a dead ringer for solid pine. She replaced the kitchen sink and counter. She also replaced the house's former front door with one that has a big expanse of glass; it floods the living room with southern light that spreads throughout the house.

Linda replaced the old bathroom sink with a pedestal and had a carpenter build a cedar platform for the still-crude shower so she would no longer have to step down into it and stand on cold concrete.

The most impressive change has been to the house's exterior. With funds from a loan, Linda hired a contractor to install fiber-cement siding over the

OVERLEAF. Today, Linda's home bears little resemblance to the house she first knew as a renter. Over the years Linda has transformed the place, removing the faux-brick asphalt siding, restoring quintessential bungalow elements such as clapboard siding and a front porch railing, and painting the exterior in a cheerful palette. She is particularly fond of the unusual "wings" at either side of the facade.

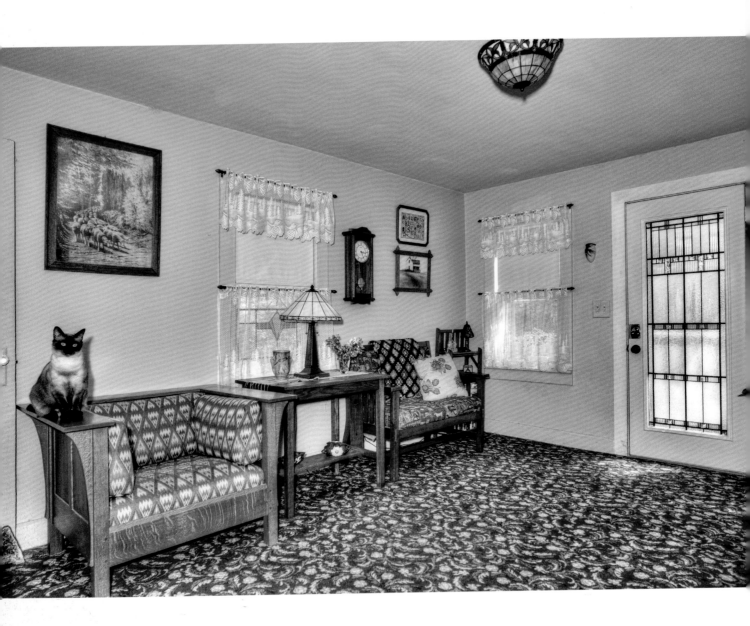

ABOVE. Tillie makes herself at home on a Stickley Prairie Chair. After noticing the piece on an auction website, Linda went to the sale and literally sat on the chair until it came up for bidding. Then, as she says, "I spent all of my Christmas money on it and was broke for weeks."

FACING. The dining room occupies the area originally used for the kitchen.

asphalt-clad exterior. The job was so well done that the fiber-cement is easily mistaken for original wooden siding. Her friend painted the exterior in period-appropriate colors, adding a splash of purple for verve.

The house may be small, but it's not the least bit cluttered. Linda sticks firmly to a self-imposed rule—when something new comes in, something old must go. She reminds herself often that most of us have more space and more stuff than we require.

Linda's persistence, good fortune, and years of hard work have enabled her to create a comfortable home just right for sharing with her husky, Margo, and three cats, Wendell, Wilkie, and Tillie. She feels incredibly lucky. And when the national economy recently took a downward turn, she did not have to simplify her lifestyle, because she had, out of necessity, already adopted one that was affordable.

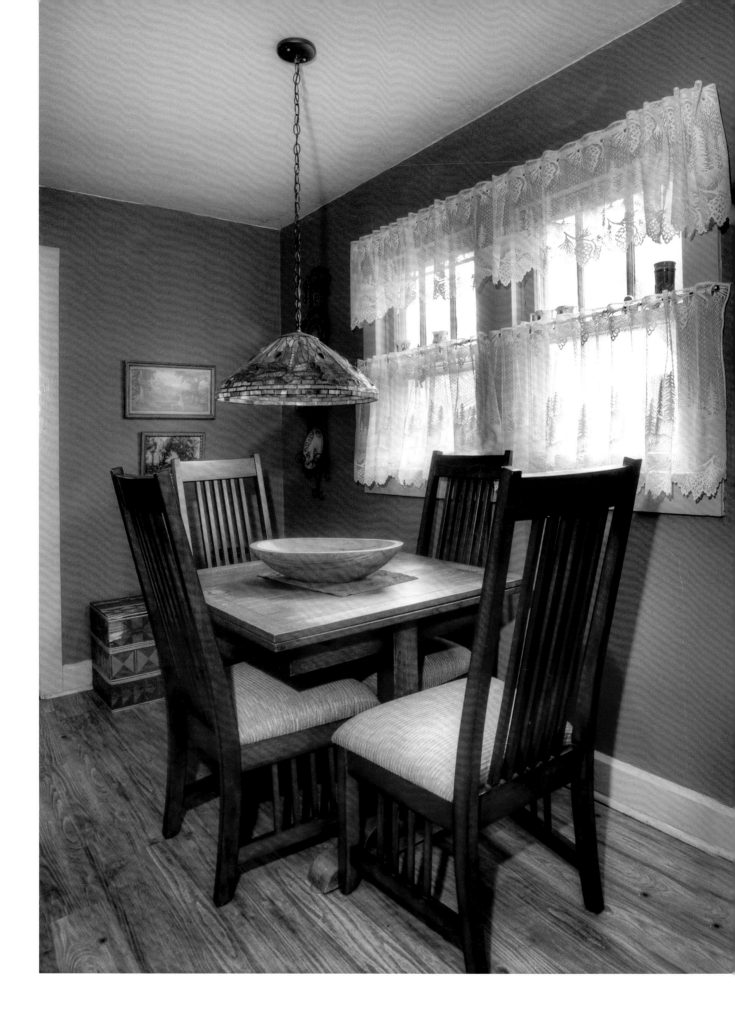

8 SERIAL MONOGAMY

AS A BABY, PEGGY SHEPHERD was put to bed in a shoebox lined with a soft towel. At least, that's what she told me, and she certainly thought she was telling the truth. When I asked her mother to verify the tale, she said it wasn't true—that the story was actually about Peggy's uncle. But I always remembered the story, because there could not be a more potent creation myth to account for Peggy's genius at making a home from meager resources.

Over fifty-five years, before her death in 2007, Peggy made several homes in and around Bloomington, Indiana. "She would buy and sell homes like she would buy and sell furniture," her sister Karen says. "Every house was a project, and when it was done, she couldn't just be happy living there; she had to move on." Architecturally, her houses were very different from one another; one was a house trailer, another a nineteenth-century log cabin, still another an upscale custom home built in the 1980s. For each, she fashioned an interior that was chic, welcoming, and filled with quirky detail. As business partner, with Sharon Fugate, in a home furnishings store called Grant St, she worked comfortably in a variety of styles. But her own homes always settled into an artful mélange of antique, industrial, and rustic elements.

Peggy's furniture, textiles, and decorative objects, most of them found at estate auctions and yard sales or bought inexpensively from dealer friends, moved with her from one house to the next. She seemed able to feel at home wherever she landed, perhaps thanks to the comfort and continuity provided by those familiar things. Everywhere she went, the marble-topped Victorian sofa table, on which she displayed her colorful collection of vintage Japanese and European pottery, would eventually reappear. The leopard-print chaise al-

AT THE TOP of this barn-worthy version of a grand staircase entrance, Peggy installed a handsome pair of salvaged doors.

97

PEEKING through a bedroom door.

But in every case, before the furniture could move in, before the paintings could be hung and the pieces of pottery unwrapped from their protective newsprint packing, there was work to be done—and lots of it.

When Peggy and I first became friends, she was divorced and sharing her home with her high school–age son, Brian. Her daughter, Carie, from a previous marriage, was grown and had left home. Peggy lived in the country, where she was restoring a Civil War–era cottage. The house sat far back from the road, at the end of an undulating velvet lawn. Directly outside the front door was a tiny courtyard with yew parterres and mossy brick paths installed by a previous owner.

The house was small—it couldn't have been more than about 1,000 square feet—and had originally consisted of just two rooms. By the time Peggy arrived, a back porch had been added to accommodate a kitchen and bedroom. There was a small bathroom outfitted with the bare essentials; the pipes sometimes froze in winter, and even when they didn't, the room was almost too cold for bathing. Throughout the house, wallpaper was peeling, the plaster beneath it cracked and crumbling. Peggy had seen past the place's broken down condition to its essential charm.

Over the six or so years she lived there, she went through every room working her magic with hammer and nails, saws, drills, and trowels, often with her then-partner's help. When she had loved the house back into good repair, it felt magical and faraway—a little like going back in time. But the remote location was also a drawback, being so far from Brian's school and friends. For his sake, Peggy decided to move back to town.

This time she bought an 1890s wood frame house on Bloomington's Sixth Street, just blocks from the courthouse square. Brian would be close to his friends, and she would be part of a community

ways crept over to a cozy woodstove or fire, where it communed with other reupholstered antique chairs and couches. Whether she was sleeping on a porch or in a basement—while restoring the rooms inside or upstairs, respectively—she set up her spindly metal bed, which was painted a pale blue-green, draped it with her favorite spread, and surrounded herself with a sumptuous array of vintage rugs and textiles. To these well-loved companions she added industrial light fixtures discarded by warehouses, plant stands crafted from bits of architectural salvage, and room-dividing screens cobbled together from old doors.

again. She could also walk to work; she and Sharon had relocated their store to a building just four blocks from Peggy's new home.

The house abutted an alley on one side and a church parking lot on the other. In front, the lot rose a few feet above the sidewalk and was girded by a limestone retaining wall. A secluded backyard was private enough to feel almost like an outdoor room. The house had two front doors, at right angles to each other. One led into a dining room, the other into the front parlor. Although the rooms were small, their ceilings, which were more than ten feet high, bestowed a gracious air.

Peggy and her partner spent months collaborating on the interior and exterior restoration. While he removed old floor boards to run new wire and pipes, she worked atop a ladder, soaking the walls with an agricultural pump sprayer, then scraping away the many layers of paper. They gutted the bathroom, insulated the walls, installed a shower, and added a washer and dryer. They restored the old windows and doors. When it was finally time to paint, Peggy finished most of the rooms in her favorite colors—"muddy," she called them—ginger, taupe, and taffy white. She painted the trim a shade of brownish aubergine.

The kitchen was blessed with light from the west and south, so it always felt cheerful. Peggy pried layers of sheet vinyl and linoleum off the floor and restored the old pine boards; here, as in the rest of the house, she wanted to preserve the floor's century-old character, so instead of sanding and refinishing, she spent days on her hands and knees rubbing out paint spatters and other marks with steel wool before brushing the floors with a fresh coat of amber shellac. She added bead board wainscot and cabinets, painted them white, and installed a stainless steel counter. On the opposite wall she placed an old pie safe that stored dishware and glasses.

For the stove she chose a long-legged 1920s model, which she had professionally refurbished. Though her other appliances were modern, the vintage stove—a focal point in a prime position—defined the kitchen's early-twentieth-century style. For privacy, Peggy resized a pair of wooden screens with Moorish fretwork patterns, painted them white, and fitted them like shutters over the lower window sashes facing the alley. She augmented her scant counter space with a prized antique butcher's block handed down by her father, who had used it behind the meat counter at his store, Shepherd's Grocery, in the neighborhood where Peggy was born.

She set up her bedroom in a sitting area directly off the parlor and separated from it by a pair of French doors. She hung gauzy drapes over the little panes of glass, which gave her room a feeling of being supremely well ensconced. An Oriental rug in shades of charcoal, rose, and taupe provided

FACING. To preserve the sense of being in a barn, Peggy kept the main floor as open as possible, using clusters of furniture instead of walls to suggest room-like spaces.

softness for bare feet in the middle of the night, and a Deco-era dresser held clothes.

Just after Christmas in 1997, Peggy's father was diagnosed with a brain tumor. He died the following year. Peggy had always adored her father; to her, he represented everything decent and good. He was kind, hard working, and an accomplished part-time builder who had constructed two new houses and restored four old ones, in addition to a log cabin. He had passed on to Peggy his love of such projects, as well as many practical skills. "She got her ambition from the best," remarks her mother.

As though losing her father wasn't wrenching enough, just several months later her former husband died of a heart attack. To see her son lose his father at such a young age was devastating. The losses threw everything into new perspective. The lingering ambivalence she had felt about her personal relationship now became an indictment; life was too short for half measures, too precious for anything less than wholehearted commitment. She and her partner separated.

By the time Brian was in college, she had realized it was time for another project. She put her house up for sale, and in the end Brian bought it, keeping it in the family. An acquaintance who ran an antique store north of Indianapolis had told her about a nineteenth-century timber-framed barn that had to be removed from its setting. After some investigation, Peggy decided to purchase the barn and convert it into a house. She bought a few acres in a secluded rural spot—the land was mostly woods, with a storage building and a reed-fringed pond—and began preparing the site. In the meantime she rented an apartment behind the old theater in Gosport, a small town nearby, but after several months she moved in with her mother, so that she could devote the funds she had been paying in rent to her construction project.

The barn conversion took three years and was the most ambitious house project of her life. With a footprint of some forty-by-forty feet, and thirty feet high at the peak of the ceiling, the structure was like a gigantic 3-D puzzle. Peggy acted as general contractor and hired several subs. Together, they figured out how to reassemble the massive, hand-hewn posts and beams and convert the barn's skeleton into a comfortable house. The main floor would be open-plan, with specific areas for cooking and dining, in addition to a great expanse of versatile living space. There would be one and a half baths, in addition to a laundry room, two bedrooms, and a loft-style guest room with a dramatic view across the ground floor. To preserve the barn-like character, she would use salvaged wide-plank floors, bead board walls, and a plank ceiling, and turn some of the original wooden barn siding into decorative panels for kitchen cabinets.

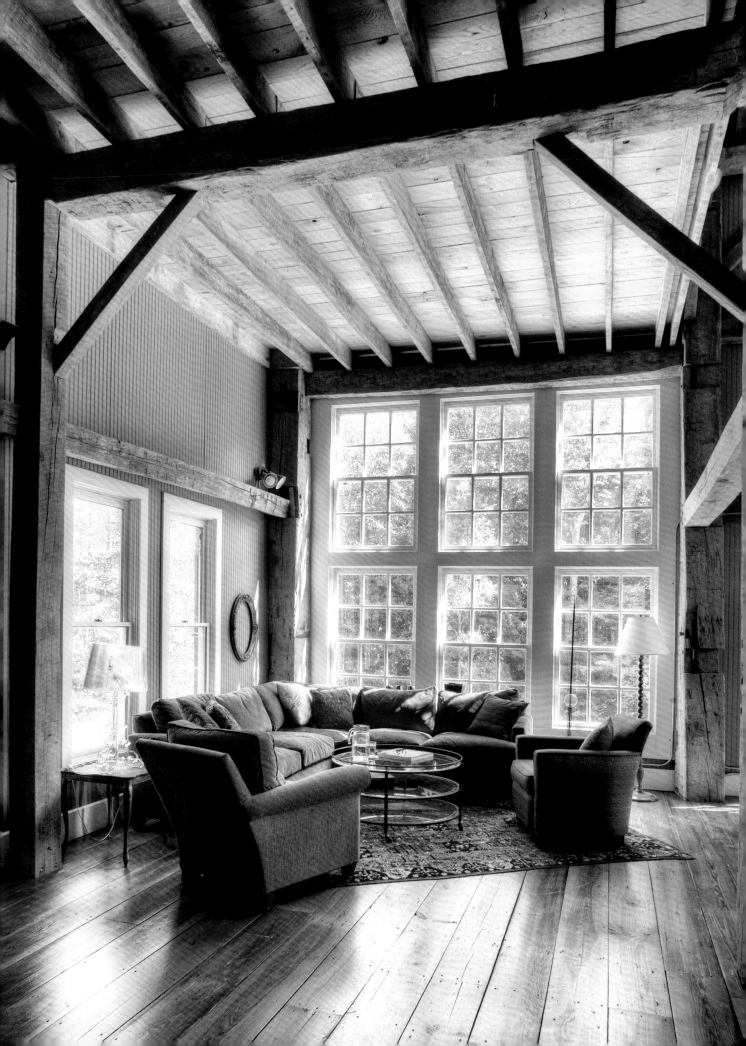

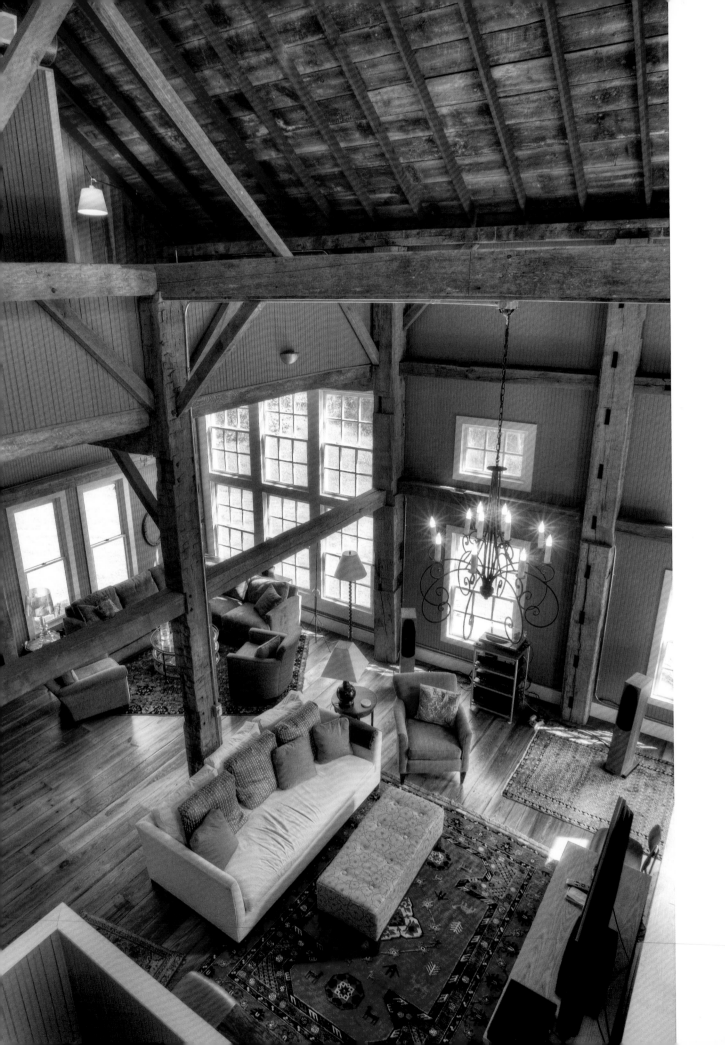

Elated, she embarked on the construction. That spring, torrential rains turned the site into a muddy bog, slowing progress for weeks. The building delay was especially exasperating because she was financing the project partly with a high-interest construction loan and knew she had no time to waste.

With a walk-out basement excavated and the foundation for the structure poured, work began on the barn proper. As soon as the structure was weatherproof, she moved into the basement. The walls were still plain concrete, bearing the marks of their forms. The house had no running water, but there was plenty of privacy to perform bathroom functions outdoors. She put rugs on the concrete floor, brought in her bed, and set up screens to differentiate spaces for sleeping and entertaining guests. With some choice old cupboards and industrial stainless steel shelving units, she set up a serviceable kitchen. She had a fridge, a crock pot, and an electric hotplate for cooking.

Gratefully aware that she could always go home to her mother's, she saw camping at the barn as an adventure. She started her days with exercise and a swim in her pond. She cut up meat and vegetables and stirred them together with broth and herbs in the crock pot so that dinner would be ready by evening. On days when she worked at the store, she dressed up and drove to town. The rest of her time she stayed at the barn, working side by side with her carpenters, plumber, and electrician. She did whatever was necessary—sourcing materials, making decisions, stripping paint from old house parts, running floorboards through a planer, and mowing the grass.

At one point she invited a mutual friend and me over for lunch in her basement dwelling. She fluttered and glided around her makeshift kitchen, serving soup, pouring tea, slicing the pineapple upside-down cake her mother had kindly prepared for our lunch. She was a homemaker in the truest sense of the term.

She had her carpenters cover the barn timbers with an exterior skin of insulated panels, which they sided with poplar boards and battens. They installed the windows she had bought on clearance, arranging them in harmonious groupings sorted from mismatched brands and sizes. Though she wished the barn could be roofed with metal, she couldn't find a contractor willing to install a steel roof on a sharply pitched structure so high off the ground, and she eventually settled for conventional asphalt shingles. She used salvaged doors and other house parts wherever doing so made sense, and for the bathroom and kitchen she had cabinets made with old doors, drawer faces, and hardware.

Since nothing was standard, either in terms of dimensions or aesthetic conception, every step of the barn conversion proved distressingly labor intensive. She faced repeated cost overruns as her builders tackled unforeseen

FACING. Looking down across the main level from the balcony upstairs affords a sense of the scale of Peggy's undertaking.

and unfamiliar challenges, and more than once she had to extend her line of credit at the bank. Her professional situation added to her financial insecurity; when the building that housed Grant St changed hands, she and Sharon agreed to close the store. Peggy emerged with some cash but no job, and, after briefly savoring her liberation, began exploring possibilities for new ways to earn a living. She worked as a substitute teacher, did some professional gardening, and consulted with clients on interior design.

Throughout the project, she had been paying for everything herself. There was no partner with whom to share even basic living expenses. As the barn changed from a busy construction site into a home, she felt its largeness in a new way. The place wanted to be shared. She loved to cook and care for others—children, family, friends—but she was living there alone. House-rich and cash-poor, she tried to come up with a way to make the property pay for itself. Perhaps she could run a spa, or a country retreat? Should she rent the main part of the house and set herself up in the basement? Audaciously, she had created a place that inspired superlatives. Unfortunately, it now also appeared beyond her means. If something didn't change, she would have to sell.

Meanwhile, she pursued other income-producing work. She flew to France for a meeting with a prospective employer at an organic cosmetics company. She discussed possibilities for managing a retail store that an acquaintance planned to open. She strove to maintain a positive outlook and appreciate the blessings of her everyday existence. And for all it had cost, the house, with its sylvan setting, majestic proportions, and sun-washed rooms, did its own part to bolster her spirits. Despite repeated challenges and setbacks, she had turned her vision into reality. It was a remarkable achievement.

On a hot summer day in 2005, Peggy cleaned out her mother's garage and drove a load of waste to the county landfill. As she emptied the bed of her mother's pickup, she watched a vintage 1940s truck back in beside her. She recognized the driver when he got out to untarp his load. They had gone to high school together and had even double-dated, but they hadn't seen each other in years.

"Mick, that's the coolest trash truck I've ever seen!" she shouted across the lot.

"I looked up, and it was Peggy," remembers Mick Harman. In the decades since high school, he had married, had three children, and divorced. He earned his living in construction and had an unusual avocation, breeding Percheron Morgan horses that he sold to the U.S. Army for use in funerals at Arlington Cemetery.

He asked if she needed help, but through force of habit, she said no. She had spent a lifetime willing herself to be strong. Only one time did I ever hear

her confide a secret longing for the luxury of letting down her guard now and then—of having the care and comfort of a protective, providing man. Self-reliance had become second nature.

They chatted a few minutes, but since she didn't need his help and was clearly busy, he said goodbye and left. A few days later he came across her sister and brother-in-law and inquired whether Peggy was seeing anyone. They didn't think so. He called Peggy's home several times over the next week, and finally she answered the phone. That Friday evening they went for a walk and became reacquainted. She told him about the houses she had restored, and a couple of surprising coincidences turned up. Years before, he had built a shop for a customer in Owen County. The road to the jobsite had taken him past a tiny old house, where he had often seen a woman working outside; she had caught his eye because it was unusual for a woman to be working in construction. That woman had been Peggy. A few years later, he had built a shed for a professor who lived in a historic house in Bloomington. Now he was astounded to learn that Peggy had been living in the house whose backyard bordered that shed while he had been building it. Somehow, through all those years, they had lived in the same community but managed to escape each other's notice.

I spoke with Peggy for the first time in months a few weeks later. When I asked how she was doing, she answered, "I have Stage Four colon cancer that has spread to my liver, and"—her choice of conjunction was notable—"I'm in love." She was clearly overjoyed to be with Mick, and her happiness had her determined to endure whatever treatment should prove necessary. She read books on alternative medicine, drank filtered water, and spent weeks living on fresh, homemade vegetable juice. At the same time, she underwent the various types of conventional treatment her doctors recommended.

One evening she and I drove to dinner at the home of a mutual friend. Peggy was upbeat as she recounted her latest news. Her doctors recommended surgery, to be followed by chemotherapy once she had recovered sufficient strength. The chemo would likely result in the loss of her hair and a bout of acne. With typical spunk, she added, "The last time I had acne and no hair I was a baby. At least this time I won't be toothless." On the drive home, she shared a bit of prognosis from the doctor—"It won't be the colon cancer that kills you, though it could be the liver cancer that will."

"It won't be *cancer* that kills me," she said defiantly. "If I'm gonna die, I'll die on the back of a bucking bronco."

The week before her surgery, she and Mick took a trip to Ohio, where he had to deliver a horse and attend a sale. After that, he says sadly, her health

FACING. After a long, hot day
of construction, Peggy went for
a swim in her pond.

deteriorated. She did find a couple of appreciative buyers for her house; since they were not in a position to move in until the following spring, they were happy for her to stay on a while.

I last saw her on a spring day in 2007. Our mutual friend had driven with me to the hospital in Indianapolis, an hour away. By then, Peggy had been in the hospital for a while; Karen, her mother, and Carie took turns driving to the city to keep her company at night, sleeping beside her in a recliner. Sometimes Sharon, Peggy's former business partner who had become one of her closest friends, went up to give the family a break. When we last saw her, she had lost a lot of weight and much of her lovely blond hair, but none of her gracious and feisty spirit.

Several weeks later, the hospital sent her home. There was no more they could do. She spent her last days in her old home on Sixth Street, where a memorial was held the following week in her shady backyard.

The story about the baby in the shoebox was simply misremembered. Peggy's uncle had been born prematurely, and, as Peggy's mother recalls, "The doctor just laid him back on the bed and said, 'He won't make it.' He could fit in a shoebox," she continues, "and a tea cup would fit on his head. He grew up to be a handsome young man and was killed in Okinawa during World War II."

9 THINKING INSIDE THE BOX

SUSANN CRAIG'S INDUSTRIAL LOFT in Chicago grew out of a serendipitous encounter. In the 1990s Susann was living in a three-story brick townhouse originally built for faculty and staff of McCormick Seminary. She and her husband, Scott, had purchased the house in the '70s when the seminary relocated to Hyde Park.

By 1993 Susann no longer needed a six-bedroom house. She and Scott had divorced, and their two grown daughters had left home. Periodically, she rented a room to students at DePaul University, and that spring she once again posted a For Rent ad on a campus bulletin board. She received a reply from a young woman named Jeanne who was in Chicago for the summer. A midwestern native, Jeanne had just graduated from Harvard with a master's in architecture and was in town for a few months before leaving to take a position with a firm in the Netherlands. She was the same age as Susann's daughters, Jennifer and Amy. Polite, intelligent, and responsible, she seemed an ideal tenant, so Susann agreed to rent her the room.

Their acquaintance deepened into a friendship over the summer. Susann admired Jeanne's focus, her ambition, her engaging intellectual curiosity. After earning a bachelor's in architecture at the University of Illinois, Jeanne had spent two years in Zurich studying urban design before going on to Harvard. At summer's end she would be heading off to work as a lead designer in the studio of Rem Koolhaas in Rotterdam.

Susann took an almost maternal interest in Jeanne's plans. She relished the conversations that grew out of their chance domestic encounters, in the course of which the two discovered they shared a passion for art. After Jeanne left, she and Susann kept in touch by mail.

A BASKET OF DOLLS occupies part of a shelf in the wall formed by a bookcase between Susann's bedroom and the main floor below. A few of the dolls are Asian and belonged to Susann's aunt, who lived in China. The hairy-looking one at the left is made of Spanish moss.

Susann has been interested in art for almost as long as she can remember. In the late '50s and early '60s she did graduate work in art history at the University of Illinois, where she formed friendships with a number of midwestern artists. She later worked as assistant director of Chicago's Dorothy Rosenthal Gallery. As much as she appreciated artwork, she found the politics and pretension of the art world off-putting and eventually decided against long-term involvement in the gallery business. In the early '70s she taught art history at the Chicago Academy of Art, and she later held a staff position at Columbia College, where he worked with students to compile a directory of traditional artisans—crafts-people whose skills had been passed from one generation to another. Susann later curated several shows of these artisans' work at Columbia College, the Chicago Cultural Center, and regional libraries.

Over the years, Susann developed a special appreciation of work by artists who lack formal training and operate beyond the mainstream art world, a category now known as outsider art. She first encountered the genre during graduate school. She and Nathan Oliveira, a visiting professor from Stanford with whom she had developed a friendship, were driving around one day randomly exploring alleys, antique shops, and anything else that caught their fancy. They stumbled across a residential yard filled with odd wooden structures, many of them covered in words—a scene of quirky creativity that was clearly the product of obsession. Intrigued, they knocked at the house, where they were met by a man in his seventies. The work was his, he told them; he had constructed every piece in his wife's memory. When Nathan and Susann asked whether they could purchase some pieces, he refused at first but eventually agreed, realizing that the two strangers had a true appreciation of his project.

Susann's interest in outsider art was deepened in 1973, when her husband was on a year-long assignment in New Orleans. In the Larry Bornstein Gallery on Royal Street, Susann saw the paintings of Sister Gertrude Morgan, whose images melded technical naïveté with striking spiritual vision. Dressing only in white and insisting she had two husbands—God *and* Jesus—Sister Gertrude, who spent her days as a street preacher in the French Quarter, used her paint-ings and her megaphone as tools of religious declamation. She drew oversized charts mapping out predictions in the Book of Revelations. She painted "The New Jerusalem" in terms of a cross-section through an apartment building. She portrayed the experience of being mystically transported in a piece entitled "Jesus is my airplane." By the early '70s, her impassioned oratory and depic-tions of religious scenes had made her a local celebrity. The work was colorful, graphic, and a powerful expression of conviction by a woman who dwelled in a kind of parallel universe. Susann found it utterly compelling.

When Susann began collecting, outsider art was still a field without a name. The elements the genre would comprise—naïve paintings, folk art, and work

AROUND A CLAWFOOT TUB is a curtain made by Jeanne Gang's mother from stainless steel threads. Translucent tempered glass surrounds the shower, barely visible beyond the curtain.

by individuals whose drive to creative expression far outweighed their lack of training—were just beginning to be acknowledged by the art establishment and were still almost entirely ignored by dealers. Susann didn't care. She began collecting whatever she loved and could afford, buying directly from artists. Over some fifty years she amassed an impressive collection of works in varied media—some traditional, such as paintings on canvas or figures in wood; others completely unconventional, such as a gaggle of geese with painted wooden heads affixed to bodies made from discarded oil cans, or a set of houses made from thousands of bottle caps strung into tube-like strands, then wired together to form structures. In conjunction with several friends, Susann worked to establish a non-profit organization to promote awareness and understanding of outsider art. That organization, Intuit: The Center for Intuitive and Outsider Art, was founded in 1991.

But Susann's collection is not limited to outsider art. Over those same five decades, she acquired works by contemporary photographers Aaron Siskind, Art Sinsabaugh, and Patty Carroll, in addition to artists with formal backgrounds and serious reputations, such as Ellen Lanyon, Seymour Rosofsky,

Linda Kramer, Hollis Sigler, and Roger Brown. She also amassed a substantial craft collection encompassing pottery, textiles, and Native American porcupine quill boxes.

Innumerable pieces from these disparate genres were spread throughout her townhouse, where they hung on walls and covered every available horizontal surface. But the eclectic, unconventional collection was out of sync with the traditional domestic architecture of her nineteenth-century home. She thought about moving to a place more suitably sized for a single person, where she could truly live with her collection and do justice to the work of the artists who had produced it.

When Jeanne returned to the United States, she made a beeline for Chicago, where she intended to establish her own architectural firm. Within days of her arrival, she was back in Susann's living room, catching up on news and sharing the portfolio of designs she had done for the Office for Metropolitan Architecture in Rotterdam. The buildings were unlike anything Susann had ever seen or imagined. Jeanne played with steel and concrete, glass and stone as though these materials were sophisticated toys. She bent buildings or stacked them like blocks, often quite literally turning design conventions inside-out. In Jeanne's hands, lofty ideals and legally mandated codes were confidently transformed from architectural impositions into elements of aesthetic desire.

Susann was stunned by the portfolio. "I got goose bumps looking through it," she remembers. Eager to help Jeanne establish professional relationships in Chicago, she began introducing her to architect friends and others she thought would be interested in meeting Jeanne and viewing her work.

Jeanne took a position with a firm while she laid the foundations for her own business. She and her then-boyfriend, Mark Schendel—now her husband and business partner—began searching for a space to use as home and office. While bicycling around the Logan Square neighborhood, they happened on an abandoned undergarment factory that was being converted into lofts. The developer of the site was willing to sell the kind of unfinished space they needed. A quick visit revealed the property would not be right for them, but Jeanne thought it might provide the ideal blank canvas on which to design a new home for Susann and her larger-than-life art collection. Eager to take on a challenge in her own name, she suggested the idea to her friend. Susann was thrilled, as well as honored to provide an opportunity for Jeanne to show her talent.

The two collaborated closely on the design from the start. On the top floor of the three-story brick building, the space was tall enough to accommodate two levels, so Jeanne designed a half-story upstairs that would overlook the living and dining areas and be accessed by a squared spiral staircase. A large

THE SQUARED SPIRAL STAIRCASE was inspired
by a similar one designed by architect Lina Bo Bardi,
who has worked extensively with primitive indigen-
ous Brazilian construction methods.

FACING. Susann's kitchen, seen here at the left,
can either be part of her home's public space or
closed off from it by a sliding panel. The kitchen is
small but perfectly functional. The zinc counters
tend to show stains, which troubled Susann at first,
but she has since come to appreciate such signs
of wear as a happy form of patina.

bank of north-facing windows offered a view that
was not particularly inspiring, so instead of install-
ing a conventional balcony, they reimagined the
entire balcony concept and decided to create one
inside the apartment. A sliding panel in the roof
would open to the sky, bringing a shaft of light into
the center of the living space. Instead of enclosing
this shaft with conventional walls, Jeanne encased it
with glass panels in different finishes—some clear,
some frosted, some opaque—which have different

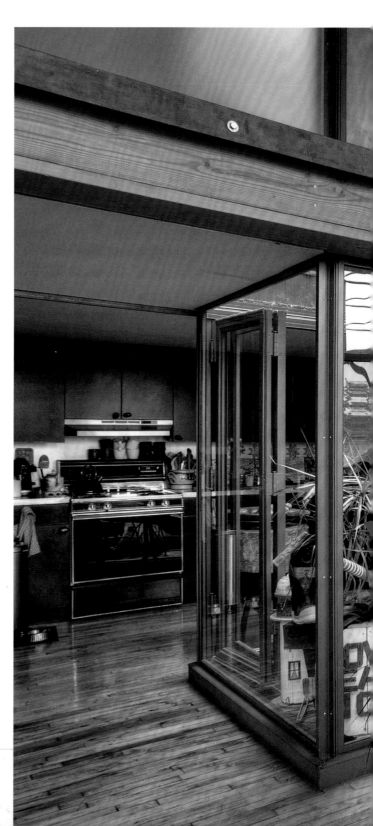

effects on the spaces around them, producing an element of mystery and playing with the sense of spatial openness versus separation. A drain in the slate floor gets rid of water from rain or melted snow.

Jeanne positioned the kitchen behind this interior balcony and placed elements of the upstairs bathroom around it, with the water closet set behind a regular solid wall. To maximize Susann's second-floor living area and incorporate windows with views to the west, Jeanne designed a bedroom and dressing area over the building's public hallway. The bedroom, which overlooks the living room downstairs, is hidden behind a wall of built-in shelves. The dressing area includes a room-size closet with

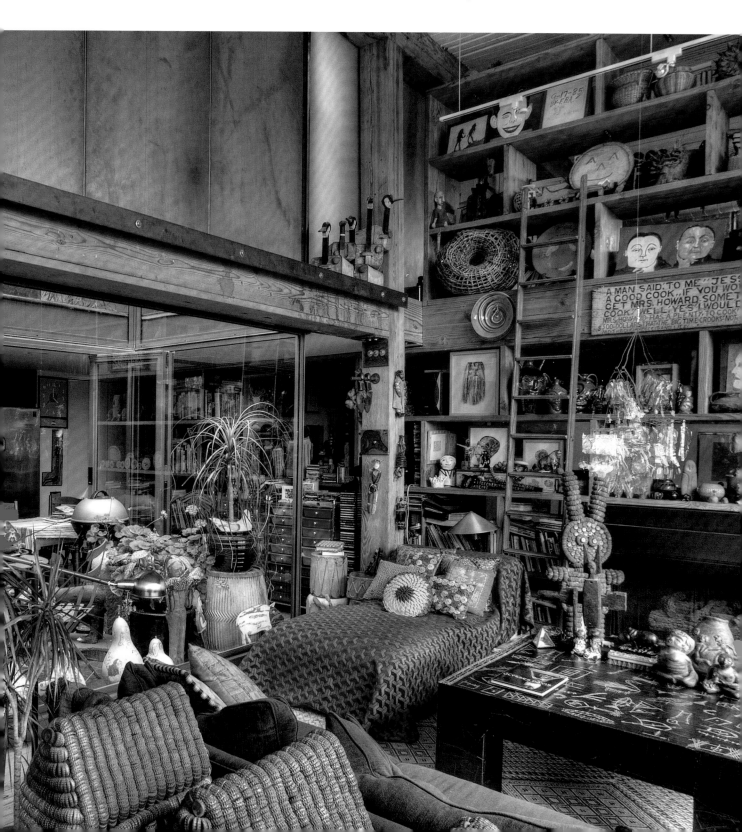

THE OLD BRASS BED came from a farm sale in Michigan. Susann bought it for just $50—perhaps because it was covered with paint. The quilt is sewn from hand-woven Guatemalan fabric that she and her daughter Jennifer bought while working in Guatemala.

five rolling racks to store the clothes and accessories Susann amassed during the thirty years she represented the work of several clothing and accessory designers, including Eileen Fisher and J Morgan Puett, at Chicago's Apparel Center.

"Probably the most important thing about Susann is her collection of outsider art," says Jeanne, who wanted to provide a variety of spaces and surfaces where the works could be displayed. The basic loft had only four walls, so Jeanne created other vertical elements that would be flexible and fun. At the entry to Susann's apartment she created a transitional vestibule to make coming home more personal and gradual than walking in directly from the building's shared hallway. The "wall" differentiating this entry space from the living room and kitchen consists of a massive set of backless wooden shelves, which allows for objects to be positioned facing either direction.

Working with the factory's original timber column and beam structure, which bisects the overall space, Jeanne designed a sliding steel "wall" of screens that can be used to separate large areas into smaller, room-like

spaces, or alternately pushed against the outside wall to produce an open feel. The screens, which slide on industrial tracks, are perforated so that art work can be hung on them.

Susann sold her townhouse and moved into the loft in 1997. She had been so intimately involved in the design that moving in was almost anti-climactic. Still, she says—and this after thirteen years—"There is hardly a morning when I don't think how lucky I am to be living here." But she takes special pleasure in her home because of her close friendship with its designer. Not only did their friendship survive their client-profes-sional relationship; it was enriched by the experience. In the years since, Jeanne Gang has built an architectural practice employing some thirty-five full-time staff whose portfolio of projects spans the globe and includes Aqua, the award-winning eighty-two-story multi-use high rise in downtown Chicago—the tallest building ever designed by a woman.

OVERLEAF
Against a brick wall hang some of Susann's necklaces. (Susann describes herself as a "recovering beadaholic.") The neon sign was designed years ago for her showroom at the Apparel Center; when she closed the showroom, "being someone who never throws anything away," she turned the sign to new use as a night light.

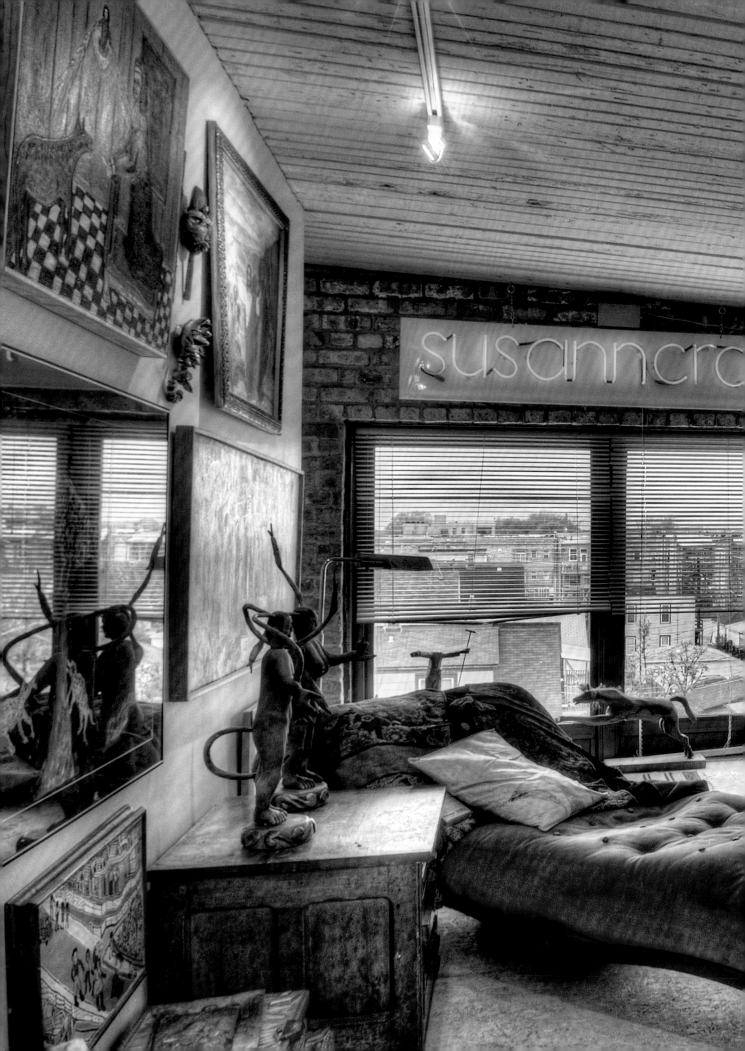

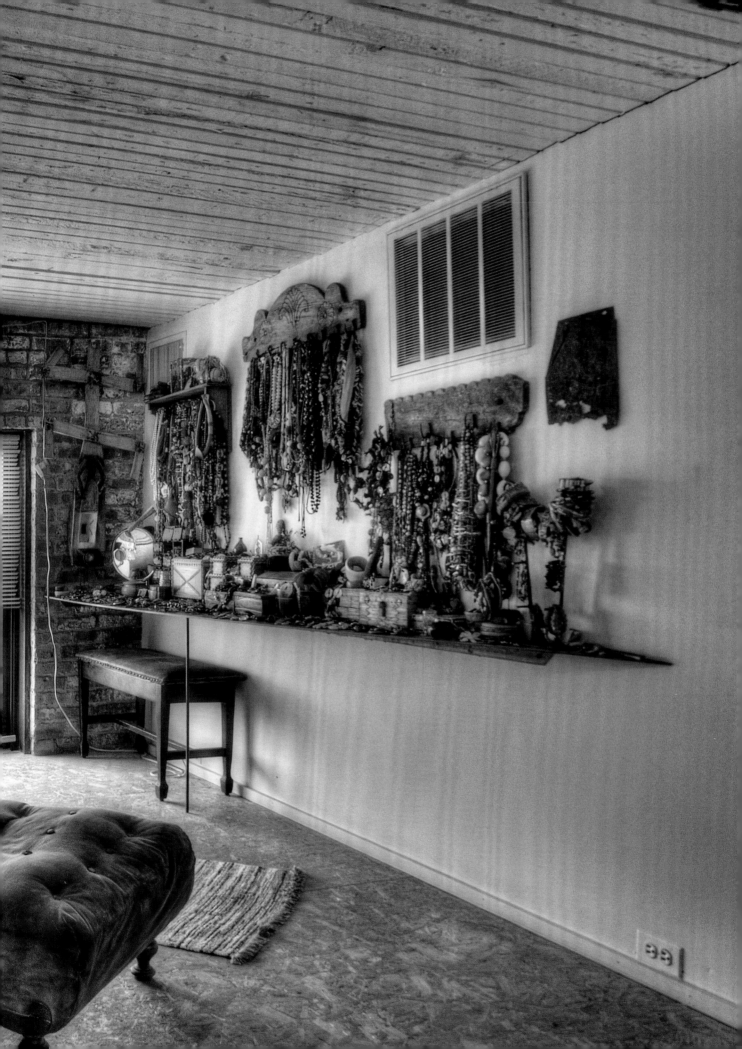

10 GRATIFICATION DELAYED

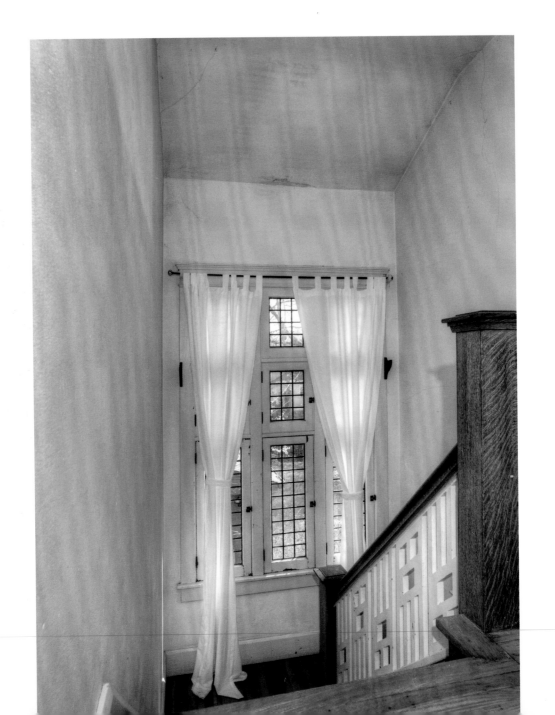

SHELL PINK PETALS flutter groundward from a magnolia, carpeting the patched asphalt drive in velvet. Hidden behind the veil of falling flowers stands a house whose red tile roof, stucco walls, and timbered front porch speak powerfully of stability and home. A window in the old front door tempts a glimpse inside—until you realize that indulging your curiosity would mean entering a corner clearly intended to be private. Likewise, you can picture yourself conversing with friends over gin and tonic on the covered porch, until you notice that the enticing, room-like space can only be reached from the home's interior, through a pair of slim French doors.

The house beckons and resists—a lovely place, and unmistakably loyal to its owner.

This push and pull of conflicting architectural messages perfectly expresses the house's present situation. A century after it was built, its owner, Nancy Hiestand, cannot make her home there—at least, for now. She lived there several months some twenty years back, before taking a job in a town fifty miles to the south, where she could raise her children after she and their father divorced. Since then, the house has sheltered a succession of tenants and is currently home to a single man in his thirties.

Nancy works as the program manager of historic preservation for the City of Bloomington, Indiana, a position she has held for thirty years, and one that often requires her presence for considerably more than forty hours a week. With scant resources other than her own time on weekends, vacations, and holidays, Nancy has determinedly held on to her tile-roofed house, antici-

STAIRCASE, Indianapolis.

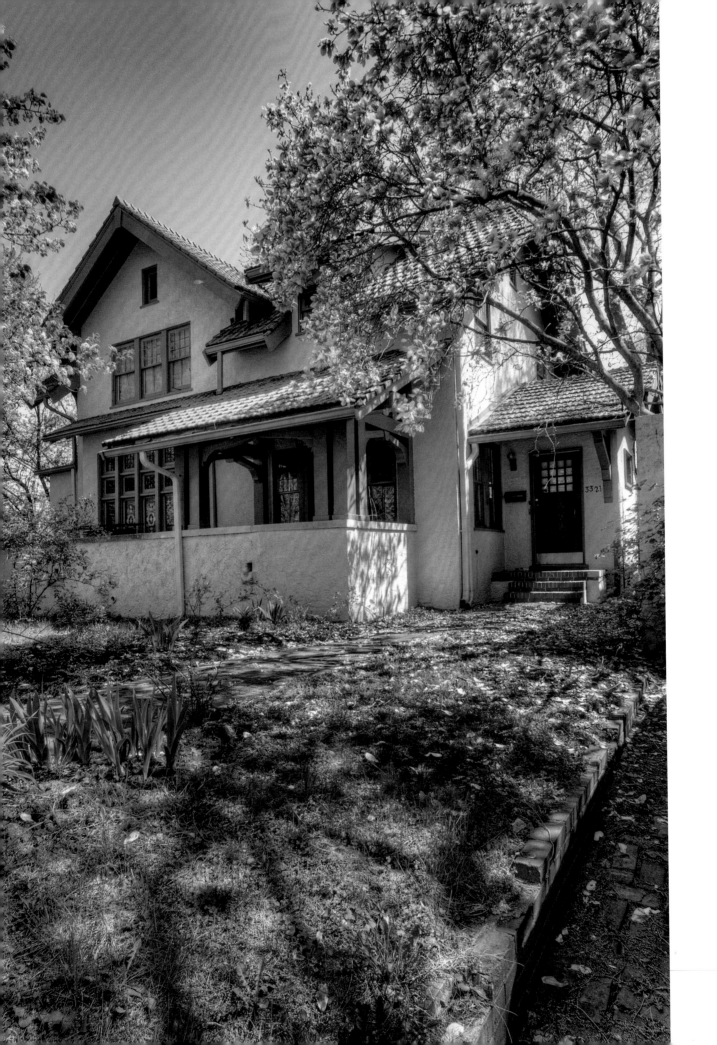

pating the day when she will once again call it home. For two decades she has packed a lawn mower and yard tools into her car and driven more than 100 miles roundtrip to weed and mow, fix leaking pipes and broken window panes, and generally care for the place. In 2002 she paid a small fortune to have several square feet of original roof tile repaired. In 2007 she attended her fortieth high school reunion with a bad case of poison ivy following a massive onslaught on the backyard vines the previous weekend. She found the original cast-iron porch light in the basement and had it sandblasted, rewired, and installed. And in 2009 she had the house's exterior painted. She is now 60 and looking forward to moving back when she retires, though she is not sure when that will be.

Nancy grew up on the north side of Indianapolis. Her parents, both orphans, had met at Shortridge High School on 34th Street, the oldest public high school in Indianapolis—and, incidentally, Kurt Vonnegut's alma mater. The school is housed in an iconic buff brick building constructed in the 1920s and listed on the National Register.

Nancy's parents bought a spacious house at Washington Boulevard and 48th Street. Her mother was a nurse at Methodist Hospital, her father an engineer at Curtis Wright, a World War II aircraft manufacturer, then later at a branch of Link Belt that fabricated industrial bearings. Their neighborhood had been developed as the city spread northward in the '20s, fueled by growing industries—publishing, pharmaceuticals, automobile manufacturing. The area was solidly middle-class, the architecture standardized, if not to the cookie-cutter degree of recent decades. Inside, the houses featured embellishments designed to express their owners' prosperity—leaded glass windows, with their aura of old-world culture, and formal staircases fitted with wrought-iron balusters straight out of Hollywood.

They had their first daughter in 1942, and Nancy followed seven years later. The girls went to neighborhood schools, took piano, ballet, and dancing lessons, and attended Shortridge High School. Nancy, in particular, was struck by the area around the high school. It was older than her family's neighborhood and characterized by dramatic architectural variety. There was something exotic about the houses' individuality and eclecticism. A tenth-scale Tudor mansion could sit right next door to a modest Craftsman bungalow, across the street from a prim Colonial Revival and a bohemian, stuccoed casita. Nancy's father took his daughters on Sunday drives to look at houses—the new, the old, the ones that made them "ooh!" and "aah!"—and she suspects his fascination, especially with the old ones, "leaked in . . . under the foundation." She can clearly remember waiting for the bus after piano classes, not fifty feet away from the house she now owns.

FACING. Located in an early suburb of Indianapolis, the house is part of an architecturally eclectic early-twentieth-century neighborhood.

Nancy met her husband when they were lab partners in a chemistry course at college. After graduating, he went to work for Burroughs, which was turning its operations away from old-fashioned adding machines to the new world of computers. Nancy became a letter carrier and recalls that she read Proust's *Remembrance of Things Past* in the back of her delivery truck, ensconced amid the bulging bags of mail.

In 1978 her husband won a promotion that took the couple to Norristown in southeastern Pennsylvania. Nancy continued working for the post office, and they bought a 1911 house with Flemish-bond brick siding. Three years later Nancy gave birth to their daughter. Motherhood had not been a priority among her ambitions. Now, one by one, its implications—physiological, logistical, and, most profoundly, existential—crept up on her. Life was no longer about her, or her marriage, or her house, or her job. From now on, her most urgent responsibility would be to their child. She took up quilting and calligraphy and mastered the art of changing cloth diapers.

Over the years, Norristown had poured outward across the rolling farmland, consuming old houses, barns, and other structures that stood in its way. Some met the wrecking ball; others were simply enveloped by alien architectural forms. Among the latter was the 1794 Selma Mansion. Originally an estate of many acres, Selma's land had been sold for development, leaving the two-story Federal structure bereft in its new setting. In 1983, when the last surviving member of the owner-family died, the Mansion was put up for sale. Nearly two centuries old, the place was in poor shape, especially since its maintenance had been neglected in recent years. A property developer was hoping to demolish the house and put a Burger King in its place.

Nancy, who had grown up in the Midwest, was appalled by the prospect of seeing a house of such clear historical significance tossed away like a piece of trash. Her outrage was intensified by a visceral sense that the past deserves to be honored, not least as the source of the present. Pregnant with her second child, she had just lost both her parents, who died within four months of each other. She yearned for a sense of continuity, even if permanence was unattainable.

Along with several acquaintances, she co-founded the Norristown Preservation Society. She had always been shy and reserved, but her newfound cause sent her boldly knocking on doors, soliciting signatures from strangers willing to oppose Selma's demolition. If she couldn't save her parents, she would do her damnedest to save that house. Looking back, she recognizes how the struggle for Selma galvanized her emotions and helped her survive an extremely painful period. Selma was saved, and Nancy became an ardent advocate of historic preservation at the same time as she became the mother of a son.

In 1987 Nancy's husband was transferred to Indianapolis. While he finished up his work in Pennsylvania, Nancy drove to Indiana to look for a house. She had carte blanche to pick a place, partly because they expected this house to function as something of a landing pad until they were firmly settled. She found a property, not far from her childhood home, that seemed ideal for raising children and promised to be an easy sell when they were ready to move on.

The family lived in that house for five hectic years. With her daughter in elementary school and her son in diapers, Nancy embarked on a master's program in urban planning at Ball State University, forty-five miles away. Nancy took the baby with her to the school, which operated a Montessori-type childcare facility as part of its teacher training program.

But ever so slowly, Nancy began to feel a creeping claustrophobia. She needed—even if it would be a long time before she could articulate the sensation—to be by herself, to find out what she was really made of. Her symptoms manifested themselves in numerous ways, and in 1990 she and her husband were divorced. At first she stayed on in their house, and he got an apartment. When Nancy decided not to keep the place, he purchased her share. It was a wrenching time, between the demands of graduate school, mixed emotions about divorce, and the daunting prospect of being a single mother. Yet there was also something liberating about her situation—at least, that was how she felt on those special occasions when she allowed herself to consider the positives.

Now she was free to look for a home of her own, and she knew just where to find it—in the exotic neighborhood where she had gone to school and taken piano lessons as a child. The area had come down a few notches from its once-fine standing. It was noisy, dangerous, and unkempt. Many properties had been turned into rentals. But one happy result of these changes was the neighborhood's new affordability.

Once she had secured a realtor willing to show her houses south of 42nd Street—an area most seemed reluctant to enter because of its reputation for crime—she was giddy at what she found. She describes house-hunting there as akin to the sensation of "going into a French pastry shop with a hundred dollar bill." She pared her interest down to two properties. Both had fabulous roofs—one slate, the other tile—uniquely designed windows, lovely woodwork, and unusual interior spaces. In the end, she based her decision largely on concern for her children's well being; the house she rejected was on a busy street that could have posed a danger.

But a second factor, too, underlay her decision. Like the safe, transitional house in which her family had spent the preceding five years, the one Nancy rejected had already been fixed up. She could have moved right in. In contrast,

OVERLEAF. Nancy's house has striking architectural features, such as the leaded glass windows, elaborate moldings, and enchanting interplay between rooms, seen in this view from the living room to the dining room.

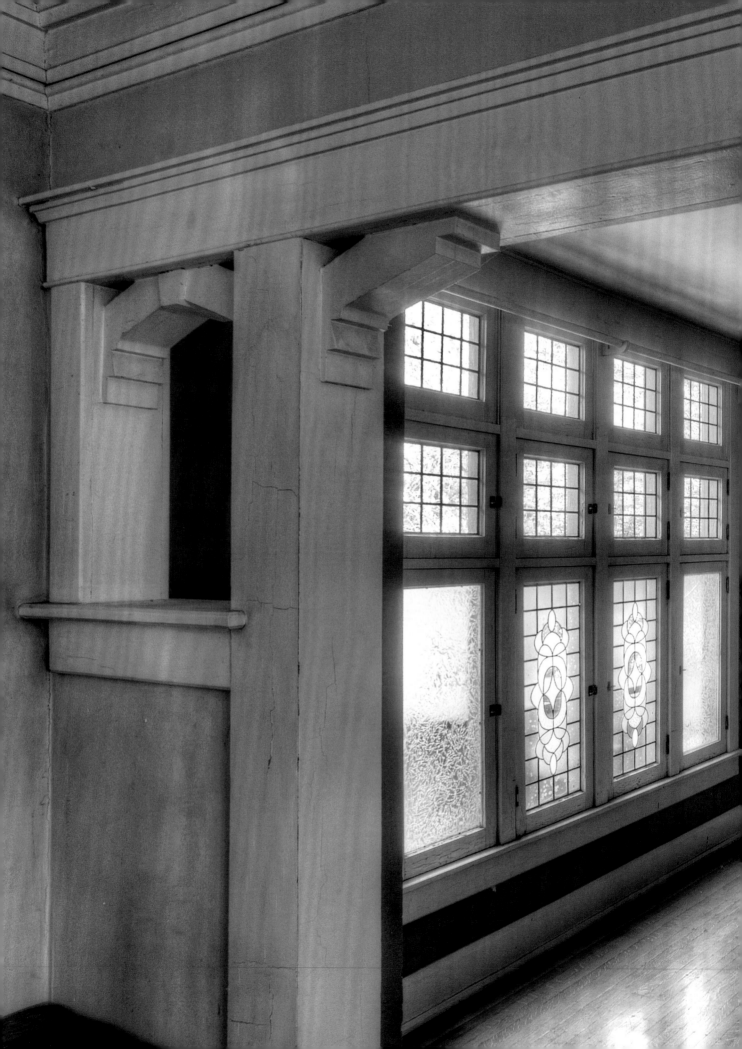

the house she bought was in need of help. She didn't want a place that was already done. She wanted to be part of the restoration.

She closed on the purchase in June 1990 while working on an internship at Ball State. She bought the property outright, using proceeds from the divorce settlement, since she knew she could not afford—or for that matter, even obtain—a mortgage, given her circumstances. She was so nervous at the closing that she could scarcely steady the pen to sign her name. Buying her house seemed "a very adult act of responsibility to undertake *alone.*"

Nancy and the children lived there for several months while she finished her internship. She desperately needed a job. When she spied a newspaper ad for a zoning planner with the city of Bloomington, she applied, trying to ignore the voice in her head asking, *Just how are you going to manage a 1½-hour commute with your responsibilities as a single mother?* Ever resourceful, she determined, on getting the position, that she would wake at 4 AM and drop the children off at their father's house, which was located within walking distance of their school.

As it happened, she never got home before 7 PM. Every month there were at least a few meetings that ran so late she had to call her former husband and ask him to keep the children overnight. She soon recognized that her schedule would be impossible to sustain. She would have to move closer to work if she had any hope of keeping her job, not to mention keeping her children in a reasonable routine. When a fellow student from Ball State asked about renting her Indianapolis house, Nancy was jolted into action. She had a month to orchestrate a move. She would keep her house, renting it out to cover the cost of property taxes, insurance, utilities, and repairs, while she and the children relocated to Bloomington for the foreseeable future.

Among the Monroe County property listings, she found only five in her price range. The place she bought was a small cabin in the woods south of town. She liked the idea of exposing her children to nature, something they had never really experienced. The cabin was small, a scant 1,200 square feet, and dark. A living room and eat-in kitchen filled the ground floor. Upstairs, two pint-size bedrooms and a bath had been shoehorned into the space to either side of the stairwell. The walk-out basement was a godsend, invaluable for storing overflow. Between the tight confines and the lack of natural light, the interior felt oppressive, an effect only worsened by the thick shag carpet on the living room floor. But it was what they had to work with, and she resolved to make it a stable, cozy home.

She furnished the living room with antiques gathered over the years—a fainting couch, a Victorian armoire from Cincinnati, an Old Hickory table

and chairs—and decorated the walls with Peter Milton etchings and her collection of Turkish plates. The place came together surprisingly well, acquiring the character of a settler's cabin—a basic shelter in the woods, furnished with treasures from the homeland. And like a settler's cabin, she thought of it as a temporary dwelling.

The days, weeks, and months fell into a steady, if packed, routine. The children went to school, and Nancy went to work, eventually switching from

FURNISHED WITH eclectic antiques and other personal possessions, the cabin where Nancy has raised her children is warm and welcoming. The living room doubles as an intimate dining area.

urban planning to historic preservation. She juggled her responsibilities and her finances, took sick days to care for fevered kids, drove hundreds of miles to soccer and swim meets, and trekked up to Indianapolis whenever she could find time to work on the house.

In 1997 her daughter began thinking about college, and Nancy realized that between her two children she would be facing eight years of tuition on top of her regular expenses. She and their father had promised the children that if they worked hard, they could go to the college of their choice; perhaps it was a way of compensating for the broken family and their modest situation, but Nancy wanted them to have opportunities she herself had been denied. To fortify herself emotionally for the coming challenge, she did something uncharacteristically self-indulgent: withdrawing some savings, she redid the kitchen, doing most of the work herself. She pulled up the sheet vinyl flooring, then cut and fitted new underlayment using a saw set up on a picnic table outside. She installed ceramic floor tile, using a diamond blade to cut the pieces, and painted the walls. The big splurge, though it was still modest in terms of typical remodeling budgets, involved the cabinets, which were custom-made by a friend to complement her home's rustic personality and to honor her love of historic architecture. She also replaced the shag carpet in the living room with wood so that the first thing she saw on arriving home from work "would not be totally depressing." Then she hunkered down to several years of lean living in domestic surroundings that felt much more like home.

No sooner had one child graduated from Smith than the other left home with a track scholarship to Columbia. It wasn't long before both had jobs, and Nancy had become an empty nester. For the first time in years, she took up painting. She began writing a book about her mother's family, knowing that her daughter would be interested someday. After scrimping and saving, ever on the watch for bargains, she bought a kayak and started paddling on a nearby lake. And on trips to Indianapolis she took along her bike for rides on the city's new trails.

A few years ago, Nancy's Indianapolis home was between renters. To keep it from looking uninhabited, which might well have attracted vandals—one of the stairwell window panes still sports a bullet hole—she decided she should stay at the old place three or four times a week, varying the days to avoid signaling that the house was regularly left untended. Staying there would be an adventure, a kind of urban camping.

She took an air mattress up on her next visit and retrieved some old furniture from the basement to make the place feel less barren. On workdays she awoke at 4 AM and drove to Bloomington. On weekends she relished the chance to reacquaint herself with her home.

After so many years it felt a little strange to walk around the rooms, now emptied of tenants' furniture and art. Sounds echoed, encouraging a hush. It was her house—had been her house all along—yet for so many years it had been home to others. The experience was not unlike encountering a favorite former lover; there was shyness, a distance. Her purpose in staying was to safeguard the house, but she found that her nights there revitalized their bond.

She has, in a sense, come home already. She has one foot in her childhood locale. And her interest in historic preservation, which grew into a career, has fulfilled an unspoken covenant with her father. He taught her to appreciate old places as repositories of skills passed down through generations and, more than this, perhaps, of all parents' hope that their children will enjoy lives better than their own.

FACING. Cabin in the woods.

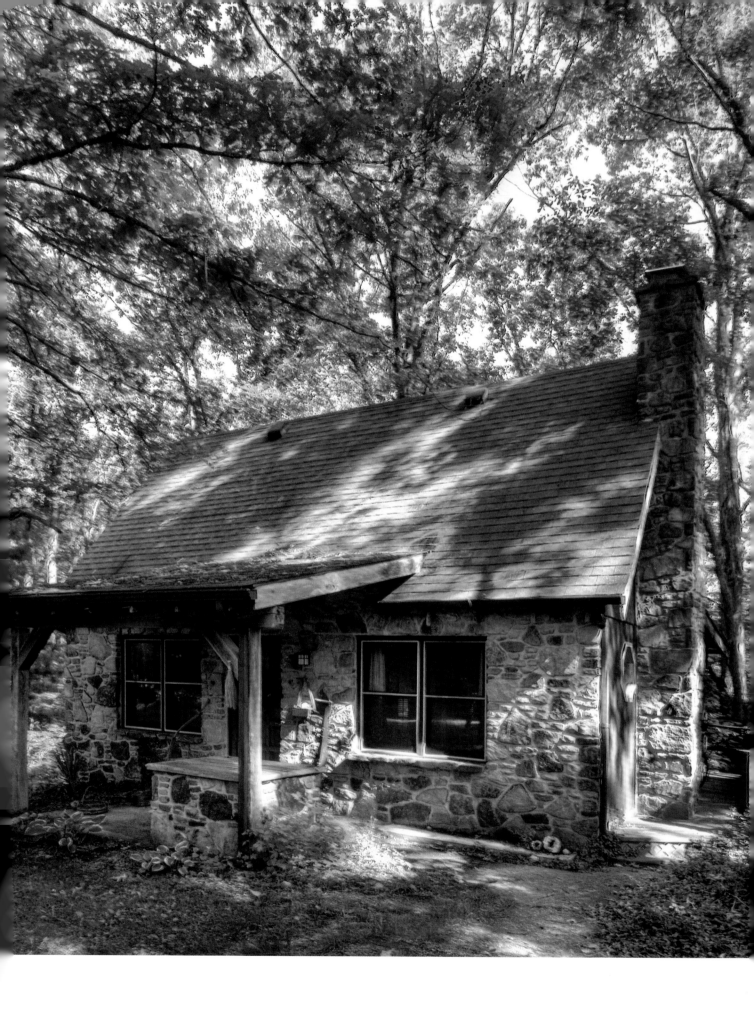

11 LOVE LOST, THEN FOUND

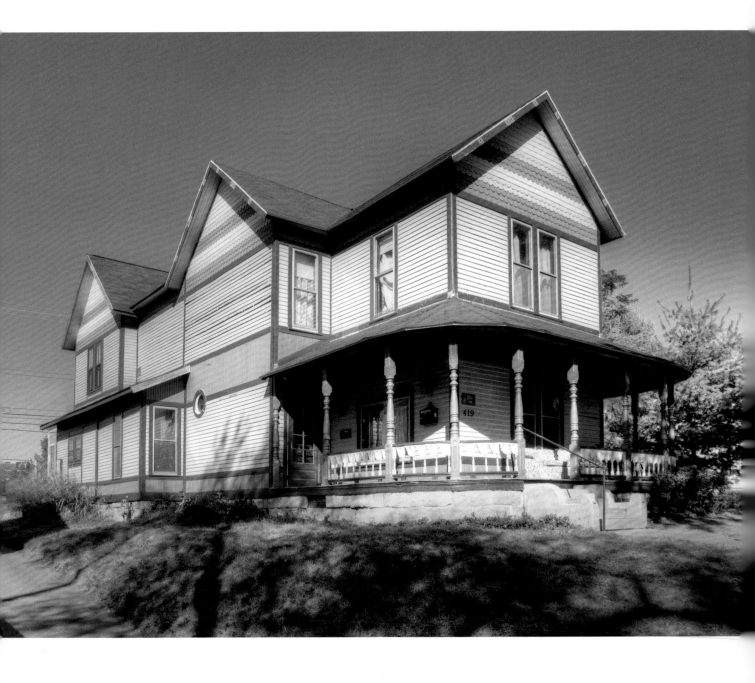

"I DON'T FEEL ABOUT ANYTHING ELSE the way I feel about my house," said Catherine Stafford, describing her graceful 1891 Victorian home during a conversation in 2004. Stafford has known the house since third grade, when she befriended Alex, the daughter of its then-owners. She always loved the place and secretly wished she could live there. The old house was a complete contrast with Catherine's family home, a 1981 passive solar project with a thoroughly modern aesthetic. That house was orderly, flooded with southern light, and had a yard that was "very not overgrown." One of Catherine's strongest memories of the place is that she and her brother had strict instructions to leave interior doors open so that air could flow freely between rooms, an important aspect of passive solar design.

Alex's house, on the other hand, had a jungle-like yard and bohemian interior. It represented freedom, mystery, excitement. In middle and high school, the girls would climb through Alex's bedroom window onto the roof and sing Welsh drinking songs in costume. "What the neighbors thought I have no idea!" Catherine chuckles. "The funny part is we weren't remotely drinking—well, anything other than soda." Catherine was charmed by the old house's architectural features—the staircase balusters, the majestic pocket doors that slid into walls, the nooks and built-ins she was always discovering, regardless of how familiar with the place she became.

What Catherine loved most was the house's wealth of doors. These doors, unlike those at home, could be closed—a simple act that opened up a universe

CATHERINE STAFFORD'S
house, after restoration.

133

of possibilities. Shutting a door created a room, a private world away from grown-ups, brothers, and other distractions.

When Catherine grew up she left her hometown and went to law school. After earning her J.D. in 1997, she stayed in Minneapolis and bought a 1916 duplex. The house had boxy proportions, a stucco exterior, and craftsman architectural details such as beveled mirrors, built-ins with curved drawer fronts, and bookcases with glass doors. A staircase led from the second floor to an attic that ran the full length and width of the house, with large windows on all four sides.

Raised by parents who were seriously hands-on—Catherine's mother and father had built themselves a country cabin, and Catherine had been recruited to help at numerous stages of the process—she had acquired considerable skills in carpentry, plumbing, and electrical wiring. She had also inherited her family's can-do gumption. Her grandfather had worked as an engineer at a steel plant, and Catherine says, "His legacy to us all was, if you don't know how to do something, go to the public library, get a book, and figure it out." Now, with her own home, she set eagerly to work in her spare time. She finished the attic to expand the house's living space, redid the upstairs bathroom, and had a new heating system installed. Her house was included on the 1998 Minneapolis–St. Paul home tour.

In 1999 Catherine returned to her hometown to be near family. She hoped to find a great old house in sufficiently rundown condition for which she could afford the mortgage. Around that time, Alex's parents decided to leave town. They knew about Catherine's interest in buying an old house and asked whether she might be interested in theirs.

Catherine jumped at the chance to buy the house that had impressed itself so firmly on her youthful imagination. The idea that it might finally be hers

was almost too much to bear. She and the sellers went back and forth, negotiating terms and a price, and eventually reached an agreement. Restoring the house would be a massive undertaking—she was no stranger to stripping brittle old wallpaper and gutting bathrooms to reach fabric undamaged by rot. But the prospect of living in the house promised to be worth every minute of the hard, dirty work it would require.

And then disaster struck. Alex's father called Catherine one day, distraught. He could not bring himself to sell the house. His beloved cat Wookie was buried in the yard, and he couldn't imagine living with the knowledge that he had sold Wookie's final resting place. The deal was off.

Heartbroken, Catherine moved on, eventually settling for a nice little bungalow. The house had been partially renovated by its most recent owner, who, as Catherine remarks with no small irony, was "not a talented remodeler." Catherine undid much of the work, replaced plumbing and wiring, and installed a new meter base and electrical panel. That first winter she set up a temporary shower in the basement, a detail she recalls vividly thanks to one particular occasion on which she discovered, in mid-shower, that her bottle of shampoo was frozen solid. She ran naked, wet and freezing, up to the kitchen to thaw it in the microwave.

When the structural work was done, she installed subway tile and a pedestal sink in the upstairs bath. She reglazed most of the house's original three-over-one windows, completely rebuilding two of them. After working on the house for two years, she was happy with her accomplishments. She felt at home.

And then, one day in 2001, she got a call. Alex's parents had finally found a way to move on emotionally. Would she still be interested in buying?

Catherine's heart leapt. Of course she would love to buy the house! But now she had committed her-

self to another house, and, frankly, she'd had her fill of do-it-yourself remodeling. How could she possibly entertain the fantasy of buying another place—which happened to be more expensive this time around—and starting over? The logistical complications were daunting. And yet, she couldn't not go through with it; no one else would restore the house as well as she, and given its location just blocks from the campus of a large university, she knew it would likely be carved up and exploited as a student rental.

When Catherine took possession of the house, the lot had become so overgrown that local children whispered about the place being haunted. Three different sets of homeless people had been living amid the undergrowth in the yard. Inside, water ran in sheets down one of the kitchen walls during storms. Instead of evicting the raccoons they'd found camping in the attic, the previous owners had erected a four-by-four post to help them get in and out of the attic access panel from the adjoining back porch. "That's the raccoon bridge!" they enthusiastically informed Catherine on one of her early visits.

For the next few years, Catherine's life outside of her job was consumed by work on the house. She put other relationships on hold, allowing herself one evening a week to get together with friends. With help from her brother and parents, she removed the aluminum siding that had hidden elaborate wooden shingles. They pulled nineteenth-century doors out of the mud in the backyard shed, restored them, and rehung them in their original locations.

Catherine personally rewired the entire house, installing a pair of 200-amp service panels with her father's help. Inching her way along the basement floor to run the new wire, she encountered dead raccoons and mummified opossums buried in the six-inch-thick rotted insulating fabric that had fallen from the radiator pipes over too many decades. Cave

crickets sprang unpredictably off the rough limestone walls of the foundation, striking her in the face. In some places the dry rot was so bad that biology students from the university requested samples for a class.

The house became a family project. Her parents doted on it like a newborn grandchild, occasionally pestering her to let them come over and work at times when she would have preferred to be left alone. Her father's gift to her every Christmas was a subscription to *Fine Homebuilding*, and, for her thirtieth birthday, her parents gave her a used set of scaffolding.

She hired a contractor to build the shell of a new addition that would replace an earlier version tacked on to add a bathroom and kitchen. Once the new addition was framed, house-wrapped, and roofed, Catherine and her father took over, doing the rough plumbing and electrical work themselves. Her father cut, sawed, milled, and kiln-dried oak trees from the family farm to make trim for the new addition, replicating the house's original details right down to the rosette corner blocks he turned on his lathe. They finished the new trim with stain and shellac to match the original woodwork. They redid all the utilities, replacing the old water line from the street, as well as sewer and phone lines. She and her father also redid all the house's plumbing and restored the windows and doors.

The new addition extended the house's upper story, adding a couple of bedrooms to the three that had already existed. Catherine planned to rent out four bedrooms to generate the income needed, beyond her personal salary, to cover the mortgage.

In 2004 Catherine set up her own law firm, housed in a small parlor on the home's ground floor. Clients came and went through a side entrance. Catherine herself slept in the house's downstairs bedroom, next to her office, and rented out the bedrooms. Her Australian shepherd, Sadie, napped in the bedroom,

behind a closed door, while Catherine consulted with clients. The kitchen, with two refrigerators, was a communal space.

She'd done it.

Not that things were perfect. The home's location in a neighborhood populated largely by student rentals presented its own challenges. Several neighbors had been overjoyed on Catherine's arrival, hoping that one more owner-occupant would help tip the scales away from student ghetto back toward close-knit neighborhood. Alas, they hoped in vain. Late-night parties continued to keep the street's residents up at night, and it was not unusual to be awakened in the wee hours by the sound of drunken vomiting in the alley.

Some students even seemed to pride themselves on their disorderly behavior. Expletives rang around the street, punctuating loud conversations. On weekends, Catherine and other owner-occupant neighbors routinely cleaned up broken bottles and other trash from their front yards. One morning she walked outside to find deep tire tracks though the grass—a mystery, considering that the yard is three feet above the street, with a limestone wall around it. How had a car flown up that high? On another occasion, Catherine came home after dark to find a couple of students having sex in her backyard. Instead of fleeing when she approached, they stood their ground. "Why did you not scatter when you saw my headlights?" she asked, incredulous. "We couldn't find our glasses," they responded. "Could we borrow a flashlight so that we can look for them?" Her patience exhausted, she sent them packing. Given her home's location, she understood that such realities were part of the package and took the mess, the noise, and the general lack of consideration in stride.

Then she got pregnant. Catherine had always wanted children and adored the idea of bringing them into her home. Now the broken bottles, mid-night retching, and substance-impaired drivers took on new significance. The thought of raising a child in such conditions was worrying. Behavior that had previously seemed merely exasperating now looked genuinely dangerous.

Her concerns about the neighborhood expanded right along with her belly. She was losing patience after five years of trying to be kind, reasonable, and proactive in her efforts to avoid neighborhood discord. She'd always made a point of visiting rowdy parties in person and politely reminding her neighbors that the city's noise ordinance required quiet after dark. But she had the police on speed-dial, just in case.

On graduation weekend, 2006, Catherine had spent Saturday at work in her home office, trying to concentrate despite the amplified music that mocked her firmly shut windows and doors. A massive sound system set up less than thirty feet away ensured that no one within a half-mile radius could fail to be aware that people were celebrating the completion of their studies.

By 9:30 PM, Catherine, more than four months pregnant, was ready for bed. With her windows rattling, she soon realized that sleep would be impossible. She climbed out of bed and went next door to reason with her neighbors, but her effort at diplomacy had no effect.

This was too much. She called the city police to make a noise complaint.

Half an hour later, one of Catherine's lodgers returned home from work. "Why are there police posing for pictures with the new graduates next door?" she asked on finding Catherine awake.

"At that I started to lose my temper," says Catherine. "I called the police to ask why the neighbors were still making so much noise." The police came out again and warned the occupants that they had better tone down the decibels.

Shortly after, Catherine heard a knock at her door. She opened it to find a pair of "drunken 40-something mothers," who righteously suggested she should be ashamed for attempting to deny their children a well-deserved celebration. The women's husbands followed next, berating her for being a selfish boor.

Before long, half a dozen parents had appeared on her doorstep. As Catherine faced them, literally barefoot and pregnant, the parents became increasingly irate, raising their voices and moving threateningly toward her. One of the fathers grabbed her shoulders and shoved her toward the wall.

Her pulse racing, she ran inside, locked the door, and called the police. At this point the neighbors were not just guilty of violating the city's noise ordinance, but of trespass and battery, too. Partygoers from other houses on the block began congregating on her lawn to lend support to the revelers' cause. Soon Catherine found herself facing a furious mob of more than fifty people. The police were forced to disperse all the neighborhood parties in the interest of public safety.

Shaking with anger, fear, and indignation, Catherine began packing her things that very night. Five years of passionate, unstinting sacrifice and investment—physical, emotional, monetary—had come to this? She had put everything on the line, had done all in her power to make it work. Not just in terms of financing the project, which was an ongoing challenge. Not just in terms of restoring the house—its structure, systems, and decoration, in addition to regular maintenance and repairs. She had set herself the far more ambitious goal of helping to rebuild her neighborhood's social fabric, participating in neighborhood and city meetings, clearing trash off sidewalks and streets. Now she felt despondent. Had her work made any difference?

In less than a month she had moved out of her house.

When she put the house on the market, Catherine received offers from out-of-town landlords, but she accepted a lower price from a local family she knew would be worthy stewards. She felt she owed this to the house and to her friends, the former owners. She still feels guilty for leaving the neighborhood, and she misses the house every day.

But moving was the right thing to do. Three years later, she is married and lives with her husband, son, and two daughters in a '20s bungalow less than an hour's drive from her parents. She has relocated her law practice to another old house downtown.

There may be a large-scale restoration in her future, but for now she is content to confine her ambitions to modest projects. Her husband gladly cooks and cares for the children while she works on their house—tiling the bathroom floor was a recent project. She is heartened by signs that her three-year-old son, whom she was carrying on that crazy night in 2006, will follow her family's do-it-yourself tradition. He perches nearby while she works, hoping for a chance to contribute and elated when his mother requests his assistance.

12 TURN-OF-THE CENTURY TOWNHOUSE

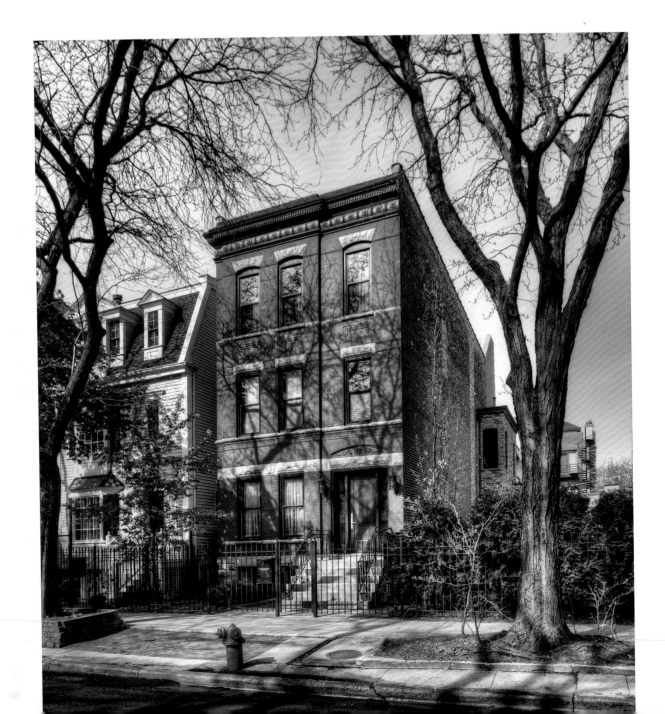

HER STATUESQUE FORM draped regally across an upholstered rocking chair, Clara Gabriel describes her home as "the house of 'yes.'" She is, she goes on to explain, referring to the improvisational dramatic device of prompting lines with, "yes, *and . . .* ?"

In this case, "yes" refers to the experience of creating her home, a project on which she collaborated with designer Jean Alan and architect Kathryn Quinn. Practically every time she asked, "Could we use this chair?" or "How about using two fabrics on these windows, instead of one?" the answer was "Yes," followed by some further inspired suggestion—"and . . . let's stain the wood a rich, dark brown," or "let's complement this mulberry velvet with amber panels and a steel-gray fire surround."

As it happens, the theatrical reference could scarcely be more apt. Not only is Clara's home itself a dramatic creation, realized with exquisite artistry and attention to detail; Jean has spent much of her career as a motion picture set decorator. When Clara described her fascination with the decades spanning the stylistic shift from Art Nouveau through Art Deco, Kathryn and Jean understood exactly the aesthetic she wanted.

Clara had been separated for almost a year when she found the house in 2002. Like its neighbors up and down the street, the brick and terracotta townhouse in Chicago had originally been built for a prosperous family in the 1890s. Over the decades, the area had become considerably less affluent, and the building was carved up into rented apartments. Some properties fell into

THE RED BRICK facade of Clara's townhouse.

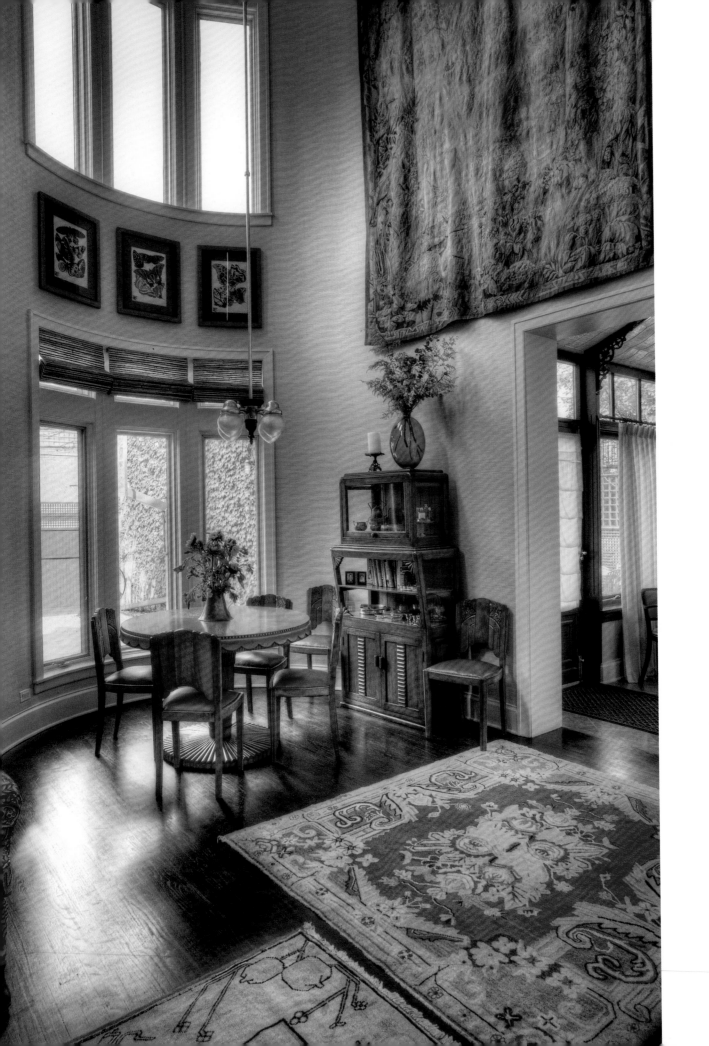

such disrepair that they were purchased for the land they stood on, demolished, and replaced with newer buildings.

By 2002 the street was well on its way back to being an attractive, economically vibrant address made all the more valuable by its proximity to Chicago's center. Curbside shade trees and stoops adorned with potted plants made for a well-tended look. Runners exhaled a wholesome aura, and the sidewalks felt safe and domestic, with nannies pushing infants in strollers. It would make an ideal location for Clara and her two sons.

The house's previous owners had restored it from four-story apartment building to single-family residence, but in the process they had removed every vestige of period architectural fabric. Clara and her architect, Kathryn Quinn, added walls, relocated a staircase, added a sunroom, and incorporated period-style woodwork and built-ins. Kathryn also introduced several turn-of-the-century motifs. Clustered roses inspired by Scottish architect Charles Rennie Mackintosh are carved into door panels throughout the house, and the grillwork for the front door's sidelights features stylized trees in the fashion of Austrian artist Gustav Klimt.

For her home's interior decoration, Clara worked with Jean Alan, whose shop in nearby Bucktown had caught her eye. Together they scoured area antique shops for rugs, furniture, and light fixtures. Markets in Chicago and other midwestern towns yielded wonderful finds, such as a rare, leather-upholstered glider from the 1930s. One day they came across a French Art Deco vase that made Clara swoon; the vase was perfect in every way, other than its staggering price. Jean pointed out that for what the vase cost in Chicago, Clara could find one just like it *and* have an adventure by going straight to the source in Paris.

There was no need to twist her arm. A couple of months later, Clara and Jean flew to France with Jean's business partner, Ruthie, who is also her daughter. At the Clignancourt flea market Clara strode ahead, stopping to touch and admire each object that caught her eye. Jean followed closely behind with suggestions for how various pieces could work together. Bringing

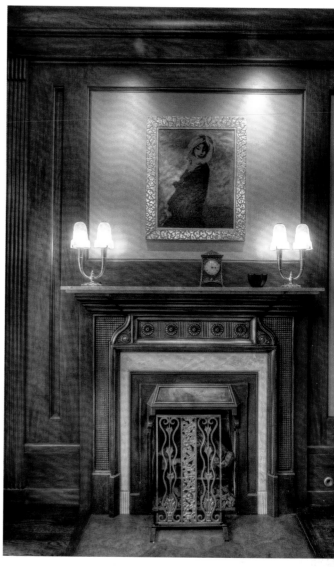

FACING. The custom-made table in Clara's two-story breakfast room was designed by Jean Alan and is an adaptation of a Parisian flea market find.

ABOVE. An antique fireplace surround in Clara's living room makes a stunning focal point.

up the rear was Ruthie, who assiduously completed the masses of paperwork necessary to ensure the antiques would safely reach Chicago. Within 2½ days they had found most of the furniture, light fixtures, paintings, dishes, silverware, and objets d'art to complete the house. "We had so much fun!" Clara remembers—a feeling Jean corroborates. Both consider the trip the start of a fruitful collaboration that has continued through subsequent projects.

Clara's life wasn't always such fun. Growing up, she lived in a low-rent section of another midwestern city. Her father had trouble keeping a job, and her mother, who had married at 19, ran a daycare facility in their home to help support the family. The sense of financial uncertainty was oppressive and unrelenting, and from the time Clara was five, her mother leaned on her for help. The daycare was an all-day, year-round undertaking. After parents left their children in the morning, Clara's mother made everyone breakfast before sending Clara off to school with the other school-age children in tow. Clara was responsible for bringing them back safely later on, and the thirteen kids spent the rest of the afternoon together.

When Clara was eight, her parents divorced. Her mother, struggling to make ends meet, supplemented her daycare income by selling cosmetics at home-based parties in the evenings, which allowed her even less quality time with her children.

The following year Clara's mother remarried and the family moved to Milwaukee. They lived in a comfortable house with eight acres on the banks of the Milwaukee River. Nature was everywhere, in complete and delightful contrast to their previous inner-city location. The front yard had a pond where Clara and her brother skated in winter, and the entire property was surrounded by a creek that offered a universe of possibilities for exploration. Four years later, her mother had another daughter, Michelle.

Clara and her brother went to a good school and enjoyed opportunities they could never before have

FACING. In a nook beneath the staircase, a sensuous loveseat shares space with a pair of antique prints by Klimt.

ABOVE. Clara has a writing desk tucked into this small hallway between the kitchen and sunroom.

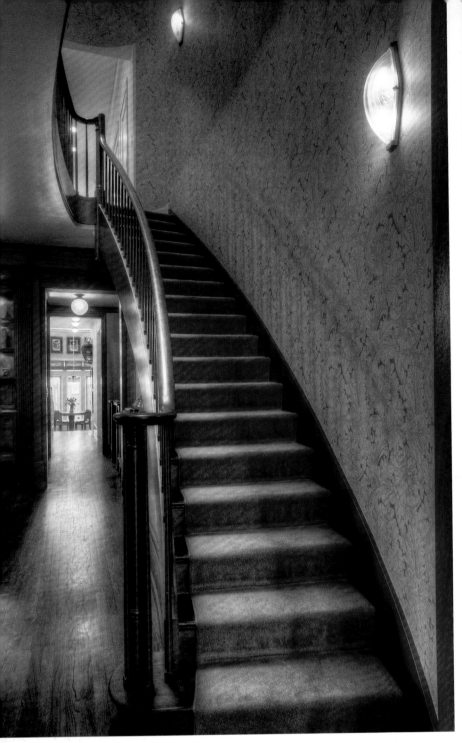

ABOVE. A sinuously curving staircase leads upward from the main floor.

FACING. Clara's craft room is furnished with a table, chairs, and cabinet attributed to turn-of-the-century Danish artist Lorenz Frøhlich, one of two

imagined. She was a serious student and filled her spare time with extracurricular activities—dance lessons, diving team, track. She was homecoming princess in her freshman year of high school. On top of these everyday blessings, summers were a dream come true; her stepfather's parents owned a soda shop and sporting goods store in northern Wisconsin, and one of Clara's fondest memories is of running her grandma's popcorn stand on the sidewalk outside the store.

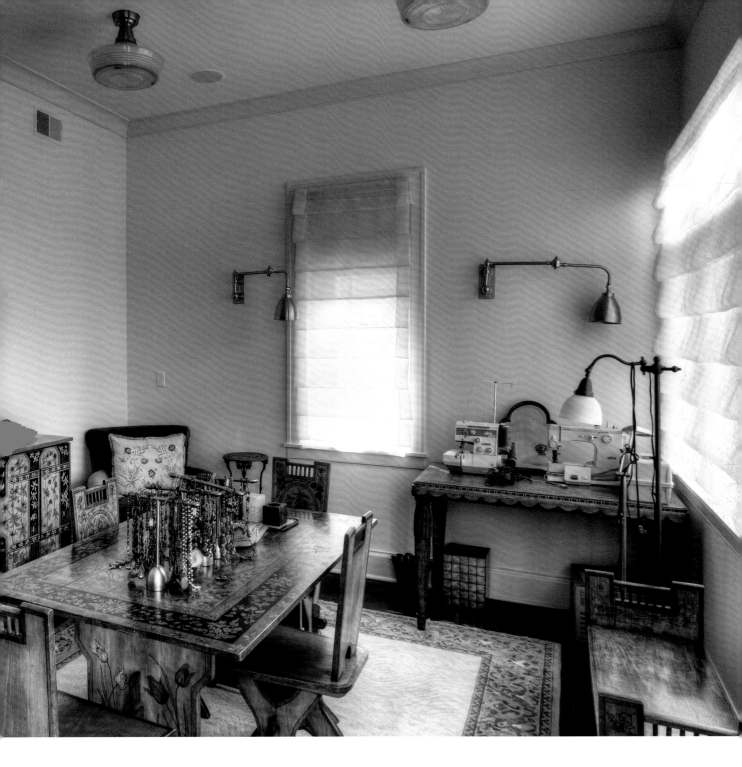

Clara's mother also flourished in Wisconsin. A stunning beauty, she could now afford to dress fashionably and have her hair professionally styled. She met friends for bridge and belonged to a gourmet cooking club. The benefits of her second marriage were clear, and she did her best to make it last. Sadly, this meant enduring her husband's emotional abuse. By Clara's sophomore year, her mother could take it no longer and returned with the children to the city from which they had moved. Clara was heartbroken at losing her friends,

illustrators who designed for Hans Christian Andersen. Each face of each piece is distinguished by paintings of flowers.

leaving her beloved school, and returning from suburban comfort to a life of anxiety and privation. They rented a tiny apartment, where Clara and her sister shared a single bed.

She left for college just as soon as she was able.

After graduating with a double major in psychology and biology, Clara decided to make a long-distance move. The distance part she had decided on, but she lacked a specific location. She systematically whittled her choices down to two—Boston or San Francisco—then flipped a coin. She was going to California.

She took a job waiting tables at a restaurant in Pacific Heights and applied to graduate school to improve her prospects. After winning a place in a doctoral program in organizational behavior at the University of California, she spent 2½ impossibly busy years taking classes and working as a research assistant while also working a second job studying management turnover for a major corporation. She had just completed her course work and was studying for qualifying exams when she lost two fingers in a freak sailing accident. The pain—both physical and emotional—was intense, and Clara's doctor

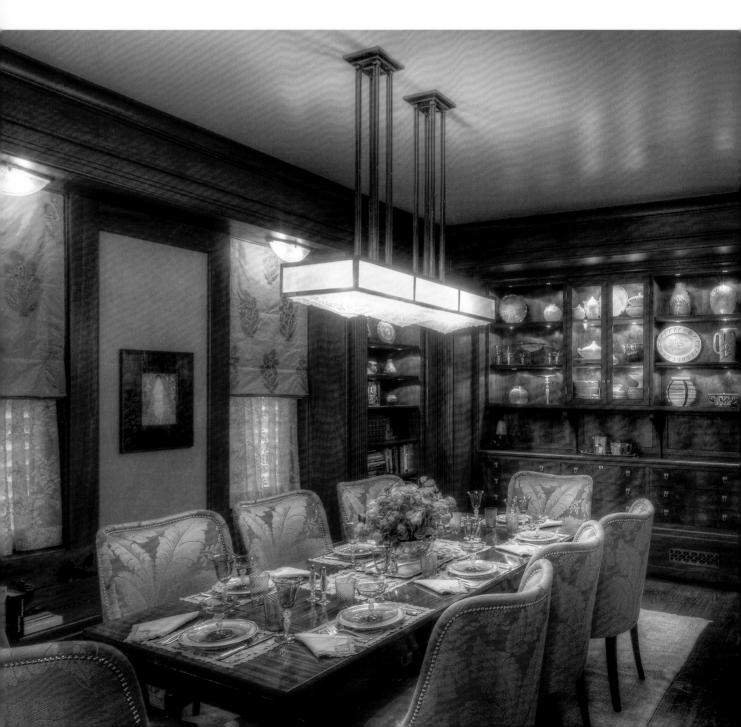

prescribed medication. When her professor refused to reschedule her qualifying exams, she took them in a pharmacological haze and did not pass. Instead of retaking them, she decided to leave with the MBA she had already earned.

At 24, she had reached a turning point. Despite the MBA, she had no money and no sense of where to go next. Before the accident her future had seemed clear; she had doggedly pursued the goal of a Ph.D., confident that things would be better on the other side of the dissertation. A bizarre, totally unforeseeable accident had pulled the rug out from

FACING. Wall paneling, trim, and built-ins throughout the house were designed by Kathryn Quinn. Clara's dining table is a Deco-era classic; unable to find suitable chairs to accompany it, Jean Alan designed her own and had them fabricated by Dessin Fournir.

BELOW. In Clara's living room the interior design and architectural decisions were largely directed by the Amritsar rug. Most of the furnishings and objets d'art came from flea markets in the United States and France. The built-in banquette was designed by Kathryn Quinn Architects and upholstered by Jean Alan.

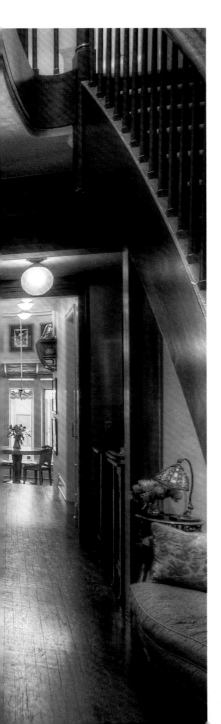

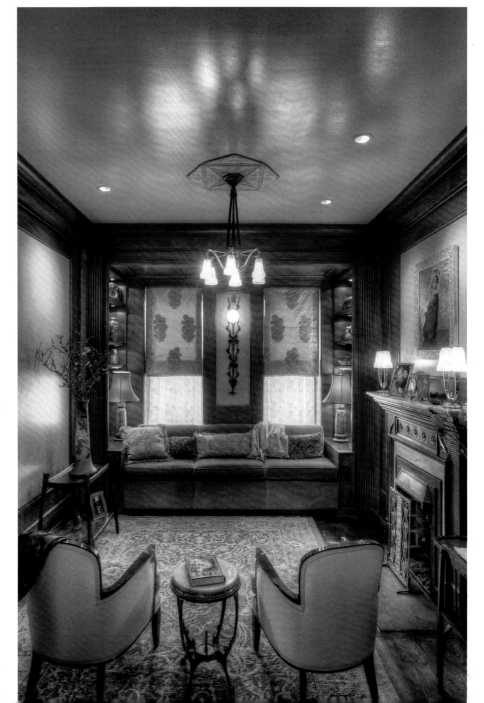

under her feet. In a blur of cognitive dissonance she drove home to her mother and got a job waiting tables at a diner. She was too confused even to start trying to figure out what might come next. The move did have one major upside—the chance to reconnect with her younger sister, Michelle, who had been a child when Clara left for California. But mostly she just felt depressed.

Several friends from college had relocated to Chicago, and after weeks of hearing Clara complain about lacking direction and being depressed, they insisted she join them; they had a couch, and it was time for her to avail herself of it. She could leave and get her own place as soon as she got on her feet. Clara had always loved Chicago, the destination for special-occasion trips throughout her childhood. There were parks, museums, restaurants, and stores with big window displays. Every Christmas her family had made a pilgrimage to the Marshall Field's department store on State Street to buy decorations and have breakfast with Santa. Her mother says that from the very first time Clara visited Chicago she vowed she would someday live there.

To Chicago she went. She landed a job as director of marketing for a museum and moved from her friends' couch to an apartment shared with a female attorney. Clara adored her job and thanked her lucky stars that she had found her way to Chicago. She loved the people, the energy, the neighborhoods, the culture, the food, and, as she says, "the incredible beauty of that lake with the skyscrapers reflected in its vastness."

Five years later, in 1989, she was dining at a sushi bar when a man struck up a conversation. They began dating. A year later he was transferred out of state and urged her to accompany him. She was torn; the thought of leaving Chicago was too awful, especially since she had found the ideal job. So she stayed another year. By then she felt certain about the relationship and moved to join him.

They dated one more year before marrying in 1992. Clara returned to school and earned a master's in social work. For her practicum she developed a domestic violence program at the hospital where her first son would be born in 1995.

Her son was born with Down syndrome and needed two surgeries within the first few days of his life. Clara spent an agonizing several weeks, staying mostly with him at the hospital. When she and her husband were finally able to bring him home, they discovered he had a breathing problem requiring further hospitalization. After they brought their baby home for good, they had to keep him on a respiratory monitor, which required them to wake several times a night to make sure he was breathing. The stress and exhaustion were almost unbearable, but thankfully their son's condition was eventually stabilized.

Chicago was never far from Clara's heart. By the time her husband had gained sufficient seniority to enjoy some flexibility in terms of location, she was pregnant with their second son and—fueled by hormones, she suspects—"insanely driven to get back." They returned to Chicago, where their second son was born in 1998.

The marriage eventually faltered, and Clara separated from her husband. She wanted to start afresh in a home that would feel like her own, so she kept very few furnishings from her marriage. She and the boys, ages three and five, moved to an apartment, where they lived for two years—the time it took to restore the house where they live today. It had been a wrenching divorce, a period of sadness and questioning, self-doubt and recrimination. Planning her home's restoration and overseeing its execution allowed her to turn her focus from regret to a project that was joyful and constructive, eminently practical as well as fun—for her sons, as well as herself. With the help of two professionals—in addition to

FACING TOP. Bathroom with glass tile and deep purple-blue ceiling.

FACING BOTTOM. The Amdega conservatory designed by Kathryn Quinn is furnished with antiques from Italy, France, and the Midwest, selected by Clara and Jean Alan. The elaborate glass chandelier is antique, from Milan.

ABOVE. In the master bath, custom mahogany cabinetry designed by Kathryn Quinn houses handmade copper sinks. A matching copper tub is surrounded by teal blue, green, and bronze tile.

many skilled craftspersons—she created the beautiful, stable home her own childhood had lacked. She is surrounded by objects that remind her of trips to Europe and her experience of building a new life.

In 2000 Clara started a non-profit dedicated to supporting children with special needs and enabling them to be fully included in regular schools. She currently runs a business that helps organizations collaborate to increase their effectiveness and encourage positive social change.

CLARA'S BEDROOM is sumptuously elegant, its walls covered in silk. The two chairs are upholstered in Fortuny fabric, and the floor lamp is vintage Murano.

13 HOLDING THE WORLD TOGETHER

MENTION INDIANA to anyone who has driven across the state and you'll hear tales of flat croplands punctuated by the gray geometry of oil refineries and industrial architecture outside Chicago. This near-level landscape was formed when the Wisconsin Glacier pressed southward across the continent's middle, scouring all in its path. Some 30,000 years ago the ice sheets began to retreat, draining their melted contents into many of the rivers we know today—the Wabash, the White, the Ohio.

In contrast with the state's northern two-thirds, the topography of Indiana's south is all tucks and folds, like a piece of paper crumpled, then partially smoothed out. Spine-like ridges give way to slopes etched with ravines, dropping into foothills and coming to rest in streams that course over rocky ledges. Some stretches are gentler, with rolling hills and broad valleys more welcoming to human settlement.

These smooth and bumpy landscapes collide at the West Fork of the White River in northwest Monroe County, where Patsy Powell's farm, Breezy Point, sits on a stubborn promontory overlooking the river's bottomland. Standing in this lofty spot it's easy to feel a sense of looking back through time—to imagine some mythic creature sheltering on this bulwark staring northward, wide-eyed at the distant glacier's vastness. As Patsy gestures across ridge and valley describing the homesteads her forebears created, she brings alive the two hundred years her family has belonged to this place.

PATSY'S FATHER bought this walnut dresser and a matching bed for Patsy's mother, Faye.

In every direction the built environment aims to halt the erosive force of the weather that carved this landscape. Stone retaining walls hold back earthen banks, and land owners plant slopes with grasses, hoping the matted roots will bind the soil. In this riparian estate, water also erodes from below. The river toys with its neighbors, respecting its bounds—if not its banks, then at least its regular floodplain—for years, even decades. Then suddenly it swells, uprooting crops and washing them downstream together with fertilizer and precious topsoil. Against such might, farmers have no more power than beavers or crawdads. But high above the rushing brown torrent, an old yellow house stands safe. "This land is just here to hold the world together," Patsy's husband, Marvin Powell, used to say of their hilltop fastness.

Isaac Van Buskirk settled in southern Indiana in 1805, some thirty years after serving the cause of the Revolutionary War. His sons, James and Isaac Jr., married and made their homes near a crook in the White River at the intersection of today's Owen, Morgan, and Monroe counties. Two of the brothers' children, David and Lucy Van Buskirk—first cousins—married and had a family.

In the spring of 1879, their daughter Cynthia married John Turner Ridge. The newlyweds bought seventy acres from Cynthia's father and within a year had a child, Mae. They had a two-story frame house built for $820 and moved in during the summer of 1882. It would be thirteen years before Cynthia gave birth to her second child, Faye, who spent her entire life in this house.

Faye played piano, loved to read, and dreamed of becoming a teacher and working at Berea College in Kentucky, a school founded by abolitionists and reformers with the goal of educating students from Appalachia—black and white—from homes with limited economic resources. But in the early 1900s, few women went on to higher education. Instead, she married at the age of 22.

When her father died that August, Faye and her new husband, Clarence Martin, stayed on with Cynthia in the family home; they would help care for her as she aged, and she would help run the house. Clarence farmed the land as his father-in-law had done, growing corn, wheat, oats, and alfalfa while raising hogs, chickens, and beef cattle. He and Faye had four children.

Patsy was the youngest of those children. She was born in her parents' bedroom in the spring of 1929. The family had sent to Gosport for Dr. Stouder, who lived a mile away over the covered bridge. The doctor confirmed that all was progressing as planned, but since the baby's arrival seemed hours off, he drove home to get some rest. Clarence would spend the rest of his life proudly relating that he had delivered his youngest daughter.

Patsy grew up on the farm, a tomboy if there ever was one. She wore her long black hair in braids and with her friend Anne, Dr. Stouder's daughter, built teepees, swung on grape vines, and rode workhorses so fat that the girls' legs stuck straight out at the sides. She learned to read by playing with the "Need List" in her mother's Hoosier cabinet; the enameled plaque had shiny red buttons that slid from side to side, indicating the need to restock matches, lard, or macaroni. Patsy spent hours playing with those buttons while she stood on a chair, annoying her mother by asking repeatedly, "Do we need beans? Do we need polish?"

She went to grade school in Gosport, riding her bike over the covered bridge and parking it at Aunt Mae's house during classes. When the river flooded, her father drove her across the bridge on his tractor. When it rose too high even for that, she had to take a longer route on foot across the railroad trestle, where she tried to avoid looking down through the ties at the roiling water, reminding herself of her father's words—*You're too big to fall through those cracks.* She swore she'd never marry, and as her older siblings grew up and left home, her father thought that might not be so bad. Patsy was always ready to help around the farm. She believes her father saw her as a pal as much as a daughter, because they worked so well together.

On a summer day in 1946 Patsy returned home with her parents from the Quincy Picnic, a social event that dwarfed even the bustling county fair. Her sister Jean, a high school teacher, was entertaining a group of students in the living room. Jean introduced Patsy and her parents to each of the students in turn. When she got to 17-year-old Marvin Powell, he piped up and told Patsy, "I bet I can make you speak like an Indian." Everyone laughed when she fell into his trap, asking, "How?"

Marvin had grown up during the Depression. One of the nicer things in his parents' house was a beautifully crafted cherry table his Uncle Abe had given his parents for their wedding. Although the table came with leaves, it was opened only when the entire family was home for a meal. Marvin's mother, Hazel, kept it in the kitchen, where she protected the top with layers of newspaper and used it as a counter. Marvin was ten when his father died, leaving Hazel to raise four children. She took in washing and ironing for cash. Two years later she married an older widower with eleven kids of his own, and the newly married couple had two more children together.

Raised in a household with many brothers and sisters, Marvin was no stranger to heated discussions. He learned to ease tensions with humor and developed a love of the absurd, simply as a means to maintaining his own peace of mind. He also learned to analyze issues and work through problems methodically instead of allowing conflicts to spin out of control. Patsy liked

his calmness. He was patient, kind, and had a clever way with words. "He would come here to see me and say, 'It's so quiet,'" she remembers. They dated for a time, but Patsy had inherited her mother's yen to teach. She was determined to go to college and devote her full attention to her studies. Once she started classes in music education at Indiana University, she informed Marvin that she would no longer have time for dating. Marvin was crushed. He joined the Air Force and was sent to Biloxi for training as a radio operator.

After a year he mustered the courage to write Patsy a letter. He would be coming home that summer on leave. Could he see her? She wrote back. *Yes.* She told him the day and time when she and her father would be home after moving her possessions back from Bloomington for the summer. The move took longer than she had expected. Marvin arrived before she got home, and her mother suggested he go up the road to visit his former high school teacher, Jean. When Patsy arrived, her mother said Marvin had come by but had left because she wasn't home (mischievously neglecting to mention that

THE CHERRY DINING table was given to Patsy and Marvin as a wedding gift from Marvin's mother, who had used it as a kitchen table in the 1930s— always with a thick protective covering of newspapers.

FACING. Patsy learned to read by playing with the "Need List" in this Hoosier cabinet, which belonged to her mother.

he was planning to return). Patsy was deeply disappointed. She had come to care for Marvin more deeply than she realized. Her mother's ruse made their reunion all the gladder.

They dated that summer and were engaged in 1950 just as Marvin left for a tour of duty in Guam. As his overseas commitment stretched out to a seemingly infinite two years, his buddies insisted Patsy would have found someone else by the time he got back. But she didn't. She spent those years teaching music at a school in Highland, Indiana. She and Marvin were married in February 1952 at the Baptist Church in Gosport and had their wedding reception at the house. Marvin's mother gave them her cherry table, in exchange for which they gave her their practical, modern Formica-topped table with metal legs.

They moved several times as Marvin was posted to different locations. Their first child, Janet, was born in Vermont, and two sons followed. Patsy had quit teaching outside the home while her children were young, but after thirteen years she was ready to be back in the classroom. Teaching requirements had changed, and she needed a master's degree to renew her license. So while raising the children she put herself through graduate school, a time she recalls as a blur of activity.

After Patsy's grandmother, Cynthia, died in 1936, her mother took the opportunity to make some changes. She had always been irritated by the lack of a proper place for her piano, so she hired a carpenter to reconfigure the staircase, which produced a corner just the right size. She had always wished the living room were brighter, so she had the built-in wardrobes to either side of the chimney breast replaced with windows to let in morning sun. The house had been heated with coal stoves from the start, but she had always longed for a fireplace, so she had one installed by brothers Ed and Bob Goss, who were locally renowned for their carpentry and woodworking. The brothers also built a fancy walnut mantel and a pair of built-in bookcases using lumber from a tree given to Faye by her father. After Clarence died in 1960, Faye enjoyed her home until her own death in 1975.

During those fifteen years of living alone, Faye had neglected some important maintenance. The sill plate at the west side of the house had rotted and needed to be replaced. The original plaster, now ninety-three years old, was cracked and crumbling. Years before, in an effort to improve the property, Clarence had covered the original clapboard siding with manufactured fiber panels and replaced the rotten front porch with a concrete floor and cinder block posts. Patsy had always disliked the facade her father created. Something about it just wasn't right. But now, as she and her siblings gathered to

discuss what should be done with their jointly owned asset, the house's unattractive appearance took on new significance. Some family members saw the house less as an asset than a liability and suggested it should either be sold or torn down.

"It was like somebody stabbed me in the heart," says Patsy today, explaining how she came to blurt out, "Marvin and I will fix it up!" Neither she nor Marvin had ever restored a house, and they had no idea what such a project would entail. But what else could she do, considering its history? Her grandmother had spent her entire adult life there. Her mother had been born and died there. Patsy, too, had been born in the house. The place was a living expression of her heritage.

She and Marvin accepted the house and surrounding land as their share when the estate was settled in 1977 and began their massive spare-time undertaking. They planned to have it restored by 1982 for the house's hundredth birthday. While trying to decide how to treat the facade, Patsy was poring through old photo albums when she suddenly understood why her father's porch had always struck her as inappropriate; from her earliest days she had been shown pictures of relatives standing in front of a stately porch crowned with a fretwork balustrade. Marvin faithfully reproduced the original design.

As she scraped off the six layers of wallpaper in the living room and stairwell—a process during which it dawned on her that she was undoing decorative choices made by her mother and grandmother—she carefully preserved a swatch of each as a record. Before reaching the final layer she chose a new pattern, and she was astonished to find, on reaching the bottommost layer, that her choice was nearly identical to the paper her grandmother had originally selected. In her grandmother's honor, she had a piece of the original paper framed, using one of Cynthia's calling cards to cover a small tear in a corner.

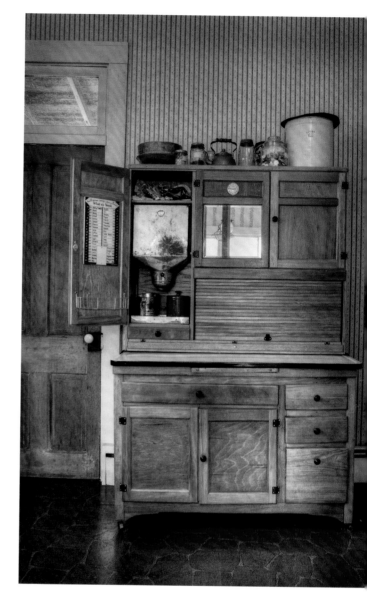

Patsy and Marvin continued working on the house after they moved in. Marvin enclosed a back porch, making a breakfast area with wainscot fabricated from old barn siding. He worked with a cabinetmaker to build new poplar cabinets for the kitchen and a pass-through into the breakfast room.

For the hundredth birthday party they invited every one of their home's descendants. Fifty family members attended, celebrating with a large sheet cake featuring a sketch of the house piped in icing.

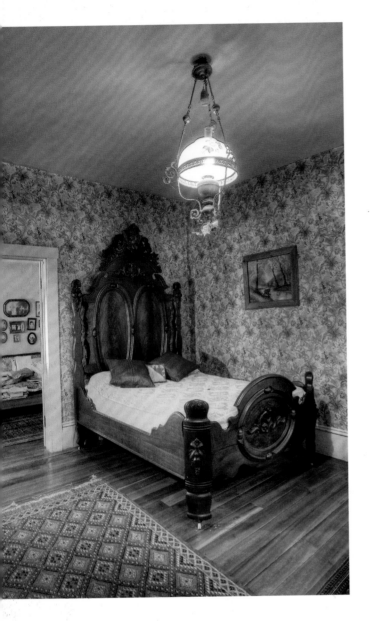

When Marvin died in 2001, Patsy was 72. Concerned about her safety, as well as her ability to manage the house's day-to-day demands, friends and family urged her to sell the place and move to town. But there was no way she could leave. Breezy Point was her home—her property in the truest sense of that word. Derived from the Latin *proprius*, our word "property" is concerned not just with ownership, but with what *is one's own*, in the sense of being peculiar or unique to one's very being. Ten years later she still lives in the house, which she shares with two shelter-rescued dogs, Prissy and Sarafina. She gives piano lessons in her living room, mows the grass on several hilly acres, is active in local historic preservation groups, and recently had a craftsman replace the rotted front-porch balustrade Marvin produced almost thirty years ago with a crisp new replica.

Her daughter, a university professor, has fulfilled her mother's and grandmother's pedagogical dreams. Now in her late fifties, she has every intention of coming home to Breezy Point when she retires.

ABOVE. The walnut bed matches a dresser Patsy's father bought for her mother at auction.

FACING. Beside the stairway in Patsy's living room hangs a framed photograph of her great-grandmother, Lucy Van Buskirk, and her grandmother, Cynthia Ridge. Cynthia and her husband, John, had the house built in 1882; the property has been passed from one generation to another in a rare, matrilineal sequence. Patsy had the photograph restored after family members discovered it in a shed.

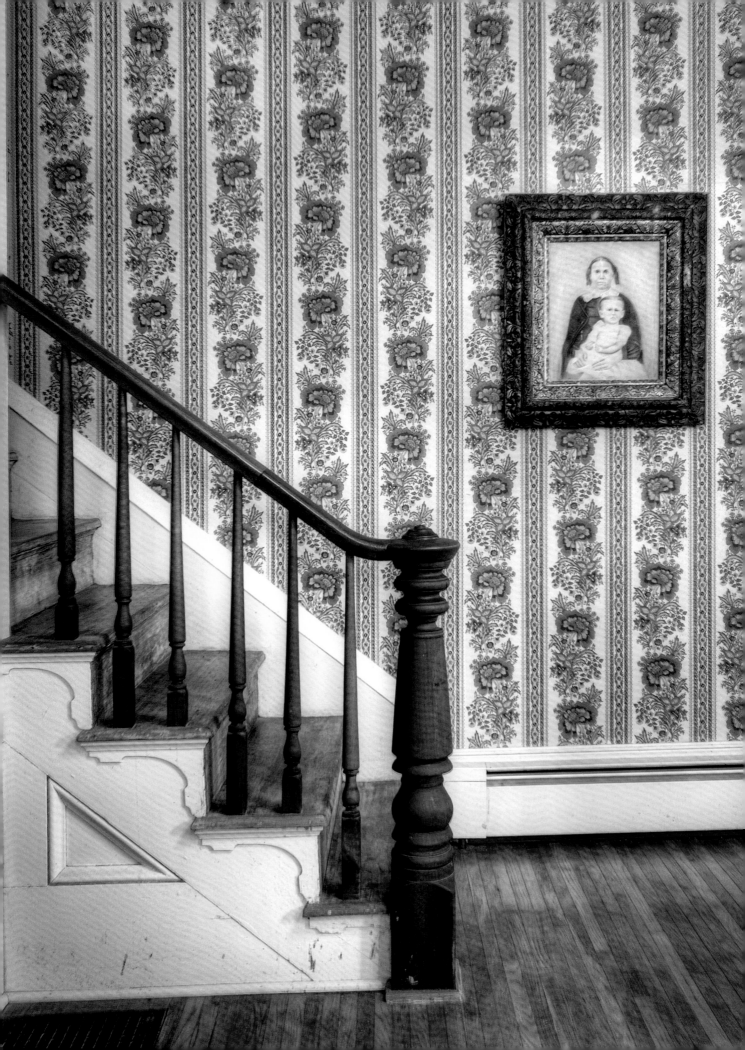

14 TENTH TIME'S A CHARM

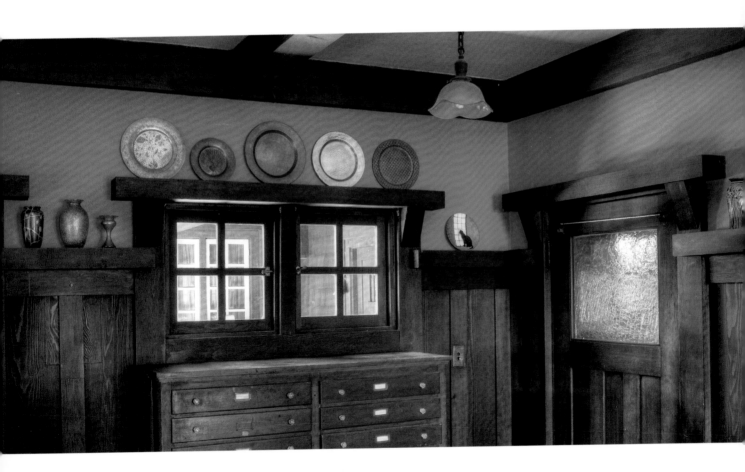

JANE POWELL first encountered the Jesse Matteson House while working on the selection committee for the Oakland Heritage Alliance's annual homes tour in 1996. She was seized by a mix of lust and longing as soon as she set foot inside. It was the house she had always wanted—an Arts and Crafts confection of stucco, brick, and wooden shingles with a 3,800-square-foot interior lined in premium Douglas fir. And it belonged to someone else.

Matteson, the builder, had owned a lumber yard. In 1905, when designing his personal residence on the outskirts of Oakland, he granted his lumber full expression in the open architectural style of the day. No skinny studs hiding behind plaster for him—instead, he let the magnificent timbers speak their parts, the posts and beams forming a sturdy skeleton fleshed out with fir panels from floor to ceiling. He topped his windows with solid plate rails, studded the walls with bosses and built-in benches, and left the beams supporting the second story fully exposed.

By 1996 the house's once-remote hillside location had become a dense residential neighborhood populated by lower-income residents, many of them recent immigrants from Central and South America. The Matteson property was owned by a housing collective, whose members, flattered to have been invited to participate in the prestigious Oakland Heritage Alliance tour, agreed to open their home to visitors.

COPPER PLATES from Mexico share space with art glass vases and a contemporary plate decorated with a picture of a cat.

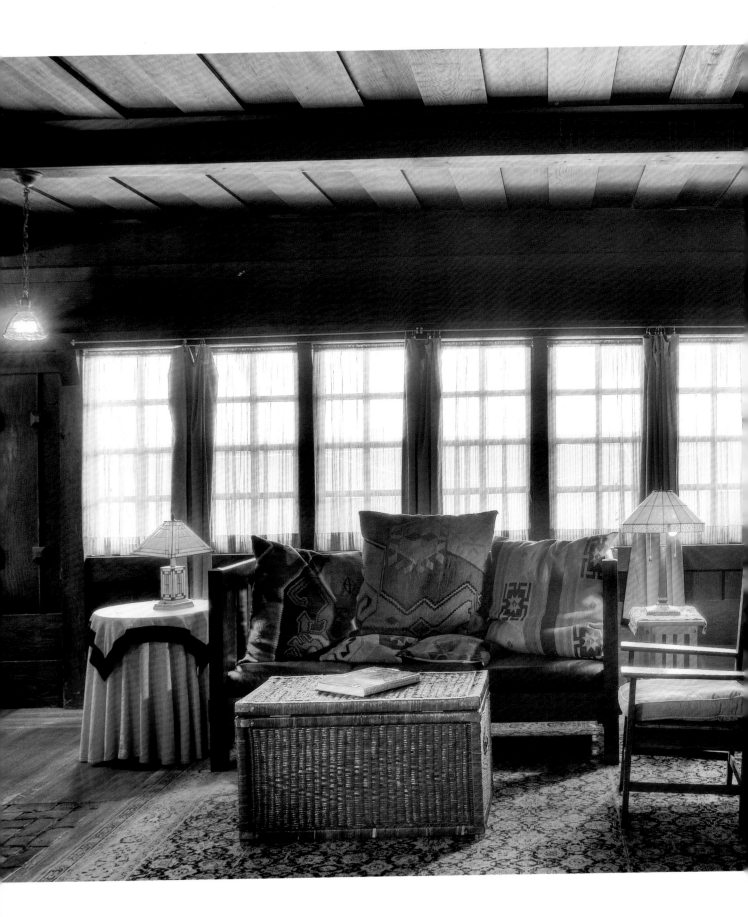

As she researched the history of the Matteson House for the tour brochure, Jane was sickened to discover that the property had been for sale just six months earlier, when she herself had been looking for a house. It had escaped her notice, being priced beyond her budget. She tormented herself for years with the knowledge that it could have—should have—been hers.

Jane came to California in 1961, when her father, Nelson Powell, took a job with Lockheed. After renting a home for a couple of years, Nelson and his wife, Margaret, bought a four-bedroom ranch in Los Altos for $36,000. Every day that summer, her mother took 11-year-old Jane and her sisters over to the house to paint. The whole interior of their new home was pinkish brown, a shade Mrs. Powell found repellent. She and the girls transformed the place with an off-white called "Candlelight Ivory"; more than forty years later, Jane still remembers the name. The girls were allowed to choose colors for their bedrooms, and, never one to hide in the shadows, Jane picked a peachy tint called "Cantaloupe."

Nelson taught his daughters the sort of skills a man of the time would have taught his sons, and Jane became very handy. As a child she built a picnic table and devised a skateboard long before com-

LEFT. The settle and throw pillows, made from kilim rugs, belong to a friend. Jane acquired the coin-operated player piano at no charge from a neighborhood house that was on the market, and the guitar, originally bought from Sears, belonged to her father. The burnout velvet throw came from an American Crafts Council show.

OVERLEAF. With its serried casement windows, redwood paneling, and massive clinker brick fireplace, the living room has the distinct feeling of a woodland cabin—which is pretty much what it was, albeit a rather grand variation on the cabin theme, at the time of its building in 1905. The fireplace separates the central living area from a cozy reading space with built-in storage cabinets.

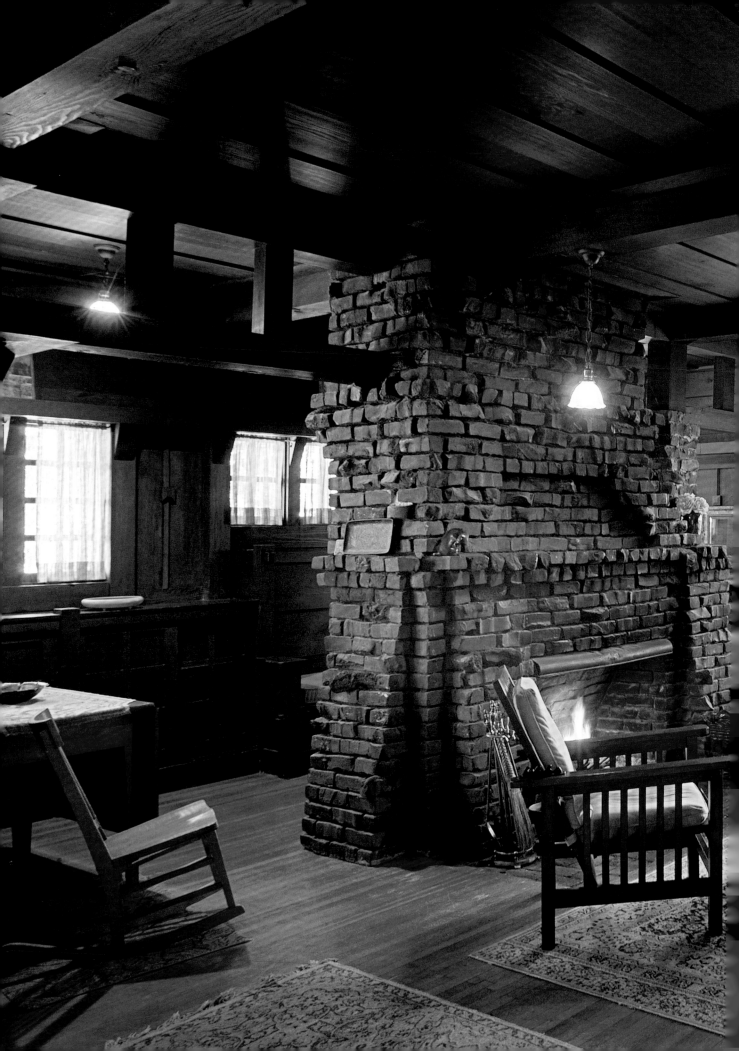

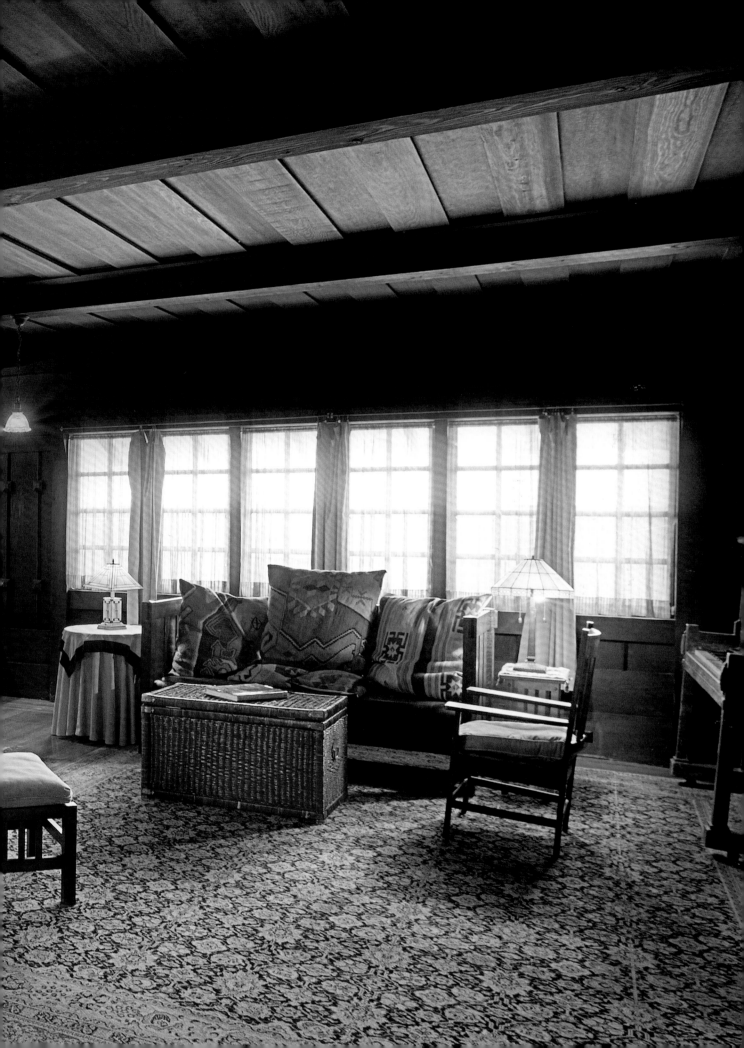

THE TILE AND PLUMBING fixtures are all original. Jane imagines Mrs. Matteson insisting that her husband finish the bathroom with fine tile as a means of providing some visual relief from the acres of redwood paneling throughout the house.

mercial versions arrived on the market. She could fix flat bicycle tires and repair a running toilet. She was also good at sewing. In college she majored in fashion design, and after graduation she supported herself partly by selling her creations at craft fairs. To supplement that income she worked in a fabric store, where she discovered she had a talent for retail display. Over the years she would work in a variety of stores catering to women, from general clothing and accessories to bridal fashions and clothes made from natural fibers. Sometimes she worked on a freelance basis, other times as a formal employee.

For a while during that era she was renting an apartment she loved, only to be evicted when the owner decided he wanted the place back for his daughter. The experience left Jane determined to buy her own home.

In 1986, while sharing an apartment in Oakland with one of her sisters, Jane grudgingly agreed to try video dating, through which her sister had found a boyfriend (now her husband of more than twenty years). Jane was shocked when she met someone who interested her, and even more surprised to find the interest mutual. After several months, she and Steve rented a house and moved in together.

Things were going well, and they decided to buy a house. After viewing no fewer than 150 properties, they chose a small 1912 bungalow in Berkeley. The mortgage broker told Jane she would have to get a job to qualify for a loan, so she went to work at Macy's in San Francisco. She and Steve moved into their home that fall and were married the following year. Eventually they felt the need for more space and bought a shingled Prairie-style craftsman in Berkeley's Claremont neighborhood. They restored the place together, with Jane leading the project.

After six years, the marriage ended. Jane needed some time away. With four cats, she was reluctant to impose on friends for an open-ended stay, so she moved in, gratefully, with her parents, who had retired to southern Oregon. She was 42. Besides her cats, she had some furniture, a growing battery of tools, and a divorce settlement. Some years earlier, she had read a book

about making a living by buying and restoring houses. It was a thrilling idea, though fraught with obvious risk. Still, if ever there was a time to try supporting herself by restoring houses, this was it. She found a bungalow in need of some loving care, purchased it, and proceeded to restore it, working by day and coming home to her mother's cooking at night. In 1996, after a year of restoration, she sold the house at a profit. She was hooked.

By then, Jane was ready to return to the Bay Area. She stayed with a friend while searching for her next project. She found a 1906 bungalow, fixed it up, and sold it, moved on to another, then sold it as well. For fun on Sundays she visited open houses, in one of which she found her seventh project, a bungalow whose previous owner had lived there since 1938 and had blessedly lacked the resources to update it. Jane financed the purchase with help from a private lender, restored it, and sold it.

Her next project was a property in San Leandro, several miles to Oakland's south, which she happened to notice in a real estate handout grabbed from a rack outside a grocery store. It was a 1926 store front with a bungalow at the back where the shop's proprietors had lived. The place was a disaster, reeking of cat urine, with rats nesting in the store area and opossums roaming the basement. The bedrooms were so stuffed with the late owner's possessions that it was nearly impossible to move around. But the place had magic, in spite of its drawbacks. The structure was unusual, its combination of commercial and residential space a distant echo of lost small-town life, when store owners and their families ate, slept, and worked in a single all-purpose building. There was powerful appeal in this integration of home and work-space, which recalled a culture so different from our own day's love-hate relationship with alienated labor. The bathroom still had its original green and purple tile. The store front was paneled with redwood beadboard and had its original counter, shelving, and glass-fronted refrigerator—a rare, irresistible find. From a practical perspective, the property had the virtue of being close to a BART station. Jane immediately recognized its potential to be used as a studio or gallery and bought it.

Jane's work with old houses had turned her into a passionate activist on behalf of historic preservation, and for several years she had been active in the Oakland Heritage Alliance, eventually serving as the group's president. She had become expertly knowledgeable about bungalows, familiar not only with the features uniting them as a genus of vernacular architecture, but also with their lovable, sometimes inconvenient, idiosyncrasies. She was an active, respected participant in local and national preservation groups and had begun consulting professionally on bungalow restoration. The time had come to

FACING. Jane painted her dining room citron bronze and has furnished it with objects purchased affordably from a variety of sources. The '20s carpet came from a friend and the Art Deco sideboard cost $50 at an estate sale. She acquired the table for $100 when Bullock's department store, where she worked, went out of business. The dining chairs cost $15 apiece— less than the cost of the fabric to upholster them! Pendant-light fixtures are original to the house.

The chairs around the edge of the room, which have seats woven from rolled cornhusks, were commissioned by Jane's parents and made by a cabinet-maker in Gatlinburg, Tennessee, while Jane's father was working on the Manhattan Project during World War II.

formalize her professional status, and she registered her business under the name House Dressing—just one of the clever puns for which she has become known.

At a lecture on early-twentieth-century kitchens at Pasadena's Craftsman Weekend in 1997, she had a minor epiphany, realizing, based on audience members' questions, that there was a need for a book about restoring kitchens in old houses. She wrote a proposal and submitted it to the publisher Gibbs-Smith. The resulting book, *Bungalow Kitchens*, on which she collaborated with photographer Linda Svendsen, appeared in 2000 and has since become a classic in the world of old-house publishing.

As property prices in California inflated, Jane had increasing difficulty finding houses suitable for restoration and resale. She was supporting herself on the profit from her labors, but the choice of properties with potential for profitable restoration was dwindling. Ironically, this was a problem she herself had helped create, by contributing to the bungalow's popularity as an architectural style. In 1999 she discovered a charming 1923 bungalow in the East Oakland neighborhood of Maxwell Park, for which she paid $178,000. The house had a stucco exterior with a beautiful arched window at the front, a massive plaster fireplace, and an arched recess in the dining room that just cried out for a vintage Arts and Crafts sideboard. The kitchen retained much of its period character, one highlight being the original yellow and black tile. She had launched into the restoration at her customary full tilt when progress was stopped short by a diagnosis of non-Hodgkin's lymphoma. Friends rallied to her aid, painting her home's interior.

As uncomfortable in the role of invalid as she was with the physical effects of her disease and its treatment, Jane engaged in various acts of rebellion. She was working on her second book, *Bungalow Bathrooms*—"a good thing," she notes in retrospect, "because there was at least one thing I could control"— and took the opportunity to incorporate suggestions for how period bathrooms might be designed with more thought to the ergonomics of throwing up. In defiance of her doctor's advice, she did what work she could on her house, and the following February she flew across the country to attend the annual Arts and Crafts Conference at the Grove Park Inn.

While checking messages on her answering machine one day in November 2001, Jane heard one that made her heart stop. The call had come from a member of the group at the Matteson House. The collective had broken up. They knew she worked on old houses—in fact, they had contacted her from time to time with questions about building products and service providers— and wondered whether she could refer them to a realtor.

"I called back and said, 'Never mind the real estate agent. I will buy your house.'"

It was a ridiculous statement. She was on her ninth house restoration, and this one had taken longer than any previous project because of her illness. Thankfully, the cancer was firmly in remission. But the Matteson House was far beyond her budget.

And yet, she was not about to let it get away a second time. She met the owners with what she calls "the strong negotiating position of, 'Look, I will do anything to buy this house.'" The next six months were torture, as Jane was terrified some wealthy buyer would make an offer so generous that the sellers could not refuse. Contributing to the agonizing delay was the lack of

THE ENTRY HALL, a vision in redwood, retains an original light fixture mounted on the newel post of the staircase over a built-in bench.

comparable properties on which to base an appraisal, since the house was by far the largest in its neighborhood. Accordingly, both parties ordered appraisals, and the sellers finally decided on an asking price of $495,000.

Jane received this information in a voicemail message while out of town at the Grove Park conference. There was nothing in the message to suggest the sellers had decided to sell the house specifically to her, and when she tried to call back, there was no answer. She called repeatedly, leaving messages each time to say she'd heard about the price, needed to speak to the sellers right away, and asking them to call back as soon as possible. Jane was in a cold sweat for more than twenty-four hours, her imagination assaulted by heart-rending scenarios. Finally she heard from the member of the former collective

who was handling the sale that she, too, was at a conference out of town, and so had not been able to retrieve or return Jane's messages. In a daze of panic and relief, Jane agreed at once to the asking price, making no attempt at negotiation.

The house in Maxwell Park was ready to go on the market, but it, too, was hard to appraise, because there were no similar properties in the neighborhood by which to gauge its market value. Fortunately, no sooner had she signed the listing papers than it became the object of a heated bidding war that netted her $100,000 more than her asking price—$368,000.

On the day of the closing in June 2002, Jane had Linda Svendsen photograph the house so that she would, for the first time ever, have professional "before" shots.

Jane has contributed numerous articles to newspapers and magazines and written six books—*Bungalow Kitchens, Bungalow Bathrooms, Linoleum, Bungalow Details: Exterior, Bungalow Details: Interior,* and *Bungalow: The Ultimate Arts and Crafts Home.* She has lectured at conferences, neighborhood associations, and preservation organizations around the country, has appeared on HGTV's *Curb Appeal* and the Food Network's *Ultimate Kitchens,* and has consulted for such distinguished landmarks as the Gamble House in Pasadena. Given her accomplishments and national reputation, some may be surprised to learn that her daily reality is not that different from that of many other single women. To make ends meet, she rents out rooms in her house and sometimes works at a fabric store, just as she did in her youth. At any given time, she has two to three renters sharing her four-bedroom, 1½-bath house. Housemates have their drawbacks, lack of privacy being the most obvious. But in some ways,

IN A CORNER of an upstairs bedroom sits a chair Jane used as a prop during her freelance display days. An ordinary chair from a chain furniture retail establishment, it was initially white. She painted it green, and it looks perfectly at home in this cozy setting.

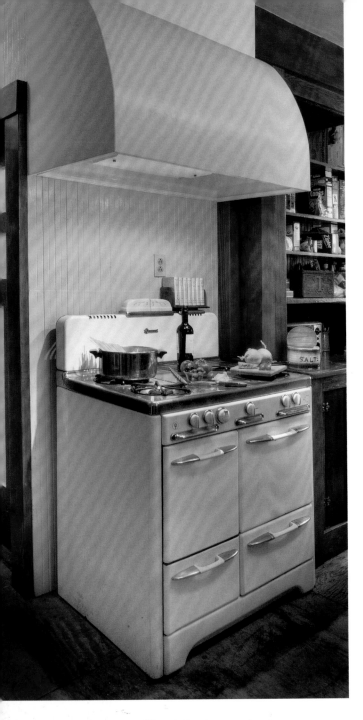

THE 1940S O'KEEFE and Merritt stove is a temporary stand-in for the 1930s Spark that will replace it following restoration. The rounded hood is made from plywood sides with a curved front formed from metal lath; the plywood and metal are plastered and house a contemporary exhaust insert. To the right of the stove is the kitchen's single original cabinet, now moved from its original location. Craftswoman Terry Schmitt is building new cabinets of vertical grain fir, using the original example as a model, and Jane is finishing the new wood with custom-tinted shellac.

she says, they're a blessing; she worries less about security, since there is usually someone at home, and out-of-town travel is easier to arrange when she can count on having someone around to feed the cats. The renters have been varied—mostly men, and mostly middle-aged. One worked on a tugboat, another is an artist who silk-screens dish towels. One former tenant became overly interested in her personally; she found it easier to evict him when he became delinquent on rent.

In 2006 Jane finally tore out the kitchen. She and her renters lived for more than four years with little more for a kitchen than a plywood counter supported by an old cabinet. For most of the summer of 2009 they used a temporary set-up on the back porch—Jane fondly recalls the more poetic aspects of that *plein air* arrangement—with small appliances in the dining room. For now, the floor is bare plywood, and the new cabinets await their drawer faces and doors. But the end is in view—the sink is mounted in a honed soapstone counter, a vintage candy store showcase serves as a practical island, and she and her tenants use the kitchen's capacious original fir cabinet as a pantry. These days, Jane spends much of her spare time applying custom-tinted shellac to her kitchen's original fir trim, which she has carefully stripped and plans to reinstall shortly. She hoped to get the kitchen close to finished in 2010.

To this day, she recalls the first time she saw the house. She had parked the car on Sunset Avenue, a dead-end street at the top of a steep San Francisco hill, with a distant view of the bay. Climbing the driveway, she looked up at the house. The sight of it took her breath away. And that was just the outside. Although her response has mellowed over the years, she finds herself filled with love and admiration every time she comes home, occasionally going back to that first, stunned moment of realization, at the closing, that the house was hers.

There had been so many houses. She had invested herself, to varying degrees, in each one, and each had repaid her care—not just with shelter, and when she sold it, income, but also with opportunities. Each had presented its own challenges and required her to master new skills. She had built a life by restoring those places to their original house-proud shine, and she had passed them on to people who valued their history and character and would act as worthy stewards. Over two decades of domestic archaeology and documentary research, those places had also taught her much about what truly mattered to people of earlier times—family, community, taking care of things so they would last. And then she'd met her match. In the acknowledgments to her 2004 work, *Bungalow: The Ultimate Arts and Crafts House*, she thanked "whatever cosmic forces brought me to the Sunset House, which is a daily source of beauty, joy, and amazement." For the first time in her life, she has no plans to leave.

ATOP A STEEP HILLSIDE, the Asian-influenced Matteson House, with its classic massing of echium at the edge of the drive, would originally have had a commanding view over the surrounding area.

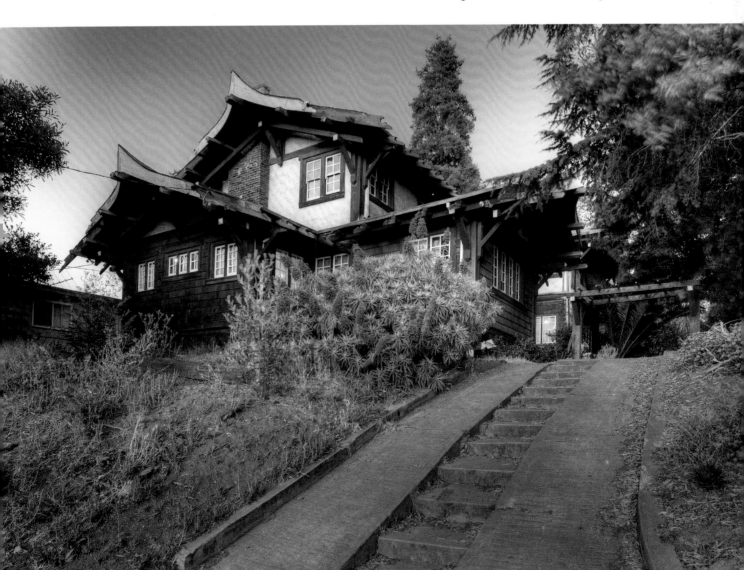

15 DIVERGING FROM THE SCRIPT

JEAN ALAN was trained to act in the supporting roles of daughter, wife, and mother, rather than in leading parts. As a teenager of the '50s, she learned to curb her own ambitions and focus on marrying a man who promised to achieve great things. Though she was fascinated by buildings and interior design, it didn't even occur to her that she could train to be an architect. She married one, instead.

Which is deliciously ironic, considering that Jean eventually made her way into the world of motion picture set decoration, where she worked on such prominent productions as *The Blues Brothers* and *About Last Night.* Later, she segued from creating backdrops for fictitious characters to producing intricately crafted domestic environments for clients in real life.

Today, Jean lives on the third floor of a hundred-year-old brick building she purchased in 1986, the lower two floors of which are rented to tenants. Well before you set foot in Jean's own apartment, you can tell it's home to someone unafraid to diverge from convention. There's a distinctive use of space, with every cubic foot put to use—but subtly, so there's no sense of being crowded.

Even the stairwell leading up from the shared entry is more than mere intermediary expanse; Jean's personality is everywhere, no less than in any other room. The high walls, painted a warm shade of teal, hold a variety of decorative objects—a coat rack hung with a collection of purses; a Patty Carroll photograph of a bare-breasted woman holding a spatter guard, her hands gesturing *namaste*, as though she's blessing all who come and go; an antique

IN JEAN'S HANDS, a radiator becomes as decorative as it is functional.

177

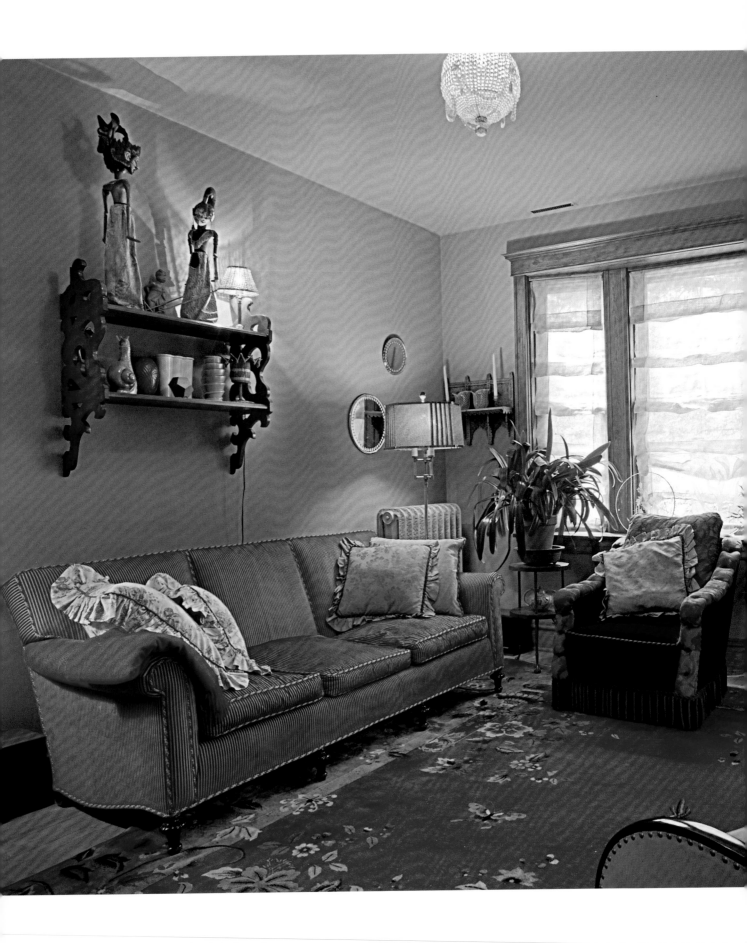

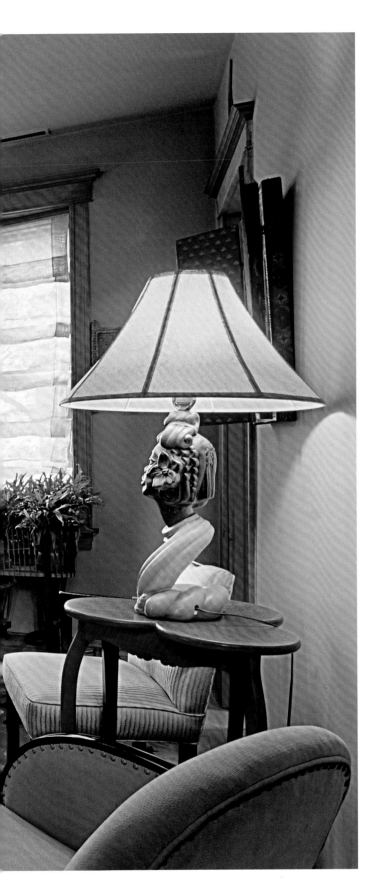

quilt of silks and velvets interwoven with a campaign ribbon from 1886. Just outside Jean's door hangs a photographer's contact sheet in a 1930s tramp art frame; the series of images shows her daughter Ruthie at seven, with an expression that morphs from distracted stares to a big, toothy smile and culminates in a fittingly final yawn. "Hysterical!" Jean calls it, though she makes the comment in the most appreciative way. She'd better; Ruthie, now forty, has a master's degree in communication from Northwestern University and has been Jean's business partner since 1994.

The door opens into a hall with cobalt tiled wainscot and glazed amber walls. Turn left for kitchen and bedroom, right for office and parlor. The entire residence occupies just 900 square feet, yet the overwhelming impression is of style, not limitation. It's colorful, sharp, and eclectic—comfortably pulled together, rather than self-conscious or contrived.

Jean grew up on the northwest side of Chicago, the elder of two daughters born to a mother who worked as a secretary and a father employed as an economist by the Federal Housing Administration. Even as prevailing social norms urged Jean to content herself with a future as wife and mother, her senses told her that there could be more. From early childhood she had a dim awareness of possibilities denied her by convention—of a life that could be exciting, challenging, gratifying. She recalls with special fondness an elderly neighbor who often invited her over to play with boxes of beading and lace.

JEAN'S LIVING ROOM is colorful and eclectic, with upholstery and shades by her own professional workroom. An Art Deco floor lamp is a memento from a set she designed for *About Last Night*, with Rob Lowe and Demi Moore; she bought the lamp after filming had ended. The painted plaster lamp base on the opposite side of the room dates to the 1940s. Jean has owned the Deco-era Chinese rug for decades.

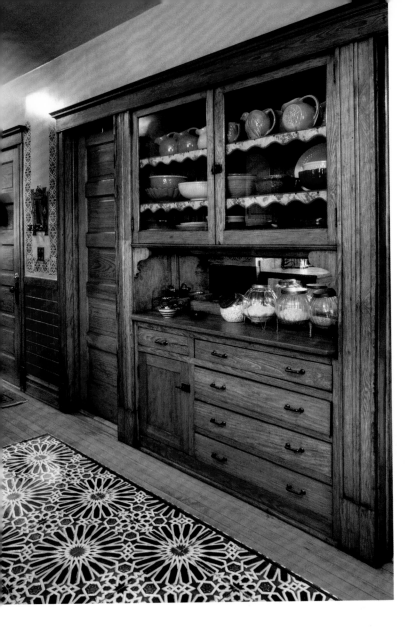

JEAN STORES her collection of colorful dishware in the original kitchen built-in. The tiles in the foreground are not on the floor, as they appear to be in this view, but on her kitchen table under an easily cleaned sheet of clear glass. The tiles, reputedly made in Sevilla, were salvaged from a 1920s movie palace in Milwaukee.

The visits were a sensual education in texture, drape, and smell, and to this day, she says, she loves to play with "stuff."

Her absorption with "stuff" grew deeper with the passing years and developed into a fascination with architecture during high school, when Jean and a few friends discovered an intriguing complex of buildings in Chicago's Old Town. With a courtyard, goldfish pond, and outdoor stairways draped with vines, the place evoked an enchanted world where artistry and sensual delight were clearly regarded not as self-indulgent irrelevancies, but as worthy ends of human endeavor. The gate to the courtyard was never locked, and the girls began letting themselves in after dark to wander around and look through windows into lighted rooms, "like 16-year-old architectural peeping Toms."

What they saw through those windows were people's homes—but homes unlike any they had known. The three-story complex, originally a Victorian family's mansion, had been thoroughly reworked in the 1930s by Edgar Miller, an art school dropout who was driven to create places that would throb with the vitality of the artisans who made them. Miller's partner in the project was Sol Kogen, an artist-turned-developer who returned to Chicago in 1927 after a decade in Paris, eager to convert old buildings into studios, as he had seen done in Europe. Collaborating with other artists and craftspersons, the pair transformed the mansion into seventeen units, each with its own distinctive architectural details, and named it the Carl Street Studios.

As a teenager, Jean knew nothing about this official history. Granted, she could recognize the buildings' Art Deco influence, but what struck her more was their distinctive appearance of being handmade. There were soaring windows, some with clear leaded glass, others with abstract patterns and brilliant colors. There were exotic arched ceilings, curving brick walls, and clay tile with matt glazes in a joyful riot of shades. These homes weren't just decorated with art; they *were* art. The Carl Street Studios made a profound impression,

convincing Jean that the world had more to offer than the "very prescribed and deeply ordinary" life she had known.

She bought a subscription to the *Village Voice*, splitting the cost with a couple of friends, and began frequenting a folk club where she sat at the feet of such countercultural prophets as Josh White, Bob Gibson, and Pete Seeger. At the University of Wisconsin in the early 1960s, she studied cultural history and spent summers designing a line of women's clothing for a store in Old Town that sold imported handicrafts, jewelry, and primitive art long before such things became common.

Jean did not complete her degree, but married at 23 and spent the next several years as a stay-at-home wife and mother. Her first daughter, Jessica, was born in 1966, and Ruthie arrived four years later. The marriage was not the kind of "true partnership" that Jean, who proudly identifies herself as "a sister of the feminist revolution," wanted, and in the late 1970s she and her husband were divorced.

By then, Jean was in her mid-thirties. During the months of upheaval and introspection that followed, as she strove to figure out how she would support herself and her daughters over the long term, her passionate interest in "stuff" reasserted itself and she vowed she would find a way to realize her creative potential. The only question was how.

She began going to movies—lots of them—not just for entertainment, but out of a growing compulsion to see how they were made. What kind of magic enabled those scripts on paper to come so convincingly alive? Each story clearly required the conjuring of an entire world. She recalls one film in particular, the early 1970s production of *The Garden of the Finzi-Continis*, as "ravishingly beautiful . . . sensuous, luscious." Scanning the credits, she noticed a recurring term: "set decorator." So *those* were the wizards responsible for transporting her from a drab theater in Chicago to an Italian villa of the 1930s, or any number of other points on the space-time continuum! At last Jean knew what she wanted to be.

She had no training or professional experience in the field, and with two young daughters she was hardly in a position to go back to school. So she simply began contacting photographers and filmmakers in the hope that someone would give her a chance to show what she could do. One of those audacious cold calls paid off, when Julie Chandler, a producer with extensive experience in television advertising, hired her to work on commercials and later brought her in to work on films. Julie didn't care that Jean lacked formal training; she recognized her talent and knew that Jean would be an asset to her own productions. Just as important, Julie understood the challenges Jean faced as a single mother and wanted to help her out.

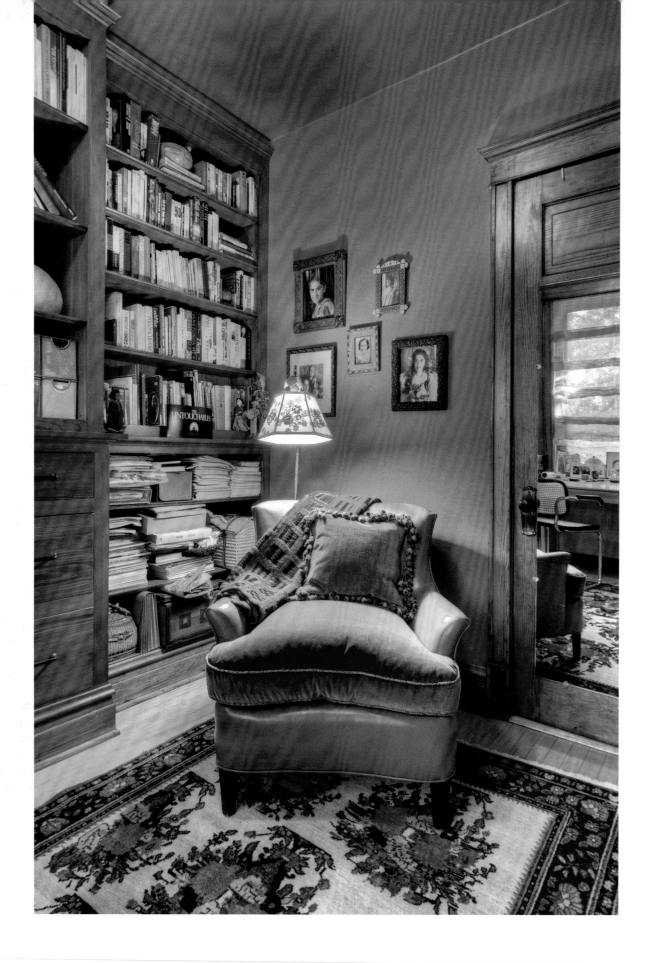

The best-known production on which Jean worked was *The Blues Brothers*, which remains a cult classic to this day. Jean's primary contribution was as set decorating assistant for the creation of the police chase scene at a mall. John Landis, the film's director, had planned to shoot the chase at an abandoned shopping center in Harvey, Illinois; for perfectly surreal effect, the characters would enter the mall through a Toys "R" Us storefront. Laughing at how times have changed ("Today," Jean notes, "that would be called 'product placement' and would command a huge fee"), she recounts the decidedly unprofessional circumstances in which she called Toys "R" Us and got the president on the phone—she called from home, using her single phone line with no call waiting, while her two daughters played noisily in the background—to ask him to participate in the movie project. But she got what she needed.

Jean spent twenty years working as a motion picture set decorator. Toward the end of that chapter in her career she spent a grueling year and a half decorating for *The Untouchables*, a weekly television series produced by Paramount Pictures. The unforgiving schedule demanded an exquisite degree of organization, so she set up her own prop shop with a full-time crew of set dressers who made drapes, fixed up old furniture, procured dishes, lamps, pictures, rugs . . . everything needed to furnish a variety of scenes. When *The Untouchables* came to an end, she took stock of her professional options. She had a top-notch drapery workroom and a relationship with a highly skilled upholsterer. There was clearly a market for vintage furniture. She realized that between her workroom, her sophisticated eye, and her knowledge of the upholstery business—by then, she had many years' experience at turning orders around on impossibly short notice—she had everything necessary to create customized furnishing products of high quality. So in 1994, in partner-

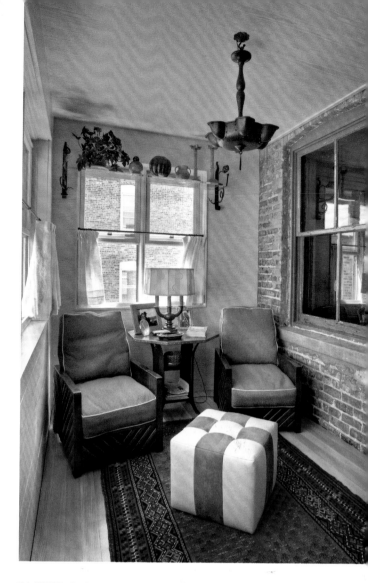

FACING. A plush blue chair in a corner of Jean's office invites sitting. In her own home, Jean says, she uses color as an artist, not as a decorator; instead of being "careful" with matching and coordination, she revels in "the joy of being expressive." She had the millwork and built-ins done at the same time as the kitchen cabinets were constructed.

ABOVE. Jean transformed the back porch into finished space with vertical grain fir floorboards and pine walls and ceiling. On the table between a pair of French Colonial palm wood chairs from Senegal is a ceramic lamp Jean bought in Paris and carried home in her luggage. The ceiling fixture was made by Argentinean iron craftsman José Thenee in the 1920s or early 1930s; the fixture was purchased in an estate sale of his personal belongings. The window on the left wall looks across a beautifully landscaped garden to Bucktown House, where Jean operates a vacation rental.

ship with Ruthie, she opened a store in Bucktown selling pillows, lamps with
custom shades, and reupholstered vintage furniture.

The business flourished, and over the years Jean and Ruthie found clients
requesting advice on how to decorate. "Bit by bit," Jean says, "they turned us
into interior designers."

Jean's older daughter, Jessica, who worked with her mother during sum-
mers in high school and college, attended Vassar College, where she earned a
degree in art history. Inspired by her mother's work, Jessica declined an offer
of an internship at New York's Metropolitan Museum of Art and moved to Los
Angeles to pursue a career in film and television production. Jessica's work,
which has to date included *Thirtysomething*, *The Matrix*, *The Thin Red Line*, and
Sherlock Holmes, is hugely gratifying to Jean, who can't but see both daugh-
ters' career choices as the deepest affirmation that she was right to trust her
nascent professional intuition some thirty years ago.

Jean bought her property at the urging of a friend who recognized that the
neighborhood, which was rundown but full of charming old houses and just
three miles from the center of downtown, would almost certainly see a dra-
matic increase in value. She had received a settlement following an automo-
bile accident and wanted to make a secure investment, so she took the plunge,
planning to make a home for herself on the top floor and rent the other two
apartments for income. At the same time that she bought her own house, she
purchased a second building just behind it; constructed toward the end of the
nineteenth century, that building houses two apartments Jean has restored
and now operates as vacation rentals under the name "Bucktown House."

Originally built around 1910 as "cold-water flats" for working-class immi-
grants, the house Jean lives in had only space heaters and a water heater in the
kitchen when she bought it. She had the entire structure rewired and plumbed
and also had furnaces installed. For her own apartment she wanted old-
fashioned radiators, because she doesn't like forced-air heat; she found a set
of radiators at salvage, had them sandblasted, and painted them in beautiful
muted shades to highlight their ornate cast decoration. She had the original
maple floors refinished, repaired the plaster on ceilings and walls, and had
the yellow pine trim refinished. Since much of the original crown molding
had been removed by the time she bought the building, she got a new knife
ground to match and had replacement crown milled to order.

Jean moved into her flat in 1994. She loves the place, the small scale of
which is easy to maintain and ensures that everything she needs is close
to hand. With natural light from all four directions—a rarity in downtown
Chicago—she has the luxury of using bold colors without overpowering the

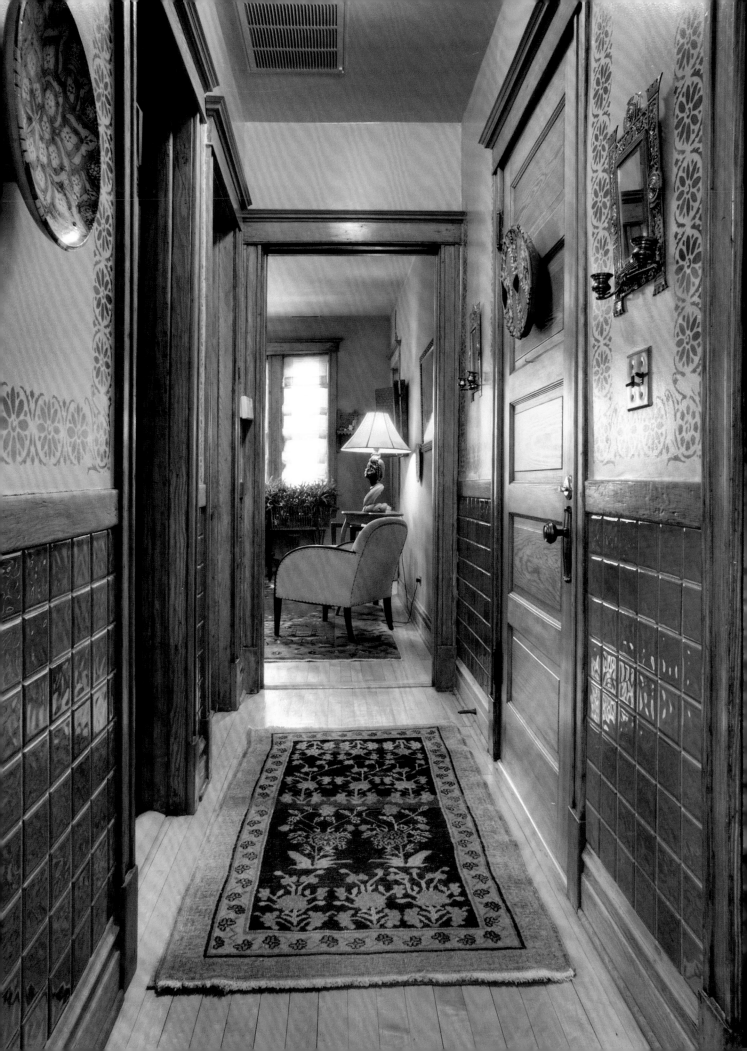

space. She sees her period-sensitive approach to design as an outgrowth of her training in set decoration. "Everything I do has a strong narrative quality and looks like it was always there."

While the work she has done in her own home, on film sets, and for clients has been deeply fulfilling, Jean has found some of her greatest satisfaction in projects undertaken for her community. In conjunction with the Chicago-based organization Design for Dignity, she has designed the Lakeview Food Pantry, a preschool for children who have been victims of violence, and a drop-in center at a facility for individuals struggling with multiple addictions. For this principled, independent, and accomplished woman, few opportunities are more rewarding than those which allow her to exercise her talent in the service of her values.

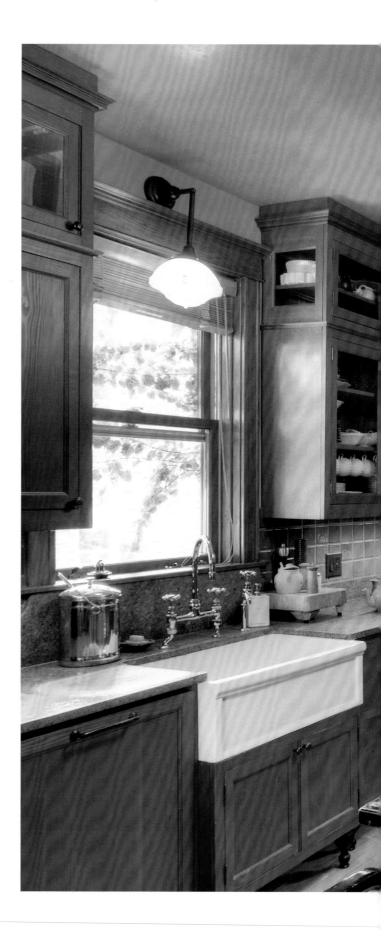

JEAN BEGAN REDOING the kitchen in 2001. She designed the new cabinets based on the original built-in and had them made from old pine salvaged from a True Value Hardware warehouse, with cast iron feet from a set of nineteenth-century retail display cabinets. Around the table, once used by a furrier for retail display, are Breuer chairs manufactured by Stendig in the 1960s.

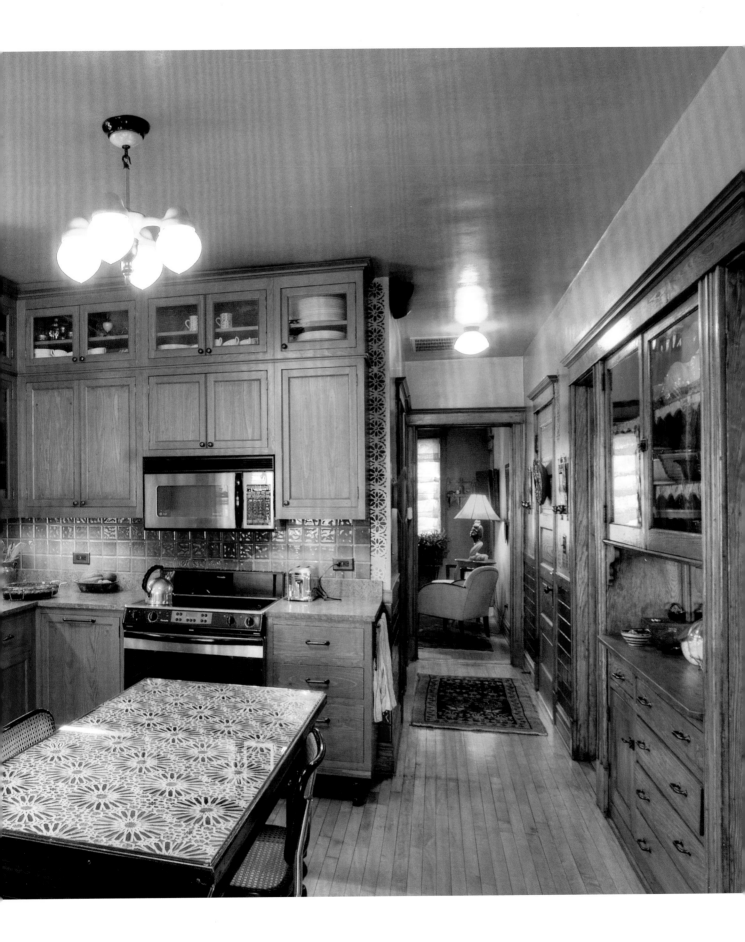

16 A Preference for Lawyers

"And so, Lady Slane, having seen the house,
 what do you think of it?"
"I think it would probably suit me very well."
"Ah, but the question is," said Mr. Bucktrout,
 again putting his finger to his lips, "will you suit it?
 I have a feeling that you might."

—VITA SACKVILLE-WEST, *All Passion Spent*

STRAIGHT OUT OF graduate school, where she had earned both a J.D. and a doctorate in political science, Jeannine Bell was hired as a professor of law at a large university. For the first year in her new location she rented a railroad worker's cottage a couple of miles from campus. Though getting to work was a quick drive by car, finding a place to park was another matter. As she saved up the down payment for a home of her own, she resolved to find someplace closer to work. Eventually she called a realtor, to whom she presented a list of parameters—she wanted to be within walking distance of her office; she had a price range, based on her income and savings she'd been able to amass during that first year of employment; and she wanted her house to be old.

The realtor took Jeannine to visit some forty properties, most of them suburban ranches from the '40s and '50s. Not at all what she was looking for. Jeannine was beginning to wonder whether she would ever find a historic home in a neighborhood within walking distance to work when, out of the blue, she received a call from another real estate agent, who had been

BOLD COLORS and posters of paintings by Lawrence, Gauguin, and Tarkay surround a daybed in Jeannine's guest room.

referred to her by a mutual acquaintance. *Could he be of assistance?* he inquired. Jeannine described what she hoped to find, only to hear the confident fellow declare, "Dr. Bell, I have something for you." The property he had in mind, a three-bedroom, one-bath Colonial Revival cottage with a basement garage, had only just been listed with the brokerage where he worked, so he could offer her the rare opportunity to see a desirable property before it became publicly available. Jeannine scheduled a viewing for the next day. No sooner had she hung up the phone than she thought better of it and called back. Could they visit today, instead?

They arrived in the early evening. The single-story house had white clapboard siding and a red front door sheltered by a gabled portico that anchored the facade, bestowing an air of confidence and distinction. Small house, large personality. The lot was compact, with a lush magnolia tree and a hedge of old yews in front. The realtor unlocked the door and showed Jeannine inside.

The door led directly into the living room, which possessed the rare quality of appearing simultaneously expansive and concise, partly because it opened onto the adjacent dining room. In the space of a moment she took it all in—the hardwood floors, the plastered walls, and above all the beautifully proportioned four-over-four-pane windows, the light streaming through which bathed the interior in a warm glow—and asked, "How much should I offer on this house?" Years later, she's still struck by her immediate certainty about the place, especially when she recalls that despite her passion for cooking, she hadn't so much as glimpsed the kitchen.

JEANNINE FOUND her dining table at a Kiwanis Club garage sale in Ann Arbor. Every one of her happily mismatched chairs has a story behind it; a woman at the Kiwanis Club nicknamed Jeannine "the chair lady" because of her fondness for collecting.

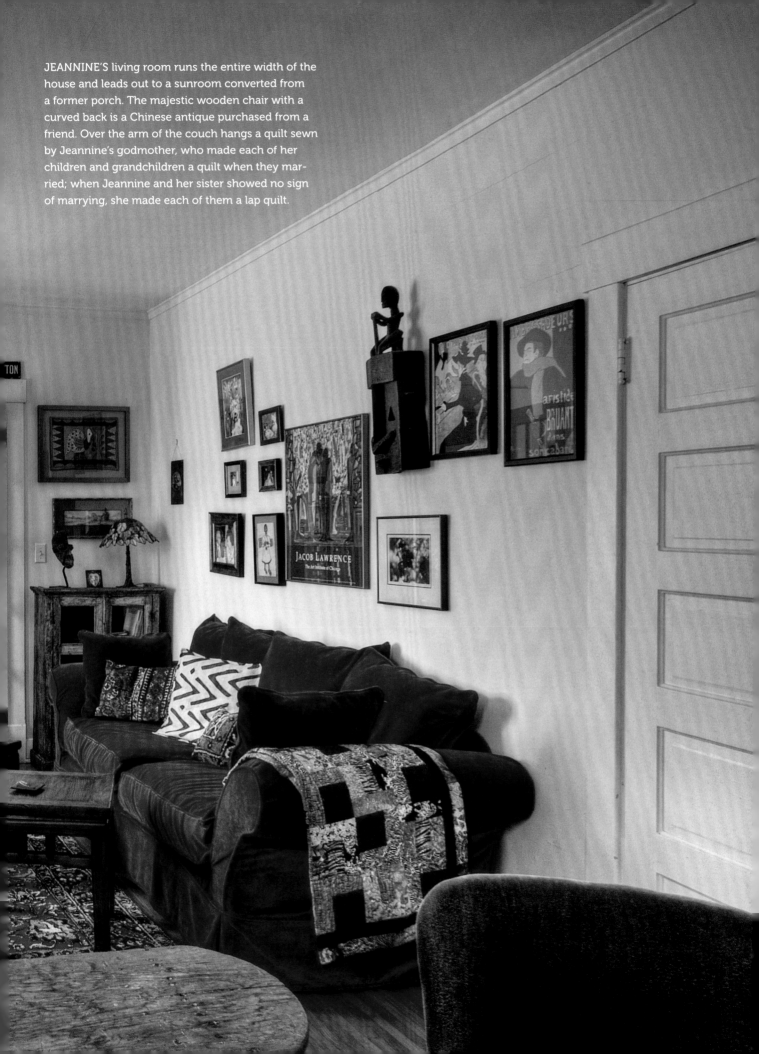

JEANNINE'S living room runs the entire width of the house and leads out to a sunroom converted from a former porch. The majestic wooden chair with a curved back is a Chinese antique purchased from a friend. Over the arm of the couch hangs a quilt sewn by Jeannine's godmother, who made each of her children and grandchildren a quilt when they married; when Jeannine and her sister showed no sign of marrying, she made each of them a lap quilt.

She and the seller agreed on a price and scheduled the closing for later that spring. Despite having an accepted offer on the property, the seller's realtor put a For Sale sign in the front yard and also ran a newspaper ad, clearly wishing to exploit the irresistible house to generate leads for other business. Savvy and legitimate though the realtor's strategy may have been, it proved a source of anxiety for Jeannine, who feared she might not end up getting the house. Fortunately her concerns were unfounded, and the closing went through without a hitch.

It was Jeannine's first real estate purchase. "Most of the new law faculty who have come since I arrived have been married," she points out, "and bought houses as soon as they were hired." But she had had no money right out of school; in fact, she had only been able to buy a used car with the help of a loan from her parents. When she closed on the purchase of her house, the down payment and closing costs took nearly all the money she had. Buying the place was a huge achievement.

Her parents, both of whom were able to see the house before the closing, were elated. "We're coming up and painting!" said her mother, a floriculturist and garden designer in New Orleans.

Before moving in, she had the hardwood floors sanded and refinished. Her mother helped her get an early start on the landscaping, and she spent the summer preparing for fall courses and working in her new garden. Buying a house, moving in, unpacking boxes, and taking tiny steps toward renovating made for a very busy summer indeed.

Jeannine wanted the house to have a second bathroom, and her mother urged her to create a master suite, rather than locating a bath in a separate room. The only logical place to put the new bath would be the bedroom closet, which was a scant three feet wide by seven feet long. By stealing some space from the back porch, her contractor was able to increase the bathroom's length to a more reasonable ten feet, which would accommodate a shower. Jeannine designed the room herself, inspired by a bathroom in a Seattle tile store. With pale pink walls above white subway tile—sharp black liner, classical cap mold at the top—the room is practical, feminine, and nicely respectful of the house's architectural style. She found a tiny wall-hung sink on a visit to Seattle and brought it back on the plane in her carry-on luggage.

Although the bathroom was Jeannine's first-ever construction project, it was a deeply satisfying success, and a few years later she renovated the existing porch on the south side of her house to make a sunroom, which is accessed from the living room through the original French doors. Once again, her parents came up to help. The three of them visited a local quarry and found a huge piece of limestone from which her father, who had built a marble patio at

the family's house in Detroit some thirty years before, crafted a limestone and gravel patio. Her mother selected a white picket fence to be placed between Jeannine's property and the neighbor's, and then helped erect it.

Jeannine shares her home with Harry, her West Highland white terrier. The dog is more than a companion; he is also a remembrance of a person and cause close to Jeannine's heart, Harry T. Moore, a teacher and tireless NAACP activist who, with his wife, was killed in 1951—on the couple's twenty-fifth wedding anniversary, no less—by a bomb planted below the bed where they slept.

Harry T. Moore—the Westie, that is—is "a white dog with black skin named for a black man who was killed by men in white sheets." Like his namesake, Harry is not afraid of staring down far bigger things. A small dog who thinks he's big, he is stubborn, tough, and almost too adorable to resist. She has negotiated an arrangement whereby Harry acknowledges her alpha status, even as he attempts to subvert their domestic order by exercising his intelligence and rascally charm.

Jeannine has furnished her home with a mix of garage sale finds, hand-me-downs from family and friends, the occasional piece of furniture bought new, and even a pair of theater chairs taken from a gang of four salvaged from the Ann Arbor Civic Theater. The walls are hung with African masks acquired through a friend. Framed posters by Harlem Renaissance artist Jacob Lawrence add punches of color to every room. Curtains, where Jeannine has used them, are filmy wisps, mere suggestions of privacy, cinched at the center to avoid detracting from the lovely windows' lines. Combined, these eclectic elements make for an interior that is sophisticated, relaxed, and powerfully inviting.

Professionally, Jeannine is a scholar who analyzes hate crime. Her current research concerns members of minority groups who have moved into established neighborhoods with homogeneous populations and found their presence distinctly unwelcome—families who have been greeted not with plates of freshly baked cookies, but by burning crosses, broken windows, and, on occasion, even murder. In contrast, she notes, her own experience as a black woman who moved into an overwhelmingly white town "has been entirely wonderful." Her status as young, single, and black has not generally been a point of curiosity, with one exception. After calling repairpersons or contractors to look at house-related projects, she has sometimes been asked, at a first meeting, "So . . . *you* own this house?" Or perhaps the emphasis is, "You *own* this house?" In either case—whether the emphasis is on her single status, her relative youth, or her race, each of which independently, for better or

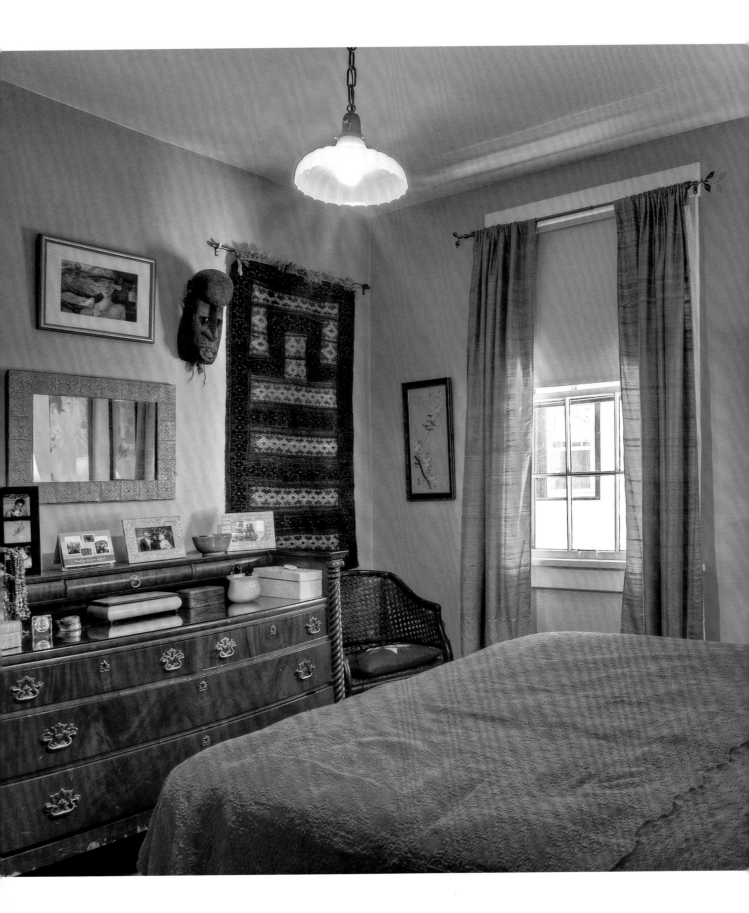

worse, might prompt the quizzical reaction—such questions make clear that she does not easily fit the standard profile of "property owner" in her locale.

This is especially ironic, in view of an extraordinary coincidence that came to light shortly after she bought her home. While talking with a friend's mother—a woman who had been a close friend of the owner some thirty years before—Jeannine learned that she is the fourth female lawyer to own the property. Apparently, this house has a preference for a certain type of owner.

HANGING ON A WALL of Jeannine's bedroom is a prayer rug. The elaborate dresser was a present from a friend.

17 OCCUPYING SPACE

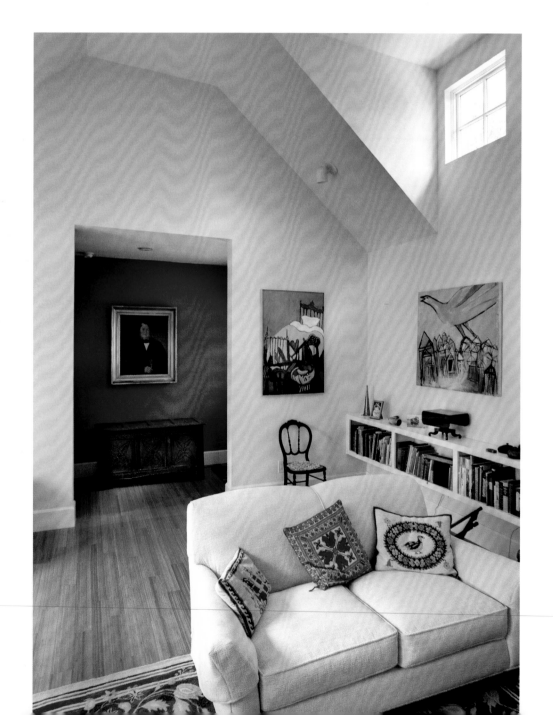

DIANA HAWES went to school in Farmington, Connecticut, where the soft, rolling landscape and 200-year-old buildings reflect the heritage of British settlers. Her father often took Diana and her siblings for drives through the countryside to look at houses, a custom she credits with stimulating her interest in architecture.

At her school in Farmington, the buildings themselves provided a kind of education. The town had been part of a prosperous community, and its wealth was reflected in refined domestic architecture. The main brick school building, which dated to the institution's founding around 1840, had a large double parlor in which students gathered each morning for prayers and announcements. Most of the other buildings, converted houses, were constructed of wood with clapboard siding, double-hung windows, shutters, and gracious facades. Some were Federal in style, others Greek Revival, depending on when they were built. Some had columns; some, transoms over interior doors; others, fanlights and sidelights at their front entrance. Inside, wooden floors were creaky, stairs winding and uneven. For Diana, this blend of age and unpretentious dignity made a lifelong impression.

Her interest in historic architecture was deepened in courses taken at Smith College, and later at Barnard College in New York, where she majored in art history. With such iconic buildings as the Gothic-style Cathedral of Saint John the Divine, the Art Deco Chrysler Building, and the modernist Seagram Building, New York was a living museum that inspired Diana to fill her semesters with courses in architecture.

DIANA'S HOME is furnished with a mix of antique furnishings and contemporary art.

She spent the summer of 1967 working for Christie's auction house in London, where she was assigned to the division handling English watercolors. She was so taken with the genre that she enrolled in a graduate seminar in the subject at Columbia University. Her professor, Louis Hawes, was charming, absent-minded, thirty-seven, and unmarried. Like Diana, he was an Anglophile and loved music. Oblivious to the impropriety of doing so, she became romantically involved with him, and they were married right after she graduated in the riot-torn spring of 1968.

Though Lou had not been granted tenure at Columbia, he received offers of employment from several other universities, among them Indiana. He had good friends in Bloomington and decided to accept a position there teaching art history.

Initially, Lou and Diana lived in rented houses, but after a year they wanted a place of their own. For both of them, home had always meant an old house. But in the late 1960s, historic preservation and old-house culture in general were not yet the popular phenomena they have since become, and many of Bloomington's old properties had been demolished.

On the outskirts of town they discovered a three-room saltbox cottage built around 1850. With a living room, combined kitchen/dining area, and just one bedroom, it was smaller than they would have preferred, but it was in a quiet location on an acre lot shaded by huge maple and walnut trees. Diana, who has what she calls "an almost biological need" for the tall ceilings she grew up with in her parents' homes, was pleased to find that the main room was ten feet tall.

They bought the house, drew up plans for an addition, and signed a contract with a builder. They were eager to get construction underway, since Diana was pregnant and they wanted the extra space. At the very last minute, when he should have been pulling up in a truck with a crew to break ground for the addition, the builder backed out of the deal. Diana was so upset that she went into labor that very night, giving birth to her son Christopher a month prematurely. For a year the home's single bedroom became a combined study and nursery, while Diana and Lou slept in the living room on a fold-out couch.

Two years later Diana gave birth to her second son, Daniel. He inherited the kitchen/dining room, where, Diana says, the former kitchen sink proved "very useful for bathing baby" and they stored his clothes in the cabinets. Over the years, the house grew to three times its original size and took on a character something like that of a New England farmhouse—a rambling collection of spaces on different levels and with various rooflines.

Diana put her love of old buildings into practice by helping to establish a local historic preservation organization called Bloomington Restorations. She studied vernacular building with Professor Warren Roberts of Indiana University's Folklore Department, and earned a master's degree in art history. With her friend Karen Craig and photographer Jim Clary, she co-authored *Bloomington Discovered*, a book that recounted Bloomington's history through its architecture. Later she coordinated the Historic Structures Inventories of Bloomington and Monroe County for the Indiana Division of Historic Preservation.

The boys grew up and left home. In 1993, just as Lou neared retirement and the couple looked forward to years of vacationing in Maine and traveling to the world's art museums, he died following a short illness. Diana, who had enrolled in a doctoral program in architectural history at the University of Illinois, stayed on in their home and worked toward her degree.

Three years later, Diana married Kenneth Gros Louis, a distinguished professor and beloved university administrator whom she had known some-what, through mutual friends. Ken, too, had been widowed and still lived in the house where he and his wife had raised two daughters. Like Diana's, his house was unique. Modest in size, and just one story high, it had been built by an Italian stone carver, Joseph Anthony, as his family residence. Anthony had carved an intricate limestone surround for the fireplace, an elaborate formal entrance, and a birdbath for the back yard. The bathroom and kitchen walls were fitted with original glass tile manufactured by a local company, Nurre Glass; those in the bath were especially striking, with a marbleized design in shades of purple and magenta. The kitchen still had its original late-1920s cabinets, right down to the Art Deco mosaic tile counter. On top of all this, Ken's house was just a few blocks from campus.

Still, says Diana, explaining their decision to part with these equally mar-velous homes, "it seemed only fair to give up both." They bought a nonde-script limestone house in a wooded subdivision just outside of town. The hilly location was peaceful, with a large lot—the perfect site on which to locate a home Diana would help design. Long an admirer of work by English architect Charles Francis Annesley Voysey, she hired a young architect friend, Malcolm Woollen, to plan a Voysey-inspired house that would be well suited to the sylvan site. The house had all the charm characteristic of Voysey's country cottage creations—a genuine stucco finish, steeply pitched roof, battered corners, and terracotta window trim. The interior space was planned with Di-ana's antique furniture and paintings in mind. Many of these things, passed on by her parents, demanded a certain type, and amount, of space. A Federal-

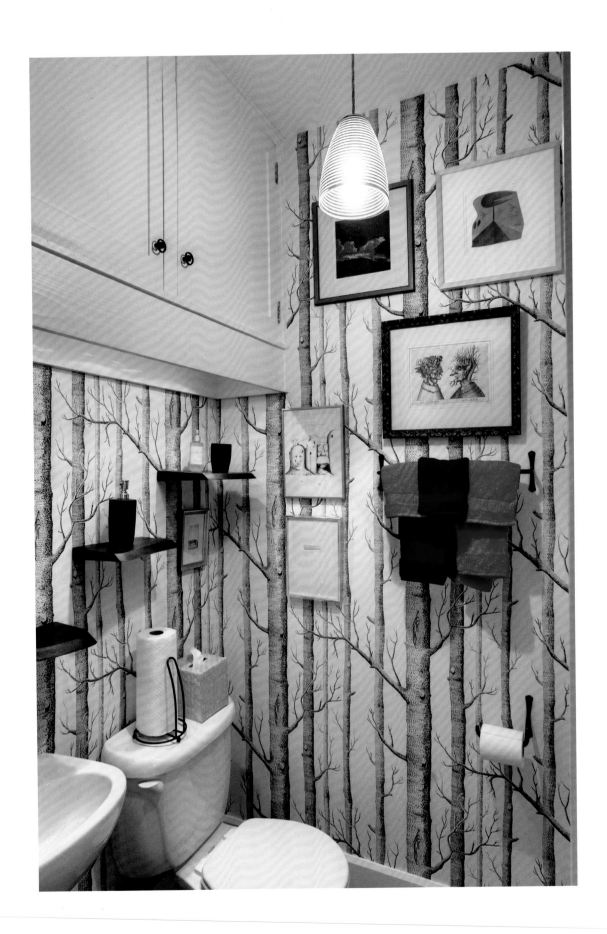

era mahogany sideboard wanted just the right position in which its old-world craftsmanship and dignity could be admired. A seventeen-foot-long carpet required a dining room of uncommon proportions. A Chinese ancestor portrait, five feet tall, would look out of place hanging anywhere but over a mantel in a room with high ceilings.

In 1997, when the house was complete, Diana had the site landscaped with an English-style cottage garden at the front. Romantic spires of hollyhocks, cascades of rugosa roses, mounding candytuft, lots of spring bulbs, and masses of small yellow dahlias provided the perfect foil to the architectural austerity. She arranged viburnums and clematis near the front door and had crabapples espaliered against the south-facing wall. In a shady spot under an old oak tree she planted celadon poppies, bluebells, and lilies of the valley. For Diana, the new home was a dream come true, combining charm and originality, space, light, and seclusion. Diana spent her time teaching courses in architectural history for the School of Fine Arts and accompanying Ken at official university functions, while tinkering unendingly with details in and around the house.

After several years she and Ken agreed to separate. Their interests had diverged, and Diana felt that Ken's admirable and absolute dedication to the university did not leave room for the kind of life she envisioned for her later years. She was crushed when Ken said he wanted to live in the house, but hoping to keep their relationship as amicable as possible, as well as to avoid causing him professional or personal embarrassment, she moved out, renting an old house on a quiet, tree-lined street in a modest neighborhood downtown.

The practical and emotional challenges of the separation were magnified as she found herself effectively shunned by certain friends she and Ken had had in common. Some were shocked, even scandalized. Ken held a prominent and honorable place in the administration of the state's preeminent university, for heaven's sake; how could she divorce a man in his position? One friend asked point-blank, *Well, I guess you'll be leaving Bloomington, then?* implying that she had neither reason nor right to stay in town.

She spent months sorting through her responses to these and other conflicting messages. On the one hand, she felt deep loyalty to Ken, for whom she had never stopped caring, and it was hard to resist the pressure to feel ashamed that she had not remained 'til death should part them. On the other hand, death had already taken one beloved husband, and she had a powerful urge to live as fully as possible during the remaining years left to her. This sense of duty to herself had been the driving force behind the separation. She and Ken had no children together, and the children from both of their former marriages were well into adulthood.

FACING. In a half-bath off the kitchen, Diana covered the walls with a forest-themed paper and framed prints that blur the lines between human and vegetable worlds.

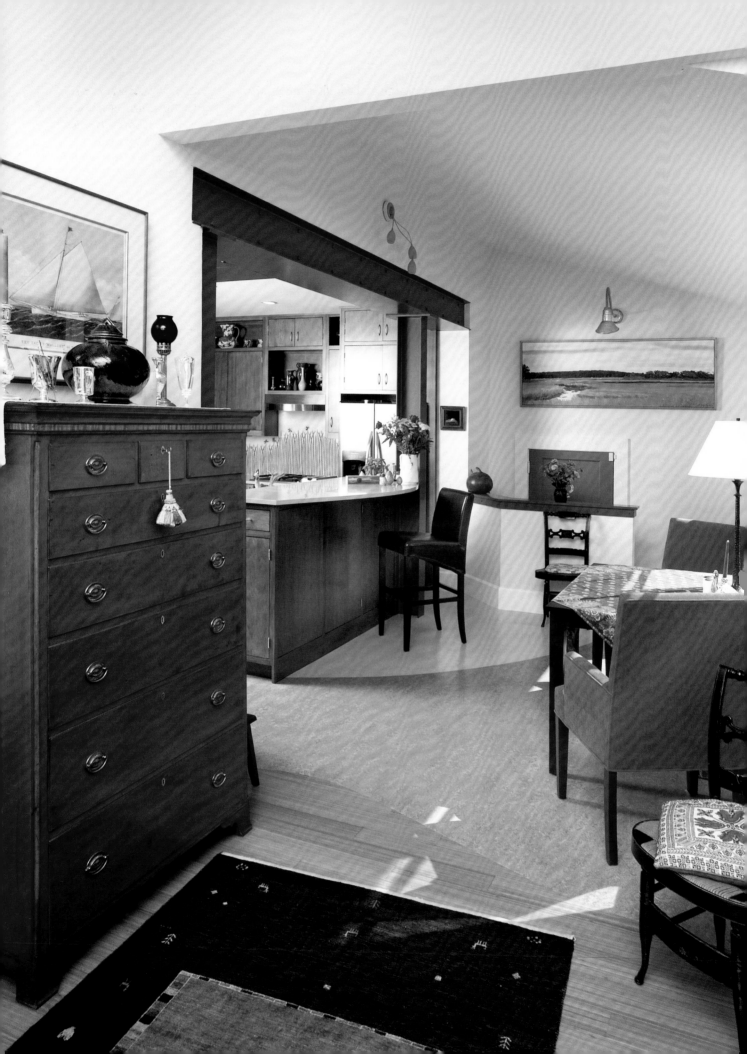

After protracted heart-searching, she concluded that she had as much right as ever to stay in Bloomington. She had lived there forty years and raised a family. She had taught courses at the university and dedicated herself to civic projects. It was time to overcome any lingering sense of embarrassment and shame.

Considering it prudent to buy a property, and eager to take on a new project, Diana looked for a house near campus. She sought a location that would encourage her to walk more, reducing her dependence on a car, and she wanted to be in a neighborhood, which would help her avoid feeling a sense of isolation.

Few places were for sale, but she found one—a modest Cape Cod built in the '30s. Diana wanted to create a space that would echo what she loved most about the home she had left, in which she had invested so much of herself. She envisioned an addition, which could be designed to accommodate her paintings and furniture, as well as have the high ceilings she craved. Though the original part of the house had two stories, she would keep the addition on one level to ensure accessibility as she grew older. She had loved the lavish landscaping at her country cottage house, but she realized there would be benefits to having the kind of small, manageable garden that would fit in this new place.

After buying the house in 2004, Diana hired her friend Christine Matheu, an architect, to design an addition. Christine had worked with Malcolm Woollen, the architect for Diana's Voysey-inspired house, at Venturi Scott Brown in Philadelphia, so Diana felt confident that she and Christine would work well together. They planned the addition around a central courtyard, transforming the house into a U shape that fit compactly on its urban lot. Christine reconfigured the kitchen to provide access to the garage from inside the house, through a sunny breakfast area that faces west. She opened up the original living room wall, extending the space into a large, south-facing hall so warm and bright that the architecture itself draws you in and insists that you sit.

Other rooms are colorful and powerfully evocative of different moods. The kitchen combines fun and practicality, with yellow walls, blue cabinets, and a custom-designed backsplash by Lara Moore over the stove. A curving inlay in the linoleum floor suggests a boundary between the cook's workspace and her guests' more leisurely domain. An I-beam painted red supports the upper story where Christine's design called for removing an original exterior wall. In the parlor, gray-green walls are tranquil and elegant, providing the perfect background for many of the watercolor landscapes Diana received from Lou and her father.

FACING. The kitchen opens onto a breakfast area, which in turn looks out to a private courtyard and garden.

The master bedroom, painted a confident, Pompeian red, looks through tall windows onto the courtyard and garden, and beyond to the original part of the house. It's a private, intimate space where Diana can feel secluded while enjoying the security of knowing that she has neighbors. For most of her life, she subscribed to the view she'd learned from her parents—"if you're going to do a big project, you take it on as a couple." Here, she proved she could do a large project without a husband or other partner. As she says, making this house her own provided an opportunity "to assert myself as a citizen of Bloomington—to show that I could do this on my own, and that I had every right to do so."

FACING. In Diana's bedroom, bold red walls and elegant antiques share space with a simple, summery blue and white rug. A drawing of Diana as a girl is reflected in the mirror.

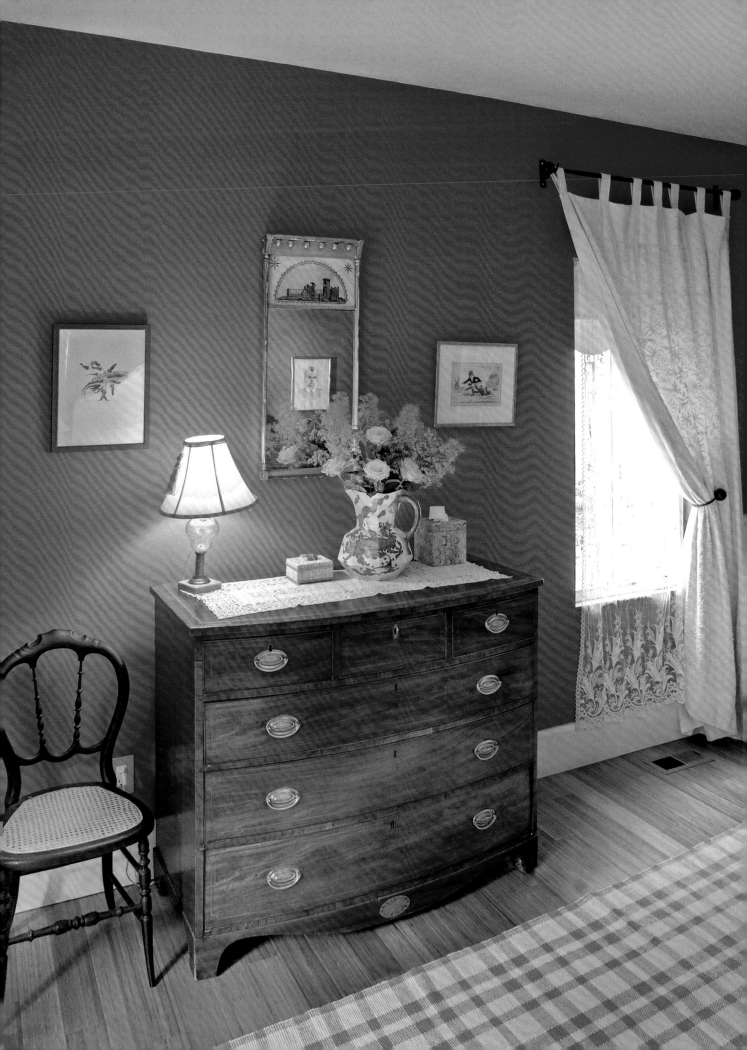

18 Home on the Range

YOU COULD SAY, with just a little artistic license, that Mary Agnes Conard rode into my life on the back of a mischievous steer.

I was pedaling my bike through the hills on a late summer evening. The air, still hot, had a dryness that hinted at fall's approach, and the dimming sunlight glinted through dust thrown skyward from a nearby quarry. Drought had bleached the fields a pale yellow-green. The creek beds were dry, their cascades of rock shelves silent, and I watched as a flock of birds, gathered in the limbs of a sycamore, took turns drinking from the last shallow pool in the bottoms.

I was nearing my turnaround when I passed a herd of Angus grazing the corn stubble behind a wire fence. One member of the group had managed to liberate himself and was strolling gladly down the road. I looked for a farmhouse, hoping to report the escape. The single nearby structure was an old gray trailer on a patch of lawn between two corn fields. The canopies of three tall maples shaded the homestead, and a pair of hounds scurried away as I approached. Rock music was coming through the trailer's open windows, where curtains rustled at each suggestion of a breeze.

I knocked on the front door and waited. After several moments an elderly woman appeared, walking slowly with a cane. Her shock of gray hair was cropped in a no-nonsense style. Her face was a landscape of lines, her complexion healthy, her eyes a clear blue.

MARY AGNES on her front stoop with Edwina, a visiting canine friend.

"Are these your cattle?" I asked. "I stopped to tell you one got out. I wouldn't want him to get hit by a car."

"He does that," she said gently. "I'll tell his owner."

Who was this woman, seemingly gracious and dignified, who lived in a trailer amid the fields? I held out my hand and introduced myself.

Her name was Mary Conard. She had been a high school teacher of English, math, and Latin and was now 94. A Latin teacher living in a trailer surrounded by farm fields? For a writer, it was an irresistible juxtaposition.

By this time the sun had ignited the reds and golds of the treetops beyond the fields. Every day, she told me, she would go outside to watch the trees come alive in the morning light. In the evening, she turned her lawn chair around to watch the sunset reflected in the woods to the east.

This, I thought, was a woman who knew how to live.

Bloomington was dry and hot at the end of May 1914. A public notice on the front page of the *Daily Telephone* addressed city utility customers:

> In order to give immediate relief from the dust, pattrons [sic] will be permitted to sprinkle from 6 until 8 o'clock each evening until oil has been laid on the streets.
>
> Patrons are warned that they MUST NOT use the water on their gardens. . . .
> Anyone violating this order will have the service shut off without further notice.
>
> —BY ORDER OF CITY WATER WORKS

Kahn's Clothing Company offered "Hot Weather Suggestions" such as straw hats and "cool underwear." A second paper, the *Evening World*, headlined stories on caring for spring pigs and avoiding grub in the sheep flock. The "Latest Local News" featured a preponderance of social announcements. *Miss Lillie Cox, of Hendricksville, is visiting Mrs. Denver Sparks on east Twelfth Street* was typical.

On the last day of that May, in a farmhouse two miles east of town, Lizzie and Clarence Latimer welcomed their first child into the world. Lizzie herself had been born in a farmhouse just a mile farther east and had family ties to her city's founding; her great-grandparents, John and Ann Henry Moore, had emigrated from Ireland and moved to Bloomington in 1818, the year of the city's establishment. Her husband's local roots ran almost as deep. Samuel Latimer, Clarence's grandfather, had come to Indiana with his Irish-born father and settled in Monroe County around 1838. Clarence was born in 1884 on the same family farm where his new daughter, Mary Agnes, first opened her eyes.

The world she saw was quite unlike the one we know today. Although Bloomington had existed for ninety-eight years, the town proper was an

island of business and urbanity in an ocean of farmland and forest. With a population of around 11,000, the city occupied just about four square miles. A few of the roads were paved with brick; some, outside the business district, were "Macadamized." The rest were dirt—muddy when it rained, and a baneful source of dust in dry spells. Hence the notice about sprinkling in May 1914. The dust was undoubtedly made thicker by the activities of approximately eighteen limestone mills and quarries, in addition to a furniture factory, that were in or close to town.

Mary Agnes Latimer, who would eventually have three siblings, grew up in what was then the country. Her father raised Guernseys on his family's 111-acre farm, his herd averaging fifteen head. Green and golden swathes of alfalfa, oats, and corn waved in the breeze where a K-Mart, a Sears, and a Showplace Cinema now stand. The family milked the cows by hand and sold their products to a creamery downtown. Mrs. Latimer drove the children to their one-room schoolhouse in the family's Model A Ford. In all but the worst weather, they walked the mile home.

Like most country residents, the Latimers grew their own vegetables and had a flock of chickens. Mary Agnes recalls the urgency and excitement of staying up late to pick beans before a frost. Spring storms, too, brought trouble; her mother would run outside to scoop up baby chicks in her apron, bring them into the kitchen, and put them in the wood-fired oven to keep warm. The family's meat came from the occasional cow that proved a disappointing milker; Mary Agnes once lamented that because her family did their own butchering, she took roast beef sandwiches to school for lunch but wished she could eat ham bologna "like the other kids."

For dry goods such as sugar, salt, and coffee the family went to town. "We did most of our trading at the A&P store," she says. "In those days you could take a basket of eggs . . . and exchange them for your groceries." The Latimers were exempt from the city's water restrictions in 1914; being in the country, they stored rainwater in a cistern and watered their cattle from springs on the farm.

Nearby farmers relied on each other and developed strong community bonds. Mary Agnes remembers spending long afternoons raking hay with her neighbors on the hottest days of summer. At threshing time the men worked outdoors and women joined forces to make an enormous lunch, cooking potatoes in a five-gallon milk can. Homegrown beans and corn were other highlights. "We fed twelve, washed the dishes, then fed another bunch," Mary Agnes recalls. Things were even busier at silo filling time.

When she turned eight, her family got a telephone and indoor plumbing—luxuries after the outhouse and the hand pump at the kitchen sink. After

OVERLEAF. Mary Agnes's trailer nestles between the three large trees roughly in line with the car passing through these acres of ripe corn in early autumn 2009.

chores there wasn't much to do for fun, at least by today's standards—no television, no shopping mall, no record player, and certainly no Facebook. Spelling bees were a popular pastime for people of all ages.

Mary Agnes graduated from high school and was elected to the National Honor Society. At college she majored in Latin. While still a student, she married Burl Conard, who worked for the university as a plumber. After Burl's death, she stayed on in their rural home. Their son Dale has continued his grandparents' legacy, raising Angus cattle and row crops with his wife, Connie, about a mile up the road from his mother's home. The mischievous steer who introduced me to Mary Agnes was one of theirs.

Mary Agnes passed away in 2010, at the age of 96. During a visit two years before, struck by her extraordinary independence, I had asked whether she would continue to live alone amid the fields. "I may get to the place where it's not safe," she acknowledged—"because I could fall. Not because I'm afraid." Her fearlessness seemed especially impressive in an age when anxiety is cultivated by advertisers as a means to sell everything from guns to insurance policies and retirement homes. When I inquired about this unusual confidence, she credited her family and early neighbors. "We trusted everybody and never thought anything about it."

Sitting on the front stoop of her trailer, she welcomed the sleek black cattle to the same sheltered spot each late afternoon. They ambled over, kneeling and then laying themselves down in the grass beneath the maples. "They bring me their flies," she'd say with wry affection. The massive bull would rest his head on a cow's hind quarters and swish his tail, a vision of contentment. Another cow licked her sister's forehead, comforting them both. It was a scene as pastoral as any artist ever painted.

When I asked whether the field across the road would be planted that season, she claimed not to know. The field was owned by a land trust devoted to preserving the vanishing rural landscape, and she had chided the owners the previous year for allowing it to grow up in weeds. "What was wrong with that?" I asked. "The weeds got so tall, they ruined my view," she replied. *View?* I was struck by the woman's aesthetic, as well as her nerve. Didn't the shearing of weeds—the first wave of growth in a forest's regeneration—constitute a greater violation? Shouldn't we be attempting to restore native flora wherever possible? On reflection, I realized that for Mary Agnes this view had been one of farmland over forty years—orderly rows stretching to the creek with a backdrop of woods beyond. Field, forest, sky—now that's a proper country view.

Some may argue with this conception, which regards cultivation as an integral part of the rural landscape. I myself was stymied by the notion, distracted by the orthodoxy of my urban-based culture from seeing the truth that Mary Agnes found so obvious. Provoked by her certainty, I wrestled with the challenge she had posed.

It wasn't long before my own classics background provided insight. Our word "cultivate" is derived from a Latin verb meaning to tend, or care for, something, and thence to honor, even worship, it. For Mary Agnes Conard, life had always been tied to agriculture—literally, tending the field—an everyday miracle by means of which we ourselves come into being and are sustained. Care for the fields, and the fields will provide for you. Through the simple act of perceiving beauty in the view across the road, she was honoring the source of her being. The pleasure she derived was itself an expression of gratitude.

She may have been long retired, but in her own way Mary Agnes Conard kept right on teaching 'til the day she died.

BIBLIOGRAPHY

Beecher, Catharine, and Harriet Beecher Stowe. *The American Woman's Home.* New York: J. B. Ford & Company; Boston, H. A. Brown & Company, 1869.

Burton, Antoinette. *Dwelling in the Archive: Women Writing House, Home, and History in Late Colonial India.* New York: Oxford University Press, 2003.

Cott, Nancy F., et al. *Root of Bitterness: Documents of the Social History of American Women.* Boston: Northeastern University Press, 1996.

Dinesen, Isak. *Out of Africa.* 1938. New York: Penguin Books, 1954.

Drew, Rachel Bogardus. "Buying for Themselves: An Analysis of Unmarried Female Home Buyers." Cambridge, Mass.: Joint Center for Housing Studies, Harvard University, June 2006.

Fell, Derek. *Secrets of Monet's Garden: Bringing the Beauty of Monet's Style to Your Own Garden.* New York: Michael Friedman Publishing Group, 1997.

Forster, E. M. *Howards End.* 1910. New York: Bantam Books, 1985.

Friedan, Betty. *The Feminine Mystique.* 1963. New York: W. W. Norton & Company, 2001.

Friedman, Alice. *Women and the Making of the Modern House: A Social and Architectural History.* New York: Harry N. Abrams, 1998.

Gallagher, Winifred. *The Power of Place: How Our Surroundings Shape Our Thoughts, Emotions, and Actions.* New York: Poseidon Press, 1993.

Hensel, Margaret. *English Cottage Gardening for American Gardeners.* New York: W. W. Norton & Company, 2000.

Hiller, Nancy. *The Hoosier Cabinet in Kitchen History.* Bloomington: Indiana University Press, 2009.

Hobhouse, Penelope. *Penelope Hobhouse's Garden Designs.* New York: Henry Holt & Company, 1997

Lees-Milne, Alvilde, and Rosemary Verey. *The New Englishwoman's Garden.* Topsfield, Mass.: Salem House Publishers, 1988.

Mack, Lorrie. *The Art of Home Conversion: Transforming Uncommon Properties into Stylish Homes.* London: Cassell, 1995.

Piercy, Marge. *The Moon Is Always Female.* New York: Knopf, 2008.

Plante, Ellen. *The American Kitchen, 1700 to the Present: From Hearth to Highrise.* New York: Facts on File, 1995.

Rothman, Sheila. *Woman's Proper Place.* New York: Basic Books, 1978.

Russell, Vivian. *Monet's Garden: Through the Seasons at Giverny.* New York: Stewart, Tabori, & Chang, 1995.

Rybczynski, Witold. *Home: A Short History of an Idea.* New York: Viking Penguin, 1986.

Sackville-West, Vita. *All Passion Spent.* 1931. New York: Carroll & Graf, 1991.

Wolf, Naomi. *The Beauty Myth: How Images of Beauty Are Used Against Women.* 1991. New York: Harper Perennial, 2002.

Woolf, Virginia. *A Room of One's Own.* 1929. New York: Harcourt, 1981.

NANCY R. HILLER is a cabinetmaker and owner and principal designer at NR Hiller Design, Inc. She is author of *The Hoosier Cabinet in Kitchen History* (IUP, 2009) and has published in numerous period design and woodworking magazines, including *American Bungalow*, *Old-House Interiors*, and *Fine Woodworking*.

KENDALL REEVES is a professional photographer and owner of Spectrum Studio of Photography & Design and Gallery 406, in Bloomington, Indiana. His previous books include *Bloomington: A Contemporary Portrait* and *Terre Haute: Crossroads of America*.

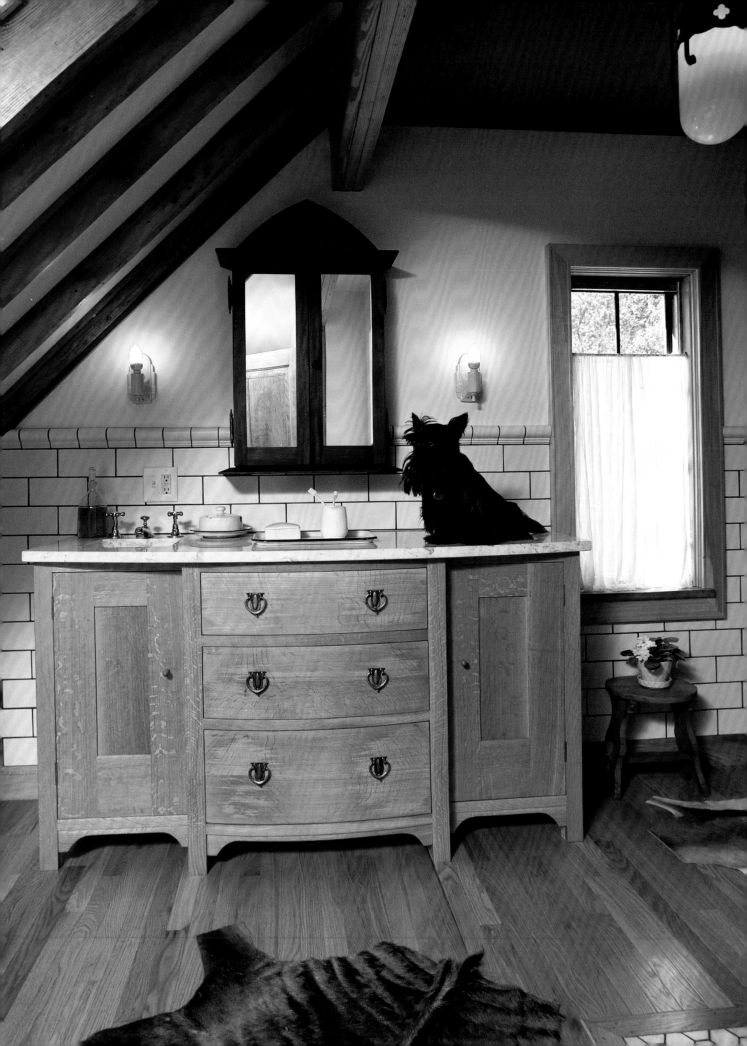